John Adrian
(Holborn Books Ltd)
14 Charing Cross Rd.
London WC2

July '83

THE INGENIOUS

Mr Hogarth

THE INGENIOUS
Mr Hogarth

Derek Jarrett

London
MICHAEL JOSEPH

First published in Great Britain by Michael Joseph Ltd
52 Bedford Square, London WC1B 3EF
1976

ISBN 0 7181 1489 2

Typeset in Ehrhardt by
Hazell Watson & Viney Ltd
Aylesbury, Bucks

Printed and bound by
Redwood Burn Ltd
Trowbridge and Esher

Picture research by Philippa Lewis

Contents

Illustrations

Acknowledgements

The author wishes to thank the following for permission to reproduce illustrations given in this book:

British Library: 1a. National Gallery: 1b, 19a, 19b, 20a, 20b. British Museum: 3a, 4a, 4b, 4c, 5a, 5b, 6a, 6b, 7, 8a, 11, 12a, 12b, 14a, 14b, 15b, 17a, 17b, 18a, 18b, 21a, 21b, 22b, 23a, 23b, 25, 26a, 26b, 27, 28, 29, 30a, 30b, 31a, 31b, 32. Victoria and Albert Museum: 3b. Service du Documentation des Musées Nationaux, Paris: 8b. Fitzwilliam Museum: 9a. National Portrait Gallery: 9b. Philadelphia Museum of Art Collection: 10a. Leicestershire Museum and Art Galleries: 10b. Tate Gallery: 13a, 16, 24b. National Trust, Ickworth: 13b Mellon Foundation: 15a. Honourable Society of Lincoln's Inn: 22a. Albright-Knox Art Gallery, Buffalo, New York: 24a.

The letter on pages 178–9 is taken from *Hogarth, His Life, Art and Times* by Ronald Paulson, Yale University Press 1971, 2 vols. ii, 264–5

Introduction

Macbeth thought that once Duncan was in his grave nothing could touch him further. The historian cannot be so sure. He knows only too well that some of the worst things that happen to people take place after they are dead. In Hogarth's case the really significant date, the unavoidable starting point for any assessment of his life and work, is neither his birth in November 1697 nor his death in October 1764. It is the publication, in March 1798, of the third volume of John Ireland's *Hogarth Illustrated*. Ireland himself set great store by this work, suggesting that because it was based on Hogarth's own autobiographical writings it would prove both authoritative and definitive, eclipsing once and for all the 'volumes of tedious narrative written by others, beginning with a pedigree and ending with a funeral'.

And so it did. Since that time it has been extremely difficult for anyone to produce a standard pedigree-to-funeral life of Hogarth without first taking into account what John Ireland did to him a third of a century after his death. 'To a large extent,' Michael Kitson has written, 'our Hogarth is the one Ireland re-arranged and touched up.'[1] The re-arrangement was certainly very influential – Ireland's editing of Hogarth's papers, though sympathetic, was staggeringly over-confident – but it has lost some of its power now that Michael Kitson himself has given us a scholarly edition of the *Apology for Painters*, one of the supposedly autobiographical manuscripts used by Ireland, and Joseph Burke has done the same for the other, the so-called *Autobiographical Notes*.* Ireland's real achievement, however, was some-

* For details of these invaluable editions, of which I have made extensive use, see p. 201.

thing much more fundamental, something which lies beyond the reach
of scholarly correction. By taking a few pages of Hogarth's most
retrospective and most introspective writings and making them serve
as a framework for the artist's whole life he quite literally turned the
man back to front and inside out. In their printed form the *Autobio-
graphical Notes* and the *Apology for Painters* together only amount to
some sixty pages; and even this is deceptively long, since the manu-
scripts themselves are full of repetitions and deletions and false starts.
The actual amount of material is very small indeed, most of it intended
as self-justification and self-examination rather than as autobiography.
It was the product of Hogarth's embittered last years, when he was
obsessed with the need to fight old battles and confute lifelong enemies.
Everything he wrote was tinged with recrimination and regret, an out-
burst aimed at relieving his own frustrations rather than satisfying the
curiosity of future generations. And yet his whole life's work was now
to be encapsulated for ever within this limited and wholly unrepresen-
tative body of written work.

As well as pinning Hogarth down under the weight of his own ran-
corous old age, Ireland also destroyed the essential unity of his art. In
the *Apology for Painters* Hogarth declared that 'drawing and painting
are only a much more complicated kind of writing'[2]; and throughout
his life he sought to communicate both visually and verbally, bringing
together into one fabric the language of images and the language of
words. His best work was based on a subtle interpenetration of word
and image which won for him the title of 'the ingenious Mr Hogarth',
a phrase which he much relished and which he utilised in his own
advertisements. It was not just a game, not just a matter of visual puns
and appropriate captions: it was part of the intellectual inheritance
which he received from his father. Richard Hogarth was a struggling
schoolmaster whose otherwise sad life was given meaning by his
interest in what the seventeenth century called 'characters' – differing
ways in which men could communicate with one another by means of
sounds and words and pictures. His son carried on his work, seeking
to link words with images in the way his father had sought to link
sounds with words. The father had had a startlingly modern interest

in voice production, in the anatomical origins of human language; the son had an equally modern concern with what he called 'the language of action', the ways in which movement and posture reflected and governed the images men produced and the words they used. Naturally enough, ideas of this sort aroused opposition from more conventional artists and from the pundits who claimed to interpret their work. They dealt in unique images, paintings and sculptures with a presence of their own rather than mere vehicles for reproduction and communication. And at the end of his life Hogarth finally allowed the persistent denigration from the 'connoisseurs' to undermine the unity of his own work. He answered them in their own language, producing images without words and words without images. While his pictures became more self-consciously painterly his writings became more self-consciously literary. He painted in order to justify what he wrote and he wrote in order to justify what he painted. It was this tragically divided Hogarth that Ireland seized and used, super-imposing him on the truer and more representative Hogarth of the earlier years.

The antitheses and ambiguities of Ireland's Hogarth were sharpened by the age in which it was produced. The third volume of *Hogarth Illustrated* came out in the same year as *Lyrical Ballads*, in which Wordsworth and Coleridge between them gave new meaning to the idea of 'the inward eye', the part played by introspection in art. Two years later Wordsworth closed the door on the eighteenth century with his phrase about poetry as recollected emotion. The new view of artistic creativity, the view which later came to be called Romanticism, made it difficult to reconcile the apparently detached Hogarth of the popular prints, the impassive observer holding up a mirror to the antics of others, with the darkly introspective Hogarth who brooded over the *Autobiographical Notes* and the *Apology*. At the same time the division he had fought against all his life, the division between the cult of the unique art object and the techniques of mass communication, grew deeper still. And the seventeenth-century aesthetic and intellectual traditions which had cradled Hogarth's work were forgotten, so that it became increasingly difficult to reverse the retrospective cast and see his life the right way round. Poor well-meaning John

Ireland, who had intended to re-unite Hogarth the man with Hogarth the artist, had achieved precisely the opposite.

The art world in England has always viewed Hogarth with mingled pride and embarrassment, rather as an aristocratic family might view one of their number who had turned out to be a famous music-hall entertainer. His value for ordinary people has never been in dispute: he has become a kind of archetypal looking-glass for Englishmen in general and for Londoners in particular. One of the books about him has even been given the faintly condescending sub-title 'the Cockney's Mirror'. But art experts and scholars, particularly those who have been influenced by the somewhat attenuated aestheticism of the nineteenth century, have found it difficult to get beyond the barriers which John Ireland so unwittingly put up. The generation that could take Walter Pater's art criticism seriously could hardly be expected to appreciate the more robust sensibilities of William Hogarth, or to understand the underlying unity of what he did. Now at last the advent of television has made that unity clear once more. Even the date of Hogarth's birth, which stands almost exactly halfway between the invention of printing and the invention of television, comes to look like a strangely convenient piece of chronological symbolism. Printing destroyed the unique nature of the written word; television completed the process which did the same for the visual image. And in between stood William Hogarth, dealing not just in words as well as images but in reproduction as well as creation, in linear images for the public as well as painterly images for the connoisseur. In the world's unrelenting march from individual creativity to mass communication his importance is enormous, his central position something more than a chronological accident.

For this very reason no book about him can ever be a mere biography. It was not John Ireland who transcended the pedigree-to-funeral approach; it was Hogarth himself who rendered it inapplicable by the nature of his work. Very little is known about his life in any case and what there is only makes sense when it is placed against the background in which he worked – the legacy of printing, the seventeenth-century debate about the nature of language, the rival attrac-

tions of art as property and art as communication. These are the elements of that forward-looking context which is the necessary corrective for the retrospective context imposed on Hogarth by John Ireland. In seeking to provide them I have tried not to run away from Ireland's work but to build upon it, to use it as a point of departure. My chapter titles are all taken either from the *Autobiographical Notes* or from utterances closely associated with them. They mark the stages of the journey which Hogarth retraced with such bitterness in his old age, but they may also be allowed to indicate the realities which lay behind those rancorous memories.

J.D.J.
February 1975

CHAPTER I
His father's pen

The first thing Hogarth said about himself in his *Autobiographical Notes* was that he was born in the City of London. The second was that 'His Father's Pen, like that of many other authors, was incapable of more than putting him in a way to shift for himself.'[1] If he had intended to lead his biographers into a dialectical approach to his childhood, an approach based on a clash of thesis and antithesis, he could hardly have done it more effectively. On the one hand there was the City of London, that picturesque and teeming labyrinth of colourful streets so beloved of romanticising historians; on the other the cold and colourless pedantry of Richard Hogarth, the unsuccessful teacher and grammarian. 'Being brought up by a schoolmaster,' remarks Ronald Paulson in his summary of Hogarth's childhood, 'would only have intensified the striking contrast between the preposterous regimentation of the grammar school and the freedom of the practical education available around the London streets.'[2] And the particular streets in question were unusually colourful because they centred on Smithfield Market, which was transformed every August by the arrival of the annual saturnalia known as Bartholomew Fair. William was born on 10 November 1697 at a house in Bartholomew Close, a few yards to the east of the market-place; and by a happy coincidence some of the best contemporary accounts of Bartholomew Fair date from 1698 and 1699. And the campaign waged by the City authorities to close or curtail the Fair, because of its 'obscene, lascivious and scandalous plays, comedies and farces', also happened to coincide with the first few years of William's life. It is therefore hardly surprising that this well documented and easily described outburst of

annual merry-making came to be used by Hogarth biographers as an epitome of all the full-blooded visual influences which were brought to bear on the future artist and which contrasted so sharply with the anaemic intellectualism of his father.[3]

Nevertheless there are certain dangers in this approach. Hogarth undoubtedly had a passionate and lifelong enthusiasm for the theatre: he said in the *Autobiographical Notes* that 'shews of all sort gave me uncommon pleasure when an infant'[4] – a remark which has been taken by biographers to refer to Bartholomew Fair but which may equally well relate to other plays and pageants, not all of them as far removed from his father's interests as the merry mountebanks who populated Smithfield each August. The mountebanks figure very prominently in the imaginary conducted tours of Bartholomew Fair; but when Hogarth himself came to reconstruct such a fair in 1733 he paid comparatively little attention to them and concentrated instead on the theatrical performances going on in the booths around the fairground. Not all of these were unintellectual or unconnected with Richard Hogarth's classical learning. Those who went to see Elkanah Settle's *Siege of Troy* at Mrs Mynn's booth at Bartholomew Fair in 1707 (as Hogarth himself probably did, since he put it into his 1733 picture) were promised that in Act II 'the scene opens and discovers the Temple of Diana, being a magnificent structure richly adorned with Capitals, Urns, Crescents, Festoons and other carved work, all gilt, consisting of ten pieces of painting, in each of which, in a large Nych in each front of these paintings, are seen the ten statues of the Heathen Gods . . . beyond them in a serene heaven is seen Diana driving a Chariot drawn by two hinds'.[5]

Elkanah Settle was also responsible for staging the annual pageantry of the Lord Mayor's Show, another of the 'shews of all sort' which Hogarth may have had in mind when he set down his reminiscences. The Lord Mayor's Show in 1701, the first that Hogarth can reasonably be expected to have remembered, included a 'maiden chariot' sponsored by the Mercers' Company and drawn by nine white horses ridden by nine allegorical figures sounding nine silver trumpets. Next year the new Lord Mayor was a member of the Vintners' Company

and so the spectacle featured St Martin, patron of vintners, attended by twenty dancing satyrs, ten halberdiers and ten Roman lictors. He was preceded by Ariadne's chariot, drawn by panthers, and by various cartloads of Bacchanals with vine leaves in their hair and satyrs in attendance.[6]

Pagan deities and other allegorical figures played a large part in Hogarth's early work and there can be no doubt that he was influenced more by the crude classical symbolism in which Elkanah Settle and others like him dealt, than by the earthy rough and tumble of the fairground itself. It was the enchanting dream world inside the booths, not the lusty reality outside them, that stayed in his mind. And however harsh and dreary and pedantic Richard Hogarth may have been, he can hardly have been totally unresponsive to symbols and allegories which originated in that same classical age which gave him his intellectual respectability. In fact he does not seem to have been harsh or pedantic at all, nor does he seem to have sent his son to schools in which there was the 'preposterous regimentation' to which Ronald Paulson refers. 'When at school,' wrote Hogarth in the *Autobiographical Notes*, 'my exercises were more remarkable for the ornaments which adorned them than for the exercise itself. I found blockheads with better memories beat me in the former but I was particularly distinguished for the latter.'[7] Though the structure of his sentence showed all too clearly that his early lessons in syntax had not been very effective, its content did at least suggest that they had not been particularly harsh. Most schoolmasters in the early 1700s were more ready to chastise than to reward boys who adorned their grammatical exercises; and if the young William gained distinction rather than punishment from his 'ornaments' it was probably because the school he attended was one which followed Comenius's method of teaching by word and image simultaneously and which encouraged its pupils to play a positive part in this process. What little we know about Hogarth's childhood suggests that he was brought up to regard words and images as complementary rather than contrasting means of communication.

The textbooks of Comenius, like the allegories used by Elkanah

Settle, were part of a powerful seventeenth-century intellectual tradi-
tion which moulded Hogarth's childhood and brought together, in
co-operation rather than confrontation, the shows that gave him such
uncommon pleasure and the father who gave him his intellectual
inspiration. Jan Comenius's most important works were the *Orbis
Sensualium Pictus* and the *Janua Linguarum Trilinguia*, both of which
transcended national differences by using pictures to teach the vocabu-
lary of Latin and of vernacular languages at the same time. 'If we
could make our words as legible to children as pictures are,' wrote a
London schoolmaster called Hezekiah Woodward in a preface to an
English edition of the *Orbis* in 1658, 'their information therefrom
would be quickened and surer.'[8] It was a sentiment which William
Hogarth was to echo more than a century later, when he wrote in his
Autobiographical Notes that his prints taught lessons which 'cannot be
conveyed to the mind with such precision and truth by any words
whatsoever'.[9] As for Richard Hogarth, his own textbook echoed
Comenius's title and produced a new variant on Comenius's method. It
was published in 1689, a year before his marriage and eight years
before William's birth, and it was called *Thesaurarium Trilingue
Publicum, being an introduction to English, Latin and Greek*. It was not
at all what it claimed to be: there was no systematic attempt to teach
the three languages in question and there was no real connection
between the first part of the book, which was a treatise on English
spelling and pronunciation, and the second, which dealt with the
accenting of ancient Greek. What was interesting was the emphasis on
phonetics, the attempt to do for sound and meaning what Comenius
had already done for word and image. There were lists of words which
'differ in Signification and Spelling, though not in Sound or Pronun-
ciation' and others of words 'spell'd otherwise than they are com-
monly pronounced'.[10]

Some twenty years earlier Bishop John Wilkins had tried to bring
together the work that Comenius had already done and the work that
Richard Hogarth was later to think of as his own. Wilkins's book was
called *An Essay towards a real Character*, a title which sounds odd now
but which was very much in the mainstream of seventeenth-century

thinking. At that time the word 'character' meant any kind of sign or symbol – a letter of the alphabet, a digit, a sign in musical notation, an ideogram or pictorial sign, a magical or hieroglyphic symbol – and there was much debate as to which of these forms were fundamental to human understanding and which were merely derivative. Because of the vestigial fears of idolatry which still haunted Christian Europe – and especially Protestant Europe – there was a tendency to assume that divine truth came packaged in words rather than images and that the latter could only be discussed in terms of the former. Wilkins, however, denied this: 'Natural characters are either the pictures of things or some symbolical representation of them.' The characters out of which words were built were themselves derived from the language of imagery and visual experience. Perhaps in the end the fourth Gospel might have to be re-written: in the beginning there had not been the Word at all but the Image. And the relationship between speech and writing was just as ambiguous, just as lacking in a divinely appointed pecking order, as that between writing and pictures: 'voices and sounds may as well be assigned to figures, as figures may be to sounds'. Underneath the umbrella provided by Wilkins both the textbooks of Comenius and those of Richard Hogarth could play their part in a system of education in which speech, writing and visual experience were continually interchangeable.[11]

It is unlikely that the educators of the young William Hogarth reached the philosophical heights to which Bishop Wilkins aspired; but at least they do not seem to have forced the boy into a regimented system of learning based only on grammar and written sentences. In addition to the information about the ornamented exercises we also know that as a child he was an amusing mimic – 'mimickry common to all children was remarkable in me'[12] – and that nothing was apparently done to stifle this gift. By the time he was six years old his father had given up his own school in Bartholomew Close and had moved to St John's Gate, where he kept a coffee house. It was intended for men of learning – 'The Master of the House, in the absence of others, being always ready to entertain Gentlemen in the Latin Tongue' – but there was also a society of tradesmen who met there every Monday night

'for the promoting their respective Trades'.[13] While the learned gentlemen were being entertained in the Latin tongue by the father, the less pretentious customers may perhaps have derived some amusement from the mimicry of the son. Certainly there was plenty of opportunity to meet men of the theatre as well as men of letters: this part of the City was the haunt of showmen and hack writers and scene painters as well as devotees of the Latin tongue. At least one neighbouring painter took a liking to William and allowed him the run of his workshop, a gesture which 'drew my attention from play – every opportunity was employed in attempt at drawing'.[14]

Nobody knows who this kindly artist was; and the other adults who surrounded the boy at this stage of his life are equally shadowy figures. In later life Hogarth showed a total lack of interest in his relatives and in his family's origins. His father is said to have been the third son of a farmer in the Vale of Bampton in Westmorland, a part of the country which Hogarth himself apparently never bothered to visit. One of his uncles was Thomas Hogarth of Troutbeck, a man of literary leanings who gained a local reputation as something of a poet. Another uncle, Edmund Hogarth, seems to have followed his brother to London and set up a victualling business near London Bridge. But even the connection between Richard and Edmund on the one hand and Thomas and Westmorland on the other has never been conclusively proved. One particularly persistent tradition places the family's origins in Yorkshire, while another suggests that they were Scots. There certainly seem to have been some distant cousins from Berwickshire who visited Hogarth occasionally in the days of his fame. If the family did indeed originate in Scotland this might explain Hogarth's reluctance to trace his ancestry or acknowledge his relatives. There were many Scotsmen and Irishmen in eighteenth-century England who bowed to the violent prejudices of the English against their native countries and even outdid their hosts in the fury of their attacks on these lands. Hogarth's earliest satirical print, *The South Sea Scheme*, included a gibe at the Scots.

His immediate family was not particularly large by the standards of the time. The first three children born to his parents had died in infancy and the eldest surviving child was his brother Richard, born in

April 1695. Then came William himself, born in November 1697, followed in November 1699 by Mary. Another daughter, Anne, was born in October 1701 and a son, Thomas, in November 1703. Thomas lived only until 1710 and another son, Edmund, born in 1705, appears to have died in 1710 also. Meanwhile Richard had died in December 1705, leaving William as the eldest surviving child and potential head of the family. In later years he did his best for his sisters, doing them a shop card when they set up as purveyors of 'the best and most fashionable ready made frocks' and taking Anne into his household as a business assistant after Mary's death in 1741. The early death of his three brothers was sad but not particularly unusual: expectation of life was low among young children in the early eighteenth century, even in families able to afford healthier living conditions than the Hogarths had to put up with. Like most of his contemporaries William Hogarth was brought face to face with the reality of death at a very early age, but there is no reason to think that this marked him for life. Even in the *Autobiographical Notes*, written at a time when he was obsessed with thoughts of his own approaching death and of the transience of all things human, he said nothing to suggest that his childhood had been overshadowed by grief and mourning. Like most children at the time, he and his sisters seem to have been reasonably resilient and they probably had their full share of fun and celebration as well as sadness.

The obvious time for celebration was the month of November, which saw the birthdays of Mary and Thomas as well as William. Children were not encouraged to make too much of their birthdays but in the case of the Hogarth family the extraordinary concentration of anniversaries coincided with a time of public festivity. It was in November, just as they began to disappear from sight among the dripping smoke-laden fogs which reputedly gave them their phlegmatic character, that Londoners celebrated the country's great national feast days. Later generations were to whittle these down to one only, the ritual burning on 5 November of the supposed Catholic conspirator Guy Fawkes: but at the time of Hogarth's boyhood most of November was one long outburst of Protestant and patriotic merrymaking. As well as Guy Fawkes' day there was 4 November, King

William's birthday and the anniversary of the day in 1688 when he had landed at Torbay to save England from the Catholic King James II. This was followed by the Lord Mayor's Show on 9 November and another popular festival on 17 November, the anniversary of the accession of Good Queen Bess in 1558. Most Protestant Englishmen looked back to this event as the real beginning of their national greatness; and in the early 1680s, after the discovery of the alleged Popish plot in November 1678, it had been customary to celebrate it with a 'Solemn Mock Procession of Pope and Devil'. Long columns of men dressed as Catholic priests wound through the streets, many of them equipped with leering and horrific masks, while others pretended to sell pardons and indulgences among the crowds. Finally the Pope himself appeared, similarly robed and masked, preceded by musicians and surrounded by clouds of incense. With him, suitably hoofed and horned, was the Devil. After the processions came the bonfires, on which effigies of the Pope and the Devil were ceremoniously burned. The processions had been discontinued by the time Hogarth was born, though the bonfires and effigies still appeared; and in 1709, just at the time of young William's twelfth birthday, a sermon preached by Dr Sacheverell in St Paul's Cathedral sparked off new religious strife and led to the revival of the processions. They continued into the early years of George I's reign, by which time Hogarth was already beginning to translate his childhood impressions into visual images of his own. The Devil and Pope pageants, like the Lord Mayor's Shows, deserve to be remembered along with the Bartholomew Fair booths as possible sources for those images.[15]

It was when Hogarth was about eleven that there took place the event which above all others might have been expected to set him against his father's intellectual pretensions and turn him instead towards the earthy and colourful world of the London streets. Just what happened and when it happened is not clear, but we know for certain that by the beginning of 1709 the coffee house venture had failed and Mrs Hogarth was having to raise money by selling pots of gripe ointment for children at half a crown a time – 'a most noble and very safe medicine . . . which, by outward use only and in the very

moment of application, cures the gripes in young children and prevents fits'.[16] The address at which this miracle cure was to be obtained was given as 'next door to the Ship in Black and White Court, Old Bailey'; and some twenty months later, in September 1710, Richard Hogarth wrote a pitiable letter from the same address to Robert Harley, the Queen's chief minister. He reminded Harley that he had sent him two proposals for the reform and extension of the taxation system and that these had subsequently been pirated by 'ignorant butchers and cobblers' while their real author wasted away in prison. He also asserted, rather surprisingly, that he was responsible for the care of no less than twenty-two children. Finally he pointed out what his wife had been careful *not* to point out in her advertisement for gripe ointment – the fact that Black and White Court was 'within the bounds of the Fleet'.[17] The Fleet prison, a few hundred yards to the south of the Hogarths' earlier homes in Bartholomew Close and St John's Gate, was used for the imprisonment of insolvent debtors; and prisoners who could scrape up enough money could buy for themselves the special privilege of living outside the prison itself but still within its 'bounds' or 'rules'. At its worst, imprisonment for debt in eighteenth-century England was a truly horrifying business and foreign visitors were constantly shocked by its absurdity as well as by its cruelty. To them it seemed to epitomise all that was worst about Englishmen – their mercenary nature and their total absorption with money to the exclusion of all else, even common humanity and common sense. An unpaid creditor could get a debtor put into prison, a course of action which made the payment of the debt even more difficult than it had been before and which benefited nobody but the jailers whose exorbitant fees the debtor had to pay if he wanted even the barest minimum of comfort. Prisoners could be required to pay for their food, for a room to sleep in, even for the privilege of not being put in irons. To make repayment and release still less likely, debtors were not allowed to earn their own living while in prison.

There is no reason to think, however, that Richard Hogarth suffered this extreme fate. He seems to have moved straight from his failed coffee house to Black and White Court without being in the prison

itself. He may even have taken refuge within the rules of the Fleet of his own accord – a common practice, since it enabled debtors to get out of paying normal parish rates as well as giving them some protection from their creditors. He may even have been flouting the regulations by keeping a school and thus earning money while still an undischarged debtor. This would explain the mysterious twenty-two children and it would also explain the conviction among early Hogarth biographers that his father kept a school during these years near that same Ship tavern which Mrs Hogarth mentioned in her advertisement. Many years later, in the *Autobiographical Notes*, Hogarth told how his father had been cheated by booksellers and abandoned by rich patrons but he did not mention anything about the time spent 'within the bounds of the Fleet'. He took a kind of perverse pride in some of his father's misfortunes but others, perhaps disreputable as well as merely pitiable, were passed over in silence.

Richard Hogarth was discharged from the jurisdiction of the Fleet in September 1712, probably as a result of the Act for the Relief of Insolvent Debtors, which had been passed some months earlier. The financial difficulties of the family were by no means over and Hogarth recalled later that as a result of these difficulties he was 'taken early from school and served a long apprenticeship to a Silver Plate Engraver'.[18] In fact, however, his apprenticeship began late rather than early. Instead of being bound at the age of fifteen as was usual he waited until February 1714, by which time he was well over sixteen. He never revealed what he did between leaving school and becoming an apprentice, or even that such a gap existed; but it is hard to resist the conclusion that he had to take up some sort of menial employment in order to bring in money. He grumbled all his life about the unrewarding trade to which he had been apprenticed but he knew all the same that in the harsh world of eighteenth-century London any trade was better than none – hence his insistence, in his famous *Industry and Idleness* series, on the chances that the idle apprentice was throwing away. At the time of his fifteenth birthday it may still have been touch and go whether any apprenticeship at all would be possible.

Uncle Edmund, the victualler at London Bridge, may have played a

part in making it possible. He was related by marriage to Ellis Gamble, a silver plate engraver who had a business just to the south of what is now Leicester Square; and when Gamble took the young Hogarth as his apprentice in February 1714 he did not apparently demand a premium. This cannot have been because of any lack of reputation on Gamble's own part, since his other apprentices paid premiums in the usual way, and it may perhaps have been because of Edmund Hogarth's good offices.[19] According to William's own account he entered into his apprenticeship with a mixture of reluctance and resignation: he had seen for himself 'the precarious state of authors and men of learning' and so any opening in the visual arts, however humble, was to be greeted with some relief – especially in view of what he himself called his 'natural turn for drawing rather than the learning a language'.[20] But he had not yet finished with the intellectualism and classical learning for which his father had stood. Within a very short time he was to find that it was this learning, rather than any natural talent for capturing the visual excitement of the London streets, which was to save him from sinking into the hopeless anonymity of London's hack illustrators and engravers.

CHAPTER II
The monsters of heraldry

While Richard Hogarth and his projected Latin dictionary were languishing 'within the bounds of the Fleet', the booksellers of London were turning their attention to other and more profitable ventures. Pierce Tempest, a rather superior bookseller of gentlemanly extraction who did business in the Strand, published during these years two books which between them suggested very clearly the things which united, as well as the things that separated, the sad defeated schoolmaster and his newly apprenticed son. On the one hand there was *The Cryes of the City of London* (see plate 1a), a very popular and successful work which contained seventy-four portraits of London street hawkers, taken from drawings by Marcellus Laroon the elder, together with descriptions of the cries they used. If Hogarth was going to desert the intellectualism of his father in order to seek inspiration and profit in the life of the London streets this was the direction in which he must look. The field was by no means exhausted yet: there were plenty of other curious and colourful categories of people in the streets of the City who could be given the same treatment as the itinerant vendors, to the great profit of the artist who undertook to draw them. On the other hand, if the world of classical learning still possessed its fascination and the frustrated apprentice engraver wanted to base his imagery on it rather than on the spontaneous drama of the London scene, there was another and far less successful work to be studied: *Iconologia, or Moral Emblems by Caesar Ripa, wherein are expressed various images of virtues, vices, passions, arts, humours, elements and celestial bodies: as designed by the Ancient Egyptians, Greeks, Romans and Modern Italians.* This compendious work, which was illustrated with more than three

hundred examples of emblematic imagery, was said by Tempest to be of use to 'Orators, Painters, Sculptors and all lovers of ingenuity'.

Richard Hogarth had defined the word 'ingenious' twenty years before in his *Thesaurarium* as meaning 'witty'; and he had suggested, perhaps rather surprisingly, that it was pronounced in the same way as 'ingenuous'. Both the definition and the remark about pronunciation suggested that as a scholar he might have serious limitations. There were many other odd groupings among the words which he said were pronounced the same – 'century' and 'sentry', 'kennel' and 'canal', 'Easter' and 'Esther' – and there were in particular those which betrayed his ignorance of European languages. 'Dolphin' was coupled with 'dauphin' and – strangest of all – 'lower' (more low) with 'Lour' (the French King's Palace).[1] Just as a visit to France might have taught him how to pronounce the word 'Louvre', so a deeper understanding of the European intellectual tradition of the sixteenth and seventeenth centuries would have shown him that the English word 'ingenious' had come to be linked with the international language of symbols and emblems, the language of which Tempest was reminding English scholars again with his translation of Cesare Ripa's work. The ingenious man was not just the witty man; he was above all the man versed in the recondite art of emblem-writing, the knitting together of word and image into a form which transcended ordinary language and gave an insight into divine truth itself. There had always been something magical and occult about emblem-writing: in Renaissance Italy, where it had reached its highest peak, it had been regarded as a scholarly mystery which dealt in symbols of power as real and as potent as the cabalistic signs of the alchemists and the practitioners of black magic. The Jesuits, first in Germany and then in France, called it 'iconomystics' and claimed it as their special preserve, an exclusive and esoteric method of teaching the mysteries of the Christian faith *'profitablement, vivement et delicieusement'*. This claim had been strenuously resisted by the Dutch print-makers of the late seventeenth century, who had secularised emblem-writing again and put it to political and satirical uses; while in England it had suffered a long decline until by the beginning of the eighteenth century it was regarded

as little more than a diversion for children or a way of whiling away winter evenings.[2]

Through all its vicissitudes the art or science of the emblem-writers had preserved a special relationship with the concept of ingenuity. In the late sixteenth century, when English scholars and poets and artists still stood Faustus-like in awe of the occult mysteries of the Italian Renaissance, translations of Italian tracts were dedicated in particular to 'the ingenious reader'; and a hundred years later, when emblems had shrunk in English eyes from a philosopher's passion to a fireside pastime, the hack writer Nathaniel Crouch could still give his catchpenny collection of popular emblems the title *Delights for the Ingenious*.[3] The ingenious man might have lost something of his old dignity and dwindled from a delver into the ultimate mysteries to a mere lover of problems; but he was still a distinct and recognisable type, a man whose particular skill lay in the merging of word and image. And William Hogarth, whose own skill in this direction was to make his very name a synonym for ingenuity, could hardly afford to neglect the art of the emblem-writer. However much he might be drawn to the bustle of the London streets, to the real characters illustrated in Tempest's *Cryes of the City of London*, he had to look also at the mythical and allegorical characters contained in the bookseller's other work.

It is clear from his earliest work that he did so. *The South Sea Scheme* and *The Lottery*, probably the first satirical prints Hogarth ever executed (see plates 5a, 5b), are both confessedly emblematic works in which reality is completely subordinated to symbolism; and earlier work still, some of it perhaps dating from the latter days of his apprenticeship, is full of the figures and symbols beloved of the emblem-writers: pagan gods and goddesses, Fortune and her wheel, scales of justice, personifications of various virtues and vices. And yet his memories of his apprenticeship were dominated by his hatred of the 'monsters of heraldry' which he was forced to copy from the pattern books and by his desperate desire, so long frustrated, to 'draw objects something like nature instead'.[4] What he actually made of himself during his early years suggests the unrepentant pride of the school-

master's son, the youth who had turned aside from scholarship itself but was still determined to make his art acceptable in scholarly and intellectual terms. What he remembered of himself, on the other hand, suggests the son of nature rebelling against intellectualism and anxious to break free from work-shop and study alike in order to record the spontaneity of nature itself. This contradiction between the apprentice Hogarth later recalled, and the apprentice who actually existed, constitutes the first great problem in the understanding of his art. He may indeed have loathed the monsters of heraldry as cordially as he said he did; but nevertheless it remains true that the work which brought him his first taste of fame was based upon them.

His earliest biographers echoed his own assessment of his apprentice days and their importance. The only anecdote which Nichols could gather relating to this period was an account by a fellow apprentice of a Sunday jaunt out to Highgate, where a tavern brawl tempted Hogarth to make a sketch on the spot: 'The blood running down the man's face, together with the agony of the wound, which had distorted his features into a most hideous grin, presented Hogarth with too laughable a subject to be overlooked.' Nichols's informant went on to say that the sketch 'exhibited an exact likeness of the man, with the portrait of his antagonist, and the figures in caricature of the principal persons gathered round him' and that it showed that Hogarth himself was already 'apprised of the mode Nature had intended he should pursue'.[5] The artist himself would not have been altogether happy about this story: he spent much of his time insisting that 'exact likeness' and caricature should not be put into the same picture. He was also concerned to assert over and over again in the *Autobiographical Notes* that in his early years he did *not* carry pencil and sketch-book around with him but preferred instead 'retaining in my mind's eye, without drawing on the spot, whatever I wanted to imitate'.[6]

In spite of these inconsistencies – and in spite of the possibly apocryphal nature of the whole story – Hogarth would probably have agreed by the end of his life that a spontaneous sketch of a fight in a tavern was closer to 'the mode Nature had intended he should pursue' than a carefully constructed emblematic print based on the stock

images of the pattern books. By the time he came to write the *Auto-biographical Notes* and the *Apology for Painters* he was so concerned to justify the point he had reached that he was prepared to blur the route by which he had reached it. He identified himself with the sturdy commercial community which he claimed to serve, with the 'trading nation' which he said in the *Apology* should import pictures and statues from poorer and more frivolous countries instead of encouraging its own citizens to turn aside from the pursuit of riches to the mere pursuit of art: 'It is not in the nature of things that these arts should ever be required in this country in like manner . . . it is a proof rather of the good sense of this country that the encouragement has rather been to trade and mechanics than to the arts . . . therefore let us sit down contented and not attempt to force what in the nature of things can never be accomplished.'[7] A native English painter, if such could be allowed to exist at all, was better employed painting native English vigour than imitating the allegorical intellectualism of the connoisseurs and the Continental artists. Since Hogarth's account of his own life was avowedly intended as an introduction to 'an entire collection of his prints . . . considered by some as descriptive of the peculiar manners and characters of the English nation',[8] his readers would presumably want to read about the broad high road that had led to those descriptions and not about the blind alleys into which his apprenticeship had sought to force him.

But the alleys were not blind and the journey down them had not been entirely involuntary. Those same emblems which were the subject of such lofty philosophical discussion throughout Europe were also the images that had dominated Hogarth's childhood and moulded his visual imagination both in the streets that he frequented and the books that he read. Minerva, goddess of wisdom and thus a prime example of the sort of concept that emblem-writers sought to convey within the double harness of word and image, was also a favourite character in the Lord Mayor's Show: the store cupboards of the various City companies were piled high with masks and costumes intended to depict her and the other members of the Greek and Roman pantheon. Ben Jonson, one of the literary heroes whom

Hogarth later defended against Continental usurpers, had spoken of the 'court hieroglyphics' which had brought together, in masques and other stylised entertainments for the diversion of monarchs, the recondite emblems devised by scholars and the colourful images of popular pageantry.[9] Other visual metaphors, such as the wheel of fortune or the knight and the dragon, appeared in all sorts of nursery guises from story-books and rhyming games to school text-books and moral treatises. The Tarot cards, perhaps the most significant of all the bridges between occult Renaissance scholarship and popular culture, were comparatively little known in England; but there was a rage in the late seventeenth century for equally allegorical and highly complicated packs of playing cards, many of which were also derived from the symbols and figures used by the emblem-writers. Hogarth himself did not play cards – at any rate in later life, after his marriage – but he can hardly have been immune to the visual influences of his friends' card playing.[10]

This comparatively minor point about card playing provides a good illustration of the sort of problem with which our ignorance about Hogarth's early years confronts us when we come to investigate the sources of his imagery. We do not even know for certain whether his father was a member of the Church of England or a Puritan dissenter – with all that this implied in terms of political, intellectual and moral issues considerably more significant than the Puritan aversion to card playing. Ronald Paulson has given us an impressive summary of the evidence concerning Richard Hogarth's possible Presbyterian origins and probable subsequent acceptance of the Anglican faith; but even he cannot be sure on this point and the suggestions he makes about Puritan influences on William's upbringing are purely conjectural.[11] From Richard's own point of view the question of his religion must have been vital at a time when he was desperately trying to re-establish himself as a learned writer and teacher after his emergence from the Fleet. In 1714 Robert Harley's administration passed the Schism Act, which forbade schoolmasters who were not members of the Church of England to teach Latin or to teach *in* Latin. The *Thesaurarium* had been written in English; but Richard had said in his preface, speaking

of the treatise on Greek which formed the second part, that he hoped to 'enlarge it, and make it Latin, and bind it up alone, if God prosper it to the end intended, which is the promotion of good learning'.[12] The Schism Act would cast a shadow on these hopes, as well as on the projected Latin dictionary, if Richard's ill-wishers could allege that he was still a dissenter.

At the end of the year 1718 the new Whig ministry of King George I decided to repeal the Schism Act. As far as Richard was concerned it was too late: he had died a few months earlier, worn out – according to his son's account – by 'the cruel treatment he met with from Book-sellers and Printers'.[13] His foothold in the world of learning had been precarious enough in all conscience and any Puritan connections he may have had could only have increased his isolation and his difficul-ties. His son stored his manuscripts away carefully and even reverently: Richard may have been pitiable and unsuccessful but he never entirely lost his dignity in the eyes of his children. Now that he was dead there was no question of his work being spurned or forgotten. It would, however, need to be translated into a different medium to suit the son who had 'a natural turn for drawing' rather than for scholarship. The first step was to make drawings which existed in their own right, as pictures engraved on copper plates from which prints could subse-quently be taken, rather than as mere ornaments on silver salvers and tankards. This, wrote Hogarth, was his own chief concern at the time of his father's death: 'Engraving on copper was at twenty his utmost ambition.'[14] Then there was the question of what the pictures should be about – what stories they should tell, what lessons they should teach, what means of communication they should utilise. If Richard had indeed been a Puritan, with the Puritan's deep-rooted suspicion of all graven images from Popish idols to printed playing cards, then this suspicion would have to be overcome and the associations between words and images, the scholarly metaphors of the emblem-writers, carefully studied. It was not a question of a sudden rejection, a dramatic leap from the narrow world of the father's pedantry to the wider world of the London streets and the natural uncomplicated images to be found there. It was a question of a bridge to be built, a

new and wider foothold to be established so that the son could raise himself, by means of the word as well as the image, into the world which his father had never been able to conquer.

Engraving on copper may have been the first step but the ambitious apprentice did not imagine, even as early as 1718, that it was the whole of the journey. The phrase about 'utmost ambition' was contradicted by another passage in which Hogarth recollected that 'the painting of St Paul's and Greenwich Hospital were during this time running in my head'.[15] He was referring to James Thornhill's mural paintings in the Cupola and Dome of St Paul's Cathedral and in the Lower Hall of the Naval Hospital at Greenwich. In June 1718, within a few weeks of Richard Hogarth's death, Thornhill was made History Painter to King George I. Two years later, just as Hogarth was breaking free from Ellis Gamble and setting up on his own, Thornhill was given a knighthood and made Sergeant Painter, a profitable position which gave him control over the decoration of the King's palaces. Nine years later Hogarth was to marry Sir James Thornhill's only daughter Jane; so that if the first four years of his apprenticeship were dominated by his own father's failure, the last two were overshadowed by his future father-in-law's success. That success was unique – no other native-born English painter had ever been knighted – and it was the result of the paintings that were running in the young apprentice's head. Thornhill was the first English artist successfully to challenge the Continental supremacy in history painting, the most highly regarded and intellectually demanding art form of the time. What was running in Hogarth's head was not simply a group of pictures but an immensely complex allegorical language, a language which brought together the monsters of heraldry and the concepts of philosophy and would have taxed his father's scholarly gifts as much as it taxed his own visual perceptions. The acquisition of this language was the next step in his journey.

The greatest obstacle to the understanding of seventeenth and eighteenth century history painting is the modern idea of history. Few people at this time thought that the disciplined study of the past was a worthwhile task for scholars; fewer still thought that history in this

sense had any significant lessons to teach, that it in some way revealed ultimate truths about God and man. History painting was concerned with the older concept of story-telling rather than with the idea of factual chronological accumulation which was later to develop. The stories which it told were archetypal and eternal, myths and allegories which ignored and even contradicted the modern notion of history. For the historian the human condition exists in time and can only be understood by examining what has happened and when it has happened. Myth, on the other hand, transcends time. Just as every age is equidistant from eternity, so every age is equally susceptible to myth and myth is equally relevant to every age. The neat straight line of development devised by the historian ceases to be the metaphor of human existence and has to give way to other and more sophisticated symbols.

The proper use of such symbols, and of the visual language in which they had to be expressed, was a difficult business and one which most early eighteenth-century thinkers considered far above the heads of mere apprentice engravers. 'In a real history painter,' wrote Lord Shaftesbury, 'the same knowledge, the same study and views are required as in a real poet.'[16] Shaftesbury had devoted most of his life to the same problem that had exercised Bishop Wilkins, the true sense of the word 'character' and the various ways in which different means of communication could be brought together. He had died in 1713; and his immensely influential ideas on the relationship between word and image, worked out during the last years of his life, were just coming into circulation during Hogarth's apprenticeship. Shaftesbury had no doubt that painting was a language and that the concepts an artist dealt in were more important than the actual marks he made on the canvas: 'The good painter begins by working first within . . . forms his ideas, then his hands . . . Thus Raphael, dying young. His ideas before his hand. All other masters, their hand before their idea.'[17] He distrusted the work of the emblem-writers because it had become an easy way out, a stereotyped and immediately recognisable means by which the artist could put second-hand ideas into second-hand visual terms without even thinking about them. To this extent

he hated the monsters of heraldry as much as Hogarth did: great art was not to be produced by using the pattern books in the same unimaginative way that a hack translator used a dictionary. And yet the monsters were the accepted symbols, the bricks out of which visual communication was built, and they could not be ignored or abandoned any more than the words in the dictionary could be replaced with new ones. The point was, however, that whereas words were part of a living language and were thus self-renewing, the emblems had become frozen into a form which had once been inscrutable but was now merely inert. Somehow they must be brought back to life.

In order to show how this should be done Shaftesbury chose one of the most familiar of all emblems, *The Choice of Hercules* (see plate 2a). Hercules himself was a monster of heraldry as well as a pagan demigod and a pageant-master's delight. His brawny form, complete with large club and some form of scanty clothing, appeared on the coats of arms that Hogarth engraved both before and after the end of his apprenticeship. Either Hercules himself or indigenous half-naked giants made in his image marched in the processions which Elkanah Settle and others staged in the London streets. And it was Hercules, wielding his club over the heads of an assortment of personified vices, who dominated Thornhill's painting in the Lower Hall at Greenwich. *The Choice of Hercules* purported to show how the hero had been led into this and other laudable exploits – and therefore how mankind itself should also prefer a life of virtuous endeavour to one of mere dissipation. The emblem, which had remained virtually unchanged since the days of the Italian Renaissance and which still featured in early eighteenth-century pattern books, depicted Hercules between two allegorical figures, one representing Virtue and the other Pleasure. Virtue was an old man ringed with such unlikely accompaniments as a sunflower and the rod of the god Mercury, while Pleasure was a sharp-featured lady brandishing a mask and a whip (see plate 2a). Shaftesbury would have none of this: Virtue must be a woman, as Xenophon had originally said, and any objects represented in the picture must be 'really portable instruments such as the martial dame who represents virtue may be well supposed to have brought along

with her'.[18] In other words, allegory must be contained within the limits of probability: all the things in the picture must have a symbolic importance but they must also be justified by the internal logic of the scene represented and not by some arbitrary language of visual and conceptual equivalents. An earlier writer, William Aglionby, had declared that a history painter must be capable of putting together any assembly of figures, 'whether true or fabulous';[19] and Shaftesbury's aim was to bring together the true and the fabulous in one composition so that the passing reality of the moment and the underlying reality of the myth could both be represented.

There can be no doubt that Hogarth as an apprentice studied the emblem books and that the images which these manuals contained had a lasting effect on his work. The shopcard which he engraved for himself in April 1720 (see plate 3a), when he set up on his own as an engraver, included a figure which has been thought by successive biographers to represent 'History' but which has a striking resemblance to the figure of Virtue in the stock emblem of *The Choice of Hercules* attacked by Shaftesbury. Shaftesbury's own version of the emblem, painted to his specifications by an artist called Paolo de Matteis (see plate 2b) and engraved by Simon Gribelin, appeared as a frontispiece when his work was published in French in 1712 (in the Parisian *Journal des Scavans*) and in English in the following year. Ronald Paulson suggests that it influenced the *Harlot's Progress* series of 1732,[20] but there is no way of knowing whether it played a part in shaping Hogarth's earlier work. If he intended to follow in Thornhill's footsteps as a serious history painter he would need to be conversant with Shaftesbury's ideas, but he would probably have scorned the picture which illustrated them as a typical example of the kind of hack work which he intended to avoid. He was determined that any picture which he produced, whether emblematic or not, would be based on the ideas of William Hogarth and not on those of some opinionated intellectual patron. He would be his own intellectual, an author as well as an artist. He would not play Paolo de Matteis to any man's Shaftesbury.

He did not need to. The various influences present during his childhood and apprenticeship, influences which for the most part

worked together rather than in opposition to one another, had produced in him a double mastery of image and idea, artistic perception and intellectual concept. The art which Shaftesbury had been describing, the art in which the idea came before the hand and in which every object shown was at once a part of reality and a tamed emblem, was to be the art of William Hogarth. Even in his earliest satirical prints he was already passing the destination which he thought he had not yet reached: he was not yet a history painter but he had already achieved an interpenetration of word and image which surpassed in subtlety and flexibility much of the work of the academic history painters. *The South Sea Scheme*, probably produced during the first few months of his career as an independent engraver, contained much that was uncertain and even crude: the allegorical and emblematical figures in the foreground were separated from the real people in the crowd in a way which would certainly have displeased Lord Shaftesbury. And yet there were some touches which carried on from where Shaftesbury had left off. The emblem-writers had provided their female figure of carnal pleasure with a whip, in order to show that such pleasure had to be paid for in the end by suffering, either temporal or eternal. Hogarth, having envisaged in his original drawing a wheel of fortune or merry-go-round to symbolise the carnal pleasures sought by the South Sea speculators, placed upon it in his final engraving a whore who brandished a birch rod in one hand while she fondled her client with the other. Her instrument of punishment clearly had a less moral and more erotic significance than the whip drawn by the emblem-writers; but on the other hand the guilt feelings which those writers had sought to inculcate were not altogether unconnected with the masochistic desires of some of this lady's clients – especially as her particular client on this occasion was a parson. Whether Hogarth was bearing in mind Shaftesbury's advice to put into his picture only 'really portable instruments such as the martial dame may be well supposed to have brought along with her' was another matter. Even the most obliging and energetic harlot might hesitate before taking her birch along with her when she went for a ride on a roundabout.

Incongruities of this sort were ironed out in Hogarth's later work.

The rod remained the mark of the harlot's trade but it tended to appear in less unlikely and more discreet places – hanging on the wall beside the bed or lying on the floor where it had been dropped. The buxom young whore in *Industry and Idleness*, apparently lacking rich customers and sleeping with a boy who was a companion as much as a client, seemed to have no need of it; but even she reverted to her allegorical nature when she dropped her smiling mask in order to inform on the idle apprentice and get him hanged. The emblems were still emblems, even though they had taken on a new and more convincing layer of human flesh. Carnal pleasure did not lose sight of her whip and her mask just because she was masquerading as a common prostitute, any more than the pagan deities forgot their old attributes when they appeared in the guise of strolling actresses.* Indeed, the element of disguise was itself part of the ambiguity of Hogarth's mature work: was it all a masquerade in which people put on allegorical costumes, or was it a dream in which allegories walked up and down in the world disguised as ordinary people? There was no doubt that his world was a stage – he said so himself over and over again – but it was not always clear who was performing to whom. What was clear was that the costumes and properties, together with much of the gestures and the stage business, were borrowed from the artificial world of stock images and allegorical figures rather than from the natural world of the London streets.

* See below, p. 119.

CHAPTER III
One who loved his pleasure

Early in 1720 Hogarth broke off his apprenticeship to Ellis Gamble and set himself up on his own as an engraver in Long Lane, a few streets to the north of the place where he had been born. His workshop was a room in the house of his widowed mother and it may well be that the need to bring in some money for her and for his sisters was one of the reasons for ending the apprenticeship early, after six years instead of the normal seven. Certainly there was no need to worry that he would offend Uncle Edmund, who had probably been his original link with Gamble: Edmund was dead along with his brother and had been careful to leave his money to his own family and not to Richard's. But there can be little doubt that sheer impatience and frustration were as important in causing the break as any financial necessity. Just as he later spoke of his apprenticeship as starting early when in fact it started late, so he also said that it was unduly long when really it was unduly short. He ended it for the simple reason that he did not intend to make his living by the trade which it had taught him. The art of engraving on silver was not only useless to him, he argued in later life: it was positively detrimental. He had other ambitions upon which he must set his sights before it was too late.

What those ambitions were at this stage is not easy to determine. At the outset of the *Autobiographical Notes* he said that because the bad habits acquired during his apprenticeship prevented him from attaining a 'beautiful stroke on copper' he turned his attention instead to painting portraits.[1] This was misleading and untrue, as he himself saw when he came to re-write the passage. In fact he did not emerge as a portrait painter until the late 1720s, by which time he had already made a name for himself as an engraver of satirical prints. The only

one of those prints which he chose to remember in the *Autobiographical Notes* was one which he called *The Taste of the Town* but which biographers have usually referred to as *Masquerades and Operas*; and the things he said about it, like the title he chose for it, showed that he remembered it not because of the period it represented but for its connections with his later achievements – the successful battle against the booksellers who pirated his work and the somewhat less successful one against the connoisseurs who sneered at it. He seemed to have no desire to recall the other satirical prints of the 1720s, some of them very successful and most of them more effective as works of art than the *Masquerades and Operas*; and he said equally little about the book illustrations done during the same period. He mentioned the plates done for a new edition of *Hudibras*, treating them as though they were his first and only venture in this field; but he said nothing about other sets of book illustrations, some of which were almost certainly earlier than *Hudibras* and just as significant in the development of his style.

In short, he chose to regard the period from 1720 to 1727, from the age of twenty-three to the age of thirty, as a sort of second and self-conducted apprenticeship. During these seven years he taught himself the things that Gamble had failed to teach him during the previous six and he also made sure that he saw something of life itself, its pleasures and its drama and the rich subject matter which it was to provide for his mature work. 'Having hit upon a method more suitable to my disposition, which was to make my studies and my pleasures go hand in hand by retaining in my mind *lineally* such objects as fitted my purpose best, I followed it in such a manner as, be where I would, I might be acquiring something of use to me ... Engraving in the first part of my life till near thirty did little more than maintain myself in the usual gaieties of life but in all a punctual paymaster.'[2]

There was a neat retrospective logic in all this. Having cursed the years of apprenticeship and the heraldic monsters that haunted them, Hogarth could go on to show how the next seven years paved the way for his real life's work, for the 'fine prints' of which he was so proud and in which he set down 'the peculiar manners and characters of the English nation'. He could show how his unique system of memory-

training, 'retaining in my mind *lineally* such objects as fitted my pur-
pose', enabled him to study life rather than art, to turn the human
drama directly into pictorial form without copying the fashionable
models recommended by the connoisseurs. 'Thus whatever I saw was
more truly to me a picture than one seen by a camera obscura. By this
idle way of proceeding I grew so profane as to admire Nature beyond
pictures and I confess sometimes objected to the divinity of even
Raphael, Corregio and Michelangelo, for which I have been severely
treated.'[3] In this way the pretended sins of the youthful engraver
could be used in ironical attacks on the enemies of the mature painter.
Everything fitted: the manuscript drafts of the *Autobiographical Notes*
might be repetitive and jumbled and lacking in good syntax, but they
contained all the ingredients necessary for an elaborate exercise in
self-justification. They could show how Hogarth had transcended the
difficulties of his early years, turning the fruitful things to good
account and rejecting the rest. The monsters had been cast out, the
connoisseurs confounded in advance, while the drama of the streets
had been translated into original and underivative imagery by means
of a personal 'grammar of objects' which brought to new and trium-
phant fruition his father's aspirations as a grammarian of ideas.

It is difficult to believe, however, that all this was foreseen by the
newly established engraver of twenty-three who ornamented his shop
card with images from the pattern books and dreamed of future great-
ness as a history painter. In his first few years of independence he was
glad to undertake anything: coats of arms, book plates, shop cards,
letter headings and other humdrum tasks as well as book illustrations
and satirical prints. It is hard to see how he found the time for the
constant 'strolling about, my studies and my pleasures going hand in
hand'[4] which he was later to think of as the principal occupation of his
carefree days. And the book illustrations, whatever he may have
thought about them in later life, revealed a greater interest in the works
of other artists than in the spontaneity of the London scene. The first
important set, probably completed in 1723, was for La Motraye's
Travels through Europe, Asia and into Parts of Africa and so could
hardly be expected to contain images of the gaiety of Hogarth's own

life retained in his mind's eye and reproduced according to his famous system. In fact the pictures he produced were adapted either from paintings brought back by La Motraye himself or from the work of Continental artists who had illustrated this and similar works. But the next commission, for a set of plates for Charles Gildon's *New Metamorphosis*, was rather a different matter. Here was a splendidly bawdy series of tales, mainly concerned with unlikely happenings in bedchambers, in which Hogarth the man of pleasure could surely make use of those images of scandalous merriment which were supposedly stored away in his mind's eye. *Hudibras* presented even better opportunities: it was full of rowdy scenes in which people fought and quarrelled and belaboured one another in the best tradition of the London streets and London taverns whose essence the young engraver was apparently imbibing during his studious but pleasurable strolls.

And yet, as Frederick Antal and Ronald Paulson have shown, the illustrations to the *New Metamorphosis* and to *Hudibras* are in fact surprisingly derivative. Many of the figures in them are modelled on the work of other artists – including some of those French and Italian painters whom Hogarth later pretended to have scorned all his life – and even some of the vivid and unexpected touches which seem to have come from real life may equally well have come straight out of pictures. The cat suspended by its tail (see plate 4), which Hogarth used in *Hudibras* and to which he was to return many years later in *The Four Stages of Cruelty*, was a recurring theme in popular prints of the late seventeenth and early eighteenth centuries. Hogarth's book illustrations could conceivably have been executed by a man who had looked at pictures and not at life; but they certainly could not have been done by a man who had looked only at life and not at pictures.

The young engraver's debt to other artists ran to something more fundamental than subject matter and composition. There was also the problem of technique, the actual physical means and manual skills whereby images were set down on the copper plate and printed onto the paper. Hogarth at this stage in his life was concerned above all with securing a wider audience: if he could not yet paint enormous history paintings which lots of people would come to see, he could at least

produce prints which could be reproduced over and over again so that lots of people would buy them. The line he cut with his engraver's tool must not be just an end in itself, a mere flourish of decoration on the surface of an object which the world might never see: it must be a means of communication. At its most pretentious this could mean that his line must become part of a universal language of images such as seventeenth-century philosophers had dreamed of and Hogarth himself envisaged when he invented his notorious 'Line of Beauty'. At its simplest it meant that the line he cut in the copper must be capable of holding just the right amount of ink in just the right places, so that the impression made on the paper would give the desired effect. In due course the contribution made by the European artistic tradition to the idea of the line as language would become clear. For the time being European ideas on the cutting of the line and the holding of the ink were more important.

The traditional engraver's tool was the burin, a square steel rod with its end cut off at an angle of forty-five degrees in such a way that the tip was the meeting place of three planes. This minute three-dimensional triangle first had to be 'set up' – that is, its three planes had to be accurately ground so that they met cleanly at the point without any false planes or blurred edges – and then it had to be pushed through the metal at just the right depth, and with just the right amount of pressure in the right direction and at the right angle, in order to cut the desired line. The tiny spiral shavings of copper turned up by the burin had to be carefully removed – carelessness in this operation could result in needle-sharp and potentially poisonous slivers of copper being driven into the fingers – and the surface of the plate and the edges of the lines rubbed down to just the right texture. It was not surprising that Hogarth, already looking impatiently beyond mere engraving to the glories of history painting, should seek a short cut. And he was honest enough to admit in the *Autobiographical Notes* that his own impatience and lack of care were as important as the lateness of his move from silver to copper: 'For want of beginning early with the burin on copper plates, as well as that care and patience I despaired of at so late as twenty, of having the full command of the graver, for on these two virtues the beauty and delicacy of the stroke of graving

chiefly depends.'⁵ He therefore turned to etching, the art of covering the plate with an acid resistant ground on which a design was cut with a needle so that when the plate was covered with acid the design was eaten out of it. It was from two French artists, Jacques Callot and Abraham Bosse, that he learned techniques that enabled him to combine etching with engraving in such a way that his line achieved the maximum of fluency and flexibility with the minimum expenditure of effort. The debt to Bosse can only be inferred: Bosse's treatise on engraving and etching was available in translation at the time and many of the tricks Hogarth employed were described in it. The debt to Callot is clearer, since Hogarth copied his style as well as his methods. The gruesome little illustrations to John Beaver's *Roman Military Punishments*, showing men being dismembered and crucified and beaten to death, are obvious echoes of Callot's treatment of similar atrocities in his *Misères de la Guerre*.

By the time the drawings for *Roman Military Punishments* were completed, probably in 1725, Hogarth's satirical prints were already well-known. The first two, *The South Sea Scheme* and *The Lottery*, were not particularly original and not particularly successful. State lotteries had been the subject of satires for nearly thirty years, ever since their first introduction in the 1690s, and they were associated in the minds of traditionalists and landed men with the shady financial tricks whereby successive ministries had juggled with government borrowing and private banking in order to circumvent Parliament's control over taxation. The South Sea scheme was only the latest and most spectacular of these tricks. Having borrowed huge sums from private financiers and privileged bankers, giving them inflated interest rates and more financial privileges in return, the King's ministers now proposed to let the National Debt be taken over by the South Sea Company, an enterprise whose directors had already shown more interest in the politics of high finance than in ordinary commerce. The company was to issue shares and then offer them – at prevailing market rates – in exchange for existing government stock. The more the new shares rose in value, the less would be the proportion of them required to buy out government stockholders; and the more the

advantage swung in favour of the company the more the stocks would rise. Whatever schemes Richard Hogarth might have sent Robert Harley in 1710 must have seemed insignificant in comparison with this new project which, by exploiting the discovery that wealth was credit and not just money, promised to make the administration and its supporters immensely rich and impregnably powerful. Harley himself, now out of office and in disgrace, was reminded by one of his followers that 'a body of men, with a stock of forty-three millions, and credit for as much more, acting by united counsels, must fill the House of Commons and rule this little world . . . What occasion will there be for Parliaments hereafter ?'[6]

Whatever other Puritan streaks Hogarth may or may not have inherited from his father, there was no doubt about his old-fashioned and austere view of economics. Like the landed men in the House of Commons, fulminating against a government that spent their hard-earned tax payments on feathering the nests of monopolistic financiers, Hogarth always thought of the manipulators of credit as parasites feeding on the producers of real wealth rather than as capitalists ready to finance and help them. He may even have been more puritanical than his father in this respect: in the *Rake's Progress* he later included a savage representation of a prisoner in the Fleet flourishing schemes to pay off the National Debt, a figure which could be seen as a satire on his own unfortunate father rather than on the magnates of the South Sea Company. But at the time of the South Sea crisis itself, in the latter part of 1720 and the beginning of 1721, the unknown William Hogarth was only one of dozens of printmakers anxious to turn out satires on lotteries and stock market crashes and other aspects of the mania for unearned and unreal wealth. His two prints were quite good of their kind, but they were swamped by a great spate of other men's work. Neither of them appeared in 1720–1, the year in which they would have been topical. Perhaps he did not complete them in time: an unfinished proof of *The Lottery*, on which he was still making corrections, has the original date, 1721, partly erased. But whatever the reason, whether it was tardiness on Hogarth's own part or reluctance on the part of the booksellers, the prints were delayed until 1724, by which

time he had already made his name with *Masquerades and Operas*.

In political terms the delay had its uses. After a spectacular boom which had taken South Sea stock to ten times its face value there had been an equally spectacular crash which had ruined thousands of investors and totally discredited the government. Feelings had run extremely high in the winter of 1720-1 and the dreadful torments which Hogarth's print showed being inflicted on allegorical figures had been put forward quite seriously as appropriate punishments for the directors of the South Sea Company. In spite of the uproar, King George I had been reluctant to dismiss his unpopular ministers and political battle had therefore been joined over the whole South Sea affair. Prints which had appeared at this time, whether they dealt with the specific scandal of the South Sea Company or the general fashion for lotteries and other forms of speculation, had marked their authors as supporters of this or that party. But by 1724 all this was over. The dramatic confrontation between an outraged country and the discredited favourites of a stubborn king had given way to a tactful and successful cover-up operation. Even the most violent back-benchers in the House of Commons, who had clamoured for impeachment of ministers and public execution of South Sea directors, had had their mouths stopped when they were given access to some of the confidential information and made to realise how deeply the royal family was involved and how serious the results of disclosure might be. Thomas Brodrick, a determined opponent of the South Sea scheme who had pressed for a secret inquiry and now chaired it, declared that in view of what he now knew he would not 'join with those whose losses have so far exasperated them as to be desirous, out of revenge, to run to extremes which may endanger the nation'.[7] There was a tacit agreement to look back on the whole affair as a national aberration rather than a political issue. Hogarth's prints could therefore feature as part of the now fashionable revulsion against speculation in general, rather than as political attacks on a particular party. Thus the delay helped to preserve Hogarth's position of political neutrality, a position which was quite exceptional among the satirists of London and which was to stand him in good stead later in his career.

In stylistic terms the delay was confusing, since it telescoped the work of three particularly formative years. *The Lottery* (see plate 5a) was a straightforward emblematical print, the allegory of which was undiluted by any representation of the real world. It betrayed a certain lack of confidence, a somewhat truculent determination to flourish artistic and intellectual credentials: the composition deliberately echoed Raphael, as if to prove that the artist was a student of painting rather than a mere hack engraver, and the meaning of the emblems was carefully explained in a long caption. Figures symbolising Virtue, Hope, Fear, Misfortune, Industry and other moral attributes were being organised by Apollo and Minerva into an elaborate charade on the stage of a theatre – a reminder of the fact that some state lotteries were indeed drawn on stage in this way. The scene was dominated by 'a picture representing the earth receiving enriching showers drawn from herself', which the caption described as 'an emblem of state lotteries'. Apollo was pointing out this picture to Britannia; but she did not seem very happy about it and it was clear from the proceedings taking place beneath her that the symbolism was ironic. Neither the winners nor the losers, neither Good Luck nor Misfortune, seemed to be doing much to further the interests of National Credit, the enthroned young lady in whose honour the whole performance was taking place. Minerva was doing her best by pointing out to the unlucky loser the superior charms of Industry; but Fame, the winged figure on the opposite side inviting the winner to support the arts and sciences, appeared to have come too late. The figure representing these worthy occupations was already sinking through the floor.

The South Sea Scheme (see plate 5b) also called itself an emblematical print, but it nevertheless made some significant advances on the traditional techniques of the emblem-writers. There was still a caption – this time in verse – but the picture itself also communicated in words as well as images. The inscription on the Monument, which in fact commemorated the Great Fire of 1666 and the papists who had supposedly caused it, had been changed to read: 'This monument was erected in memory of the destruction of this city by the South Sea in 1720'. In the background, alongside the roundabout with the flagel-

lating harlot and the other representatives of questionable appetites, there was a visual and verbal cross-reference to *The Lottery* in the shape of a notice which advertised 'Raffleing for husbands with lottery fortunes in here' and which had attracted an enormous queue of women. Since this is one of the very few prints for which a preliminary drawing exists we can see something of the development of Hogarth's ideas: in the drawing the whore is without her birch rod and the notice merely states: 'A Ten Thousand pound man to be raffled for'. What Hogarth had not yet devised was an effective way of merging emblem and reality. This was partly because of his very inadequate command of perspective, which meant that the lines which ought to have led the eye from the allegorical foreground to the real-life background simply did not do so: the counter of the Devil's butcher's shop, together with the terrace and walls of the building in which the raffle was taking place, destroyed by their own unreality any sense of reality which the drawing of the crowd might otherwise have conveyed. But it was also a matter of mood: the allegorical violence in the front of the picture was curiously detached and even remote, its victims statuesque and impassive as befitted their emblematic nature, in complete contrast to the bustling degradation of the background. In spite of Shaftesbury's advice and influence, artists had not yet managed to wake the emblems from their long sleep.

There was nothing statuesque or impassive about *Masquerades and Operas* (plate 6a). Here the signs and allegories were relegated to the background, while a real-life crowd dominated the front of the picture. It was a crowd in movement, one half of it on its way to a masquerade on the left of the print while the other pressed into a theatre on the opposite side to see a pantomime. These two swirling groups of people were linked by Hogarth's first really effective real-life emblem. She was a woman with an enormous wheelbarrow full of old books, which she was pushing in the direction of the theatre-goers with a cry of 'Waste paper for shops'. The direction of her perambulation was a little strange – there were no shops in sight and nobody in the crowd looked like a potential purchaser of waste paper – but in other ways she was a neat invention. In the first place she bridged the gap between

image and word: the significance of what she was doing only became clear when the titles of the books were read. In the second place she bridged the gap between the allegorical language of the would-be history painter and the reality of the London streets. If her meaning had links with the *Iconologia*, her appearance could be traced back to the *Cryes of the City of London*. And, perhaps most important of all, she had a real part to play in the composition of the picture: she existed for it and not just in it. All in all she was a great advance on the harlot with the birch rod.

The message of *Masquerades and Operas* was obvious enough: traditional English culture, in the shape of the authors whose works were being carted off for waste paper, was about to be engulfed in a flood of fashionable foolishness. There was the Italianate foolishness of William Kent in the background, the mania for neo-Palladian architecture which had led to the town house of Kent's patron Lord Burlington being regarded as the shrine of good taste. Hogarth labelled it 'Academy of Arts' and put Kent on top of it with Raphael and Michelangelo – two of the artists in whose divinity he was ironically said to have lost faith – doing him homage. Then there was the equally Italianate musical foolishness at the Opera House in the Haymarket, the building on the left of the picture with a sign outside showing English noblemen begging Italian singers to accept a present of £8,000. It was Lord Burlington who was a principal backer of Handel's Royal Academy of Music, which put on Italianate operas in this building. Another occupant of the Opera House was the Swiss impresario John Heidegger, who staged his enormously popular masked balls or 'masquerades' there. Hogarth showed him leaning out of the window while a devil and a jester led the crowd of costumed revellers under an arch marked 'Masquerade'. The note for £1,000 brandished by the Devil referred to the Prince of Wales's donation of that amount for the support of the masquerades he enjoyed so much. The Prince's extravagant patronage of Heidegger had already given rise to criticism, criticism which was to become even sharper when the Prince became King and continued to employ the Swiss, even after a Middlesex Grand Jury had presented him as 'a principal promoter of vice and immorality'.

Thus all the reasons for the title *Masquerades and Operas* could be
seen on the left-hand side of the picture. But there was more to come:
the waste paper seller and her load had little to do with either operas
or masquerades and the theatre towards which she was pushing her
barrow was notorious for performances quite different from the over-
sophisticated Italianate elegance which Lord Burlington expected
from his artists and musicians. It was the Lincoln's Inn Fields theatre;
and the pantomime which the crowds were flocking to see, the debased
extravaganza which in Hogarth's eyes was usurping the place which
ought to be occupied by Shakespeare and Ben Jonson, was John
Rich's *Harlequin Doctor Faustus*. Like the fashionable conjuror Isaac
Faux, whose performances at the Haymarket Opera House were also
alluded to in the print, the pantomime had originated in the booths of
Bartholomew Fair. Later in life Hogarth became known as the defender
of all things English against all things foreign; and those who thought
only of this fact, and who remembered only the title *Masquerades and
Operas*, could allow themselves to believe that his first successful print
was purely an attack on foreign importations – Swiss masquerades and
Italian operas, with Italianate architecture thrown in for good measure.
In fact, however, Hogarth's real charge against the fashionable world
of London was not just that it was unpatriotic but also that it was
vulgar and plebeian. The surrender to the huckster and the mounte-
bank, to the popular culture of the London fairs, shocked him just as
much as the craven acceptance of second-hand foreign frivolities. In
fact the caption said nothing about operas or architecture, Italianate or
otherwise, but concentrated purely on the degradation of the theatre:

> *Could new dumb* Faustus, *to reform the Age,*
> *Conjure up* Shakespeare's *or* Ben Jonson's *Ghost,*
> *They'd blush for shame, to see the* English Stage
> *Debauch'd by fool'ries, at so great a cost*
>
> *What would their* Manes *say? should they behold*
> Monsters *and* Masquerades, *where useful Plays*
> *Adorn'd the fruitful* Theatre *of old,*
> *And* Rival Wits *contended for the* Bays.

The charge was pressed home even more forcibly in subsequent revised impressions of the print – Ben Jonson's name was added to Shakespeare's and the others in the wheelbarrow, while a new set of verses made more specific mention of fairground tricks like stage dragons and Isaac Faux's 'matchless show'[8] – and then at the end of the year it was repeated in a new etching called *A Just View of the British Stage, or, Three Heads are better than one* (see plate 6b). The three heads were those of Robert Wilks, Colley Cibber and Barton Booth, the three managers of the Theatre Royal in Drury Lane. They had bowed to the fashion for pantomimes and instead of defying John Rich they had begun to copy him, putting on harlequinades in place of the 'useful plays' which Hogarth thought they should be enacting. He therefore showed Ben Jonson's ghost witnessing one of these extravaganzas and not merely blushing but making water angrily over the stage properties. These included various emblems of pomp and fantasy, flying dragons as well as broken statues, and a selection of the tricks that had been used in *Harlequin Doctor Faustus*. Some weeks earlier Drury Lane had put on a pantomime called *Harlequin Sheppard* in an attempt to cash in on the notoriety of Jack Sheppard, a thief who was hanged in November 1724 after a series of spectacular escapes from prison; and so Hogarth depicted the three managers involved in a grand farrago of nonsense which transcended both harlequins and celebrated an earlier prison escape, a horrific descent into the privies of Newgate gaol made many years earlier by the 'right villainous John Hall'.

So it would seem that the raucous delights of Bartholomew Fair, however much they may have featured among the 'shews of all sort' that gave such uncommon pleasure to Hogarth the boy, did not meet with the unreserved approval of Hogarth the young man. The pleasures which he was so concerned to merge with his studies were not apparently those of the fairground. Nor were they those of the brothel and the bedchamber, if the evidence of the *New Metamorphosis* illustrations means anything. But they may well have been those of the tavern. 'There is nothing which has yet been contrived by man,' said Dr Johnson half a century later, 'by which so much happiness is produced as by a good tavern or inn.'[9] Hogarth as a young man would

certainly have agreed with this verdict. He belonged to a famous and
very convivial drinking club at the Ball and Butcher tavern in Clare
Market and it seems that his links with it went back as far as 1720, since
in that year he apparently engraved a benefit ticket for the comedian
James Spiller, one of its most notorious members. Another member was
the Duke of Wharton, who was busy in 1724 forming a society for the
advancement of flirtation. 'They call themselves *Schemers*,' wrote Lady
Mary Wortley Montagu, 'and meet regularly three times a week to
consult on gallant schemes for the advantage and advancement of that
branch of happiness . . . I consider the duty of a true Englishwoman is
to do what honour she can to her native country; and that it would be a
sin against the pious love I bear the land of my nativity to confine the
renown due to the Schemers within the small extent of this little island,
which ought to be spread wherever men can sigh, or women wish.'[10]

Hogarth is said to have portrayed Wharton demonstrating his gal-
lantry at the Ball and Butcher; and he was certainly associated with
him in freemasonry, another of the Duke's convivial interests. The
Grand Lodge of the London freemasons, of which Wharton was
Grand Master in 1722–3, had been formed from drinking clubs at the
Apple Tree tavern, the Goose and Gridiron and the Rummer and
Grapes. In November 1724 Hogarth completed a print entitled *The
Mystery of Masonry brought to light by the Gormogons*, which showed a
masonic procession emerging from the Rummer and Grapes and
mingling with one organised by the rival breakaway society known as
the Gormogons, with which Wharton was now said to be associated.
Masonry was mocked – while one mason kissed an old woman's naked
backside others were shepherded along by a dancing monkey in
masonic regalia and by a Don Quixote symbol of folly and self-delu-
sion – and the newer society was described in the caption as being
'distinguished with peculiar grace'. But it is hard to believe that
Hogarth intended the print to be taken seriously. He was a freemason
himself by November 1725 and may even have been involved with
masonry while he was actually working on the drawing. Masonry had
already been attacked because it had the impertinence to mix gentle-
men with 'mechanics, porters, ragmen, hucksters and tinkers' and it

was also suspected of being dedicated to the support of the Stuart pretender to the throne rather than to the Hanoverian King George I. In 1722 the freemasons had felt it necessary to send a deputation to the Secretary of State in order to assure him that 'they were zealously affected to his Majesty's Person and Government'. Having found an organisation that brought him into convivial association with potential aristocratic patrons, Hogarth may well have been anxious to stop it running to extremes. Ronald Paulson makes the interesting suggestion that Sir James Thornhill, a prominent freemason and Hogarth's future father-in-law, may have been so eager to reform the society and ensure its respectability that he actually encouraged Hogarth to produce the print and to make ironical use of the Gormogons as a means of castigating excesses within the parent society.[11] As for the Gormogons themselves, they seem to have been as insubstantial and as light-hearted as the Schemers. Their manifesto, announcing that the Grand Mogul and the Czar of Muscovy were already members of the society and that the 'whole Sacred College of Cardinals' would soon join, appears to have been one of those hoaxes which have taken in historians more easily than they deceived contemporaries.

There was one thing above all others which characterised the young Hogarth's attitude to the pleasures of London, both to the cultural enjoyments of the theatres and to the grosser and more convivial pleasures of the drinking clubs. It was, quite simply, discretion. He was certainly not an uncommitted and forthright outsider, fearlessly castigating in the name of the common people the esoteric cliques of the fashionable world. Early in 1724 he moved from his mother's house in Long Lane and established himself 'at the Golden Ball, the corner of Cranborne Alley and Little Newport Street'. Cranborne Alley has changed its direction and its spelling, as well as becoming a street, but Little Newport Street still remains, a few yards to the north east of what is now called Leicester Square and was then known as Leicester Fields. It was an obvious enough move for an ambitious young artist in search of patronage; but it was not a social and moral gesture, an invasion of the effete and aristocratic West End by the down-to-earth honesty of the City of London. Those who see eighteenth-century

history in terms of a class struggle have sometimes been tempted to see it in this way, but there is little in Hogarth's early work to support their view. He was always careful to hedge his bets, making sure that for every important person he risked offending there was another he could hope to please. Just as *Masquerades and Operas* rejected those same plebeian tastes he was later supposed to have brought with him, so *The Mystery of Masonry* may perhaps have been executed at the behest of the very people he was apparently attacking. There was more subtlety in this young man than his later reminiscences revealed. The world which he subsequently pretended to scorn was in fact the world into which he was making his own careful way, pausing only to attack particular enemies and to kick away those rungs of the ladder which he no longer needed. He was not intimidated by the fashionable world of pleasure, but he was not seduced by it either. He viewed it objectively, seeking ways in which his pleasures could serve his ambitions rather than the other way about.

In any case the amount of time available for pleasure was shrinking steadily. As early as October 1720 he joined Vanderbank and Cheron's academy in St Martin's Lane[12] and from that time forward there were long hours of study there – including the sessions of copying which he later denied – as well as the demands of his work as an engraver. It was perhaps understandable that he said nothing about the academy in the *Autobiographical Notes*, because he was deliberately trying to depict his youth as a time when he was formed by his pleasures rather than by his academic studies; but it was strange that when he came to give an account of this institution in his *Apology for Painters*, he did not say that he had once studied there. The desire to believe in his own carefree youth clearly went very deep. In old age he became tragically embittered, not only about the connoisseurs but also about the politicians. Just as his earlier desperate search for artistic and academic respectability now seemed to have been doomed in advance, so his careful and discreet approaches to men of power now seemed pusillanimous and futile. In fact, however, his early career was dominated by the search for patrons just as his early style was formed by the search for a foothold as a history painter.

CHAPTER IV
Great men's promises

Hogarth's attitude to patronage, like his attitude to booksellers, was avowedly conditioned by his memories of the treatment his father had received. As soon as he came into contact with booksellers – 'this tribe', as he called them contemptuously – he found them as grasping and as unscrupulous as they had been in his father's day. He had to deal with booksellers whether he liked it or not; but at least he could steer clear of the 'great men' whose promises, airily made but never kept, had done so much to break his father's heart. Richard Hogarth had shown extraordinary optimism and extraordinary naïvety in turning directly to Robert Harley, one of the most powerful men in the land, with scarcely any preparatory work among the lesser heights and out-works of the citadel of power. William would be more circumspect, taking care to make his name as an impartial and uncommitted artist first, so that when he did come into contact with great men he could deal with them as an equal and not be forced into servile dependence. This at any rate was the impression he tried to give in the *Autobiographical Notes*. The pride which he took in the nature of his work, in its moral and instructive value as opposed to the uselessness of mere collectors' pieces, was coupled with an equal pride in the fact that he had always dealt with 'the public in general' and had never sought to build his career on the promises of great men. If he had penetrated to the centre of things it was by invitation and not by intrigue. He had moved from the general to the particular, from the treatment of the nation's morals to the notice of the nation's leaders. He had not repeated his father's mistake of aiming too high too soon.

A recent discovery by Ronald Paulson casts considerable doubt on

this view of things. He has reminded us of a print in the British Museum which has not before been attributed to Hogarth, even though it is signed by him and is in a style closely resembling that of his early works. It is entitled *His Royal Highness George Prince of Wales &c* (see plate 7) and it shows Hercules, Hogarth's early favourite among the emblems, introducing a portrait of the Prince to Britannia and to three emblematic ladies who are proffering it power, wealth and artistic tribute. Hercules's club is planted firmly on the heads of the hydra of discord and it is across the defeated body of this monster that the first lady offers the sceptre of power. Paulson argues on stylistic grounds that the print probably dates from 1722, by which time Hogarth would have been able to see Thornhill's newly completed ceiling of the Upper Hall at Greenwich.[1] This had included a seated figure of Hercules holding a circular portrait of Queen Anne and her husband, Prince George of Denmark. But by 1722 the symbolism in Hogarth's print would have been meaningless and outdated, since the political achievement which it was clearly intended to celebrate had already turned sour. That achievement was the reconciliation of the King and the Prince of Wales in April 1720, the month in which Hogarth produced his shop card and set himself up as an independent engraver. For years the enormous political power of royal patronage had been divided against itself, since every gift or promise of office made by the King's ministers could be countered by a similar offer from the heir to the throne, the future fount of patronage as opposed to the present one and often in conflict with the reigning monarch. The independent members of Parliament, those who did not seek patronage and had their wealth invested in ways that did not depend on government favour, flattered themselves on their ability to defend the country against royal tyranny and to secure majorities in the House of Commons big enough to bring down governments. But in fact it was the party of the Prince of Wales, the ranks of those who did not scorn office at all but merely sought it in the next reign rather than the present one, that made up these majorities. If only the King and the Prince could be reconciled, so that all the career politicians of whatever age and aspirations stood together, the independent men would

find themselves powerless. And in April 1720 such a reconciliation did in fact take place. The sceptre of power – or at least a share in it – was offered to the Prince across the inert body of the hydra of discord.

But the hydra was not in fact dead at all; and it is this fact that makes it unlikely that even the most naïve printmaker would celebrate its death retrospectively after an interval of two years. Few of those who actually saw the reconciliation, which took place appropriately enough on St George's day, doubted that the royal actors were reluctant puppets and that the victory of the political stage managers would be short-lived. 'The King,' wrote one of the court ladies, 'was much dismayed, pale, and could not speak to be heard but by broken sentences.' Sunderland, the chief minister who had arranged the family reunion, told her that 'the king is so out of humour with him about this thing that if the Pretender were in England he could cut them all down'. And behind the façade of national unity schemers of all kinds, political and financial alike, sought to use the situation to further their own particular ends. 'In short, there was not a rogue in town that was not engaged in some scheme or project to undo his country.'² Sunderland and his colleagues had sought to transcend the divisive and centrifugal tendencies of English political life, only to find that they had revealed and reinforced its very worst features. And it was the financial aspect of their apparent success, the notorious South Sea scheme, which seemed at first to be its surest guarantee but which soon became its undoing. And Hogarth, who castigated the South Sea project so soundly in 1721, would hardly be expressing starry-eyed symbolical hopes about it in 1722. Since the stylistic evidence for the dating of the print is inconclusive – after all, Thornhill's Lower Hall paintings at Greenwich, which had been running in Hogarth's head since his apprentice days, also showed Hercules engaged in similar activities – the political evidence must be allowed to point at least to the strong probability that it was done in 1720, apparently in an outburst of rather naïve enthusiasm for the illusory benefits of Sunderland's success. In political terms the young engraver seems to have been at this stage the ingenuous Mr Hogarth rather than the ingenious Mr Hogarth.

It was the third of his mythological ladies, the one on the extreme left of the print, who was the really crucial one. The lady with the sceptre of power was harmless enough and the companion who looked over her shoulder and made a vaguely beneficent gesture towards unseen glories outside the picture was equally so. She represented the arts – hence the lyre on her sceptre – and Hogarth was already sufficiently realistic to know that the arts must take a subordinate position behind the more important realities of power and money. The lady who represented wealth, commercial as well as financial, had a noticeably more sombre expression than her colleagues and knelt partly in the shadow while they both stood in the light. She gestured towards a heap of money and other articles, the financial and commerical side of the political reconciliation. What exactly the Prince was offered in return for agreeing to the political accommodation with his father was never known, since the details were later suppressed as part of the cover-up operation; but it seems likely that he was won over by promises similar to those made to lesser political figures. All those who agreed to support the ministers in their bid for a monopoly of political and financial power, the bid which Harley's correspondent said would 'fill the House of Commons and rule this little world', were to be allocated blocks of South Sea stock at prevailing rates. Thus when the price went up they would be able to sell at a handsome profit, out of which they would then be allowed to pay retrospectively for their allocations at the earlier and lower rate. Both King and Prince had been involved with the South Sea Company for some years past and it is highly probable that private allocations to these august personages were among the secrets which the Cashier of the South Sea Company later said would 'amaze the world' if they were ever revealed. The pile of money in the foreground of Hogarth's print stood for hopes that were respectable enough in 1720, hopes of renewed national unity reinforced by strengthened national credit. But by 1722 – indeed, even as early as the beginning of 1721 – these hopes had turned into shady transactions which it was dangerous to know too much about. Nobody but a fool would have spent his time on such a print in 1721 or 1722.

And Hogarth was not a fool. Later in the century the division of the political scene into opposing parties came to be accepted and even applauded: Englishmen began to think that this agreement to disagree, this polarity between government and opposition, was a guarantee of liberty. But to Hogarth's generation the older seventeenth-century view of parties, that they were 'conspiracies against the nation', seemed the essence of political wisdom. His premature celebration of the reconciliation of 1720 soon became embarrassingly out-of-date – which was presumably why it was disowned and suffered two and a half centuries of neglect – but at the time it was produced, it was not entirely unrealistic. Robert Harley, the potentate to whom Richard Hogarth had appealed, had looked forward to something of the same sort: he had believed that government without party, government above party, was not only possible but essential. Like Sunderland in 1720, he saw it not as royal absolutism but as the only way of uniting a dangerously troubled and almost ungovernable country. The accession of the Hanoverian dynasty in 1714, which historical hindsight was to see as the beginning of English political stability, appeared to contemporaries as just another twist in a complex and threatening situation. The Tories, the party towards which many independent men in the Commons were emotionally and nostalgically drawn, would be the real victors if King and Prince could not agree, if party conflict continued to undermine political stability. And the Tories have been shown by recent research to have been rather more than the mere bucolic romantics for which they were once taken. Many of the allegedly independent gentlemen who made such a fuss about freedom, both in their localities and in the House of Commons, were in fact in secret communication with the agents of the Pretender, the exiled son of James II, and with the French secret service men who hoped to use him against the King of England. And those hopes were centred not on the freedoms the country gentlemen thought they were defending but on the number of tenants and hired labourers they would be able to call to arms in the event of Jacobite invasion or civil war.[3] In retrospect the hopes of 1720 came to seem not merely absurd but even unconstitutional, a threat to that balance between parties which underpinned

English liberty. But at the time there were many others as well as William Hogarth who looked to them as the only answer to a desperate situation.

It is therefore important to remember that beneath Hogarth's surface attitude of political neutrality there was a deeper level at which there was a real political commitment. To the cynical it might seem that he was merely being as stupid and as over-ambitious as his father, seeking to appeal directly to the royal actors in the 1720 charade, and to their immensely powerful political manipulators, before he had even ingratiated himself with the lesser figures in the political scene. But the evidence of his next few prints contradicts this view of things. Once the Prince of Wales had failed to live up to the bright hopes of 1720 Hogarth turned on him fiercely, satirising his support of Heidegger in *Masquerades and Operas* and mocking his protégé Sir Richard Manningham in *Cunicularii, or the Wise Men of Godliman in Consultation*, in December 1726. By the time Hogarth published this latter print its principal subject, Mrs Tofts of Godalming, had already been exposed as an impostor. She had claimed to have given birth to rabbits and for a time her grotesquely fecund activities had fooled the medical profession – including surgeons high in the King's own favour as well as Manningham himself, the Princess of Wales's male midwife whom Hogarth showed as 'an occult philosopher searching into the depth of things'. The satire was unfair as well as ill-advised, since Manningham had by this time made up for his initial gullibility by exposing the hoax.

A few months later, after the Prince of Wales had succeeded his father as King, Hogarth did something that was even more indiscreet. He translated his bitter resentment of the new King's continued patronage of Heidegger into a mock masquerade ticket, over which the lion and the unicorn presided in postures rather less dignified than their usual stately stance in support of the royal arms. Beneath these lolling heraldic monsters a crowd of masked revellers, presumably including the King and the members of his court, wandered about in a rather aimless fashion between two altars dedicated to the worship of physical love. Over their heads towered what the caption described

as 'a pair of Lecherometers shewing the Company's Inclinations as they approach 'em'. One was almost as meteorological as the barometer it was obviously modelled upon; but the other, more explicit, ranged from 'Expectation' and 'Hot Desire' to the post-climactic 'Sudden Cold'. If 1720 had demonstrated too great a desire for the favour of a Prince, 1727 showed too little regard for the anger of a King. There can be little doubt that Hogarth's commitment was to principles and not to persons.

Meanwhile there had appeared an even more uncompromising attack on the hierarchy of great men. Towards the end of 1724 'a very rare Hieroglyphic Print representing Royalty, Episcopacy and Law, composed of emblematic attributes' was advertised in the newspapers. Its caption claimed that the figures shown were 'Some of the Principal Inhabitants of the Moon, as they were Perfectly Discovered by a Telescope brought to the Greatest Perfection since the last Eclipse'. The eclipse in question had taken place some months earlier, in May, and the reference to it seems to have been a rather forlorn attempt to hitch the print onto an already dying sensation. The popularity of fantasies with a lunar setting was more lasting: Bishop Wilkins had published his 'Discovery of a World in the Moon' in 1638, thirty years before his scheme for a philosophical language, and Elkanah Settle's play 'The World in the Moon' had been first produced in the year of Hogarth's birth. Lunar fantasies of one kind or another were a mainstay of the popular theatre and also of the pageantry of the streets. The method used in *Royalty, Episcopacy and Law* (see plate 8a), which consisted of building up apparently human forms from inanimate and symbolic objects, was also linked with the same traditions. One of its earliest and most famous exponents had been the Italian Giuseppe Arcimboldo, a sixteenth-century Milanese painter whose work for the court of the Holy Roman Emperor had included the designing of costumes and floats for pageants and other festivities (see plate 8b).[4]

The print was unsigned and Hogarth made no reference to it in his later works; but it bears the marks of his style and his widow did not contest his biographers' attribution of it to him. It is quite different

from the rest of his early work and it has a dreamlike quality which he was not to reveal again until the very end of his life. Working in this vein, within the European tradition of grotesque and imaginative art whose products ranged from the horrific fantasies of Hieronymus Bosch to the masquerades of John Heidegger, Hogarth felt free to produce satire fiercer and more generalised than anything he had so far drawn. The soldiers made out of fire-screens are harmless enough, as are the looking-glass courtiers and the lady made out of a fan and a teapot. The figure representing the Law – which might equally well be taken for some kind of civic dignitary – suggests little more than incompetence and emptiness; but the episcopal figure in the centre, pumping money into his coffers as he pumps out twangling sermons from his jew's harp of a face, is a savage comment on the corruption of the eighteenth-century Anglican Church. By comparison with this evil ecclesiastical apparatus even the King himself, with the face of a coin and with meaningless regalia held in non-existent hands, seems merely pathetic, a victim rather than an instigator of the jobbery and chicanery that goes on around him.

Satire as generalised as this was perhaps less dangerous than the more specific and more limited attacks on particular people or parties which formed the usual stock-in-trade of the printmakers. Jonathan Swift had reached a similar position: he made fewer enemies now that he wrote of the degradation of the whole human species than he had when he had lashed the follies of individuals. When his masterpiece *Gulliver's Travels* was published in October 1726 his friends in London told him with some relief that 'the politicians to a man agree that it is free from particular reflections'.[5] Hogarth for his part took the opportunity to produce another generalised view of the absurdities of the hierarchy, particularly of the ecclesiastical hierarchy, in his *Punishment inflicted on Lemuel Gulliver*. The print, which appeared within two months of the publication of the book, purported to be a frontispiece originally intended for Swift's first volume but subsequently omitted. There was of course no real association between Swift and Hogarth, any more than there was any real affinity in their work. Some years later, when Swift heard about the savagery of some aspects of Hogarth's

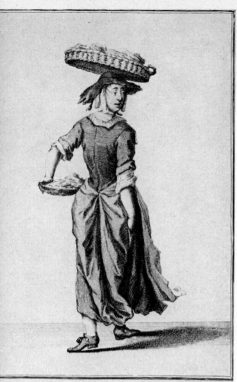

Buy my Dish of great Eeles.
A mes belles Anguilles freches.
Aaguille fresche, Aaguille.

1a Eel seller, from *Cryes of the City*, by Marceluss Laroon

Right) *The Shrimp Girl* by arth, mid 1750s

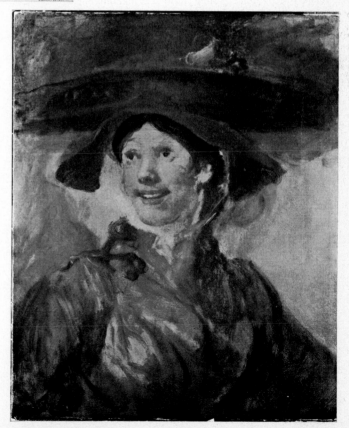

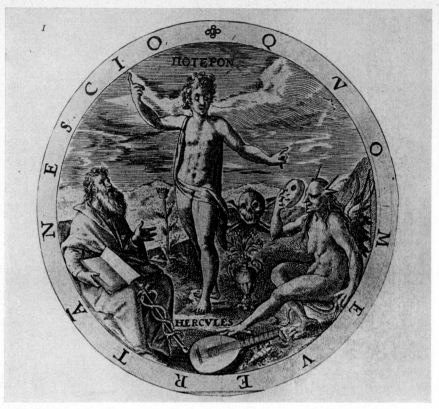

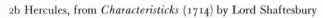

2a Hercules, from *A Collection of Emblemes* (1635) by George Wither

2b Hercules, from *Characteristicks* (1714) by Lord Shaftesbury

3a Hogarth's shop card, published April 1720

3b Sir Robert Walpole's salver (detail), made by Paul de Lamerie, 1728/9, out of
silver from the Great Seal, possibly engraved by Hogarth

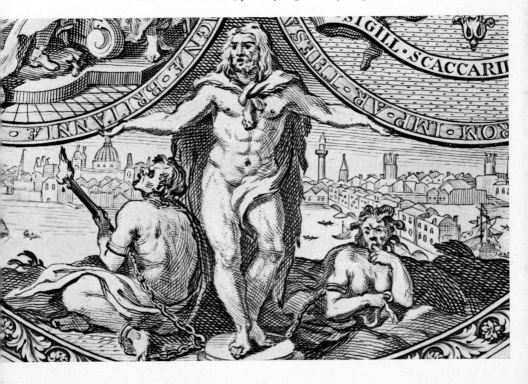

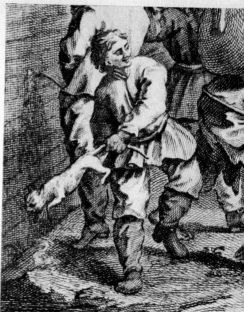

4a (Top left) *Mother Damnable,* (detail) print, 1676; 4b (Top right) *Hudibras encounters the Skimmington* (detail) by Hogarth, 1726; 4c (Above) *First Stage of Cruelty* (detail) by Hogarth, 1751

PLATES OPPOSITE

5a (Above) *The Lottery,* second state, 1721 (24), by Hogarth; 5b (Below) *The South Sea Scheme,* first state, 1721/2, by Hogarth

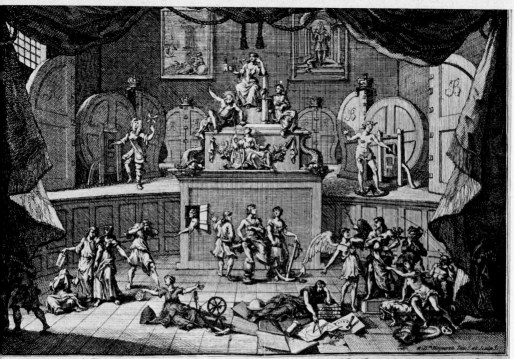

Explanation. 1. *Upon the Pedestal National Credit leaning* ... *a Pillar supported by Justice.* 2. *Apollo shewing Britannia a* ... *ing representing the Earth receiving enriching Showers* ... *wn from her self (an Emblem of State Lottery's.)* 3. *Fortune* ... *ving the Blanks and Prizes.* 4. *Wantonness Drawing y̆ Numb.* ... *fore the Pedestal Suspence turnd to & fro by Hope & Fear.*

The
LOTTERY

6. *On one hand,* Good Luck *being Elevated is seized by* Pleasure & *Folly;* Fame *persading him to raise sinking* Virtue, Arts &c. 7. *On y̆ other hand* Misfortune *opprest by* Grief, Minerva *supporting him* *points to the Sweets of* Industry. 8. Sloth *hiding his head in y̆* *Curtain.* 9. *On y̆ other side,* Avarice *hugging his Mony.* 10. Fraud *tempting* Despair *w̆th Mony at a Trap-door in the Pedestal.*
Price one Shilling.

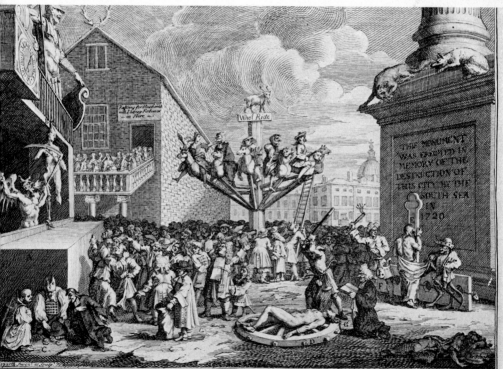

here y̆ Causes why in London. | *Trapping their Souls with Lottery Chances* | *Leaving, their strife Religious bustle,* | (B) Honour (D) Honesty, are Crimes
many Men are made Undone. | *Shareing from Blue Garters down,* | *Kneel downt & play spetch & Hussle.* (C) | *That publickly are punish'd by*
nt Arts & honest Trading drop. | *To all Blue Aprons in the Town.* | *Thus when the Shepherds are at play* | (G) Self Interest and (V) Vilany,
Swarm about y̆ Devils Shop. | *Here all Religions flock together.* | *Their flocks must surely go a stray.* | *So much for Monys, magick power*
uts out (B) Fortunes golden Haunches | *Like Tame & Wild Fowl of a Feather.* | *The woeful Cause y̆ in these Times.* | *Guess at the Rest you find out more*
price 1 shilling

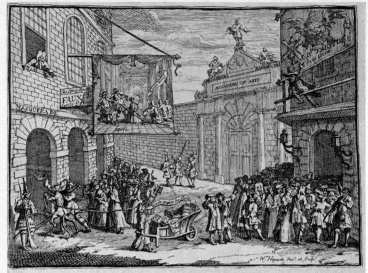

O how refin'd how elegant we're grown!
What noble Entertainments Charm the Town!
Whether to hear the Dragon's roar we go,
Or gaze surpriz'd on Fawks's matchless Show,

Or to the Opera's, or to the Masques,
To eat up Ortelans, and empty Flasques
And rifle Pies from Shakespear's dinging Page,
Good Gods, how areat's the gusto of the Age

To be sold at ye Golden Ball in Little Newport Street Price 1 shill. 1724.

6a *Masquerades and Oper* second state, 1724, by Hog (in this, the second state, Hogarth substituted a new set of verses for those used in the first state and quote on p. 52).

6b (Below) *A Just View of British Stage,* first state, etching and engraving published December 1724, Hogarth

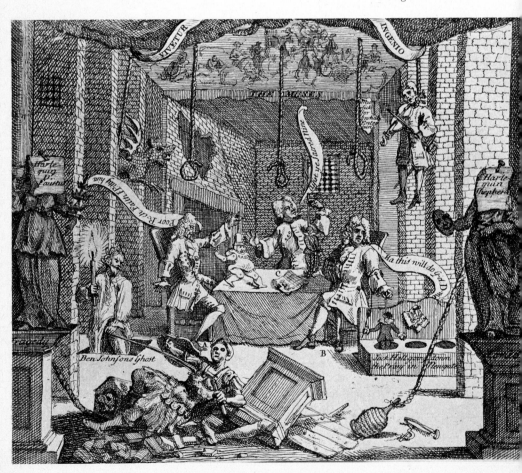

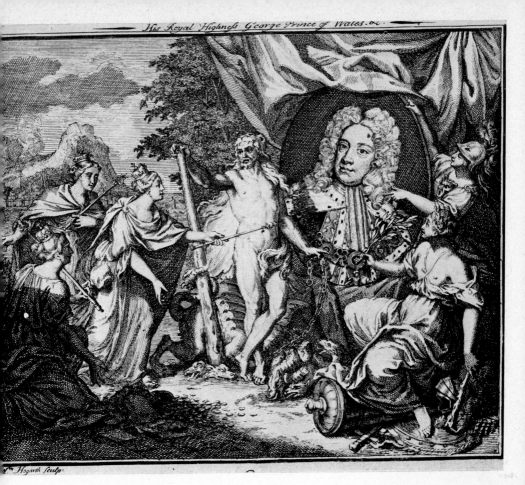

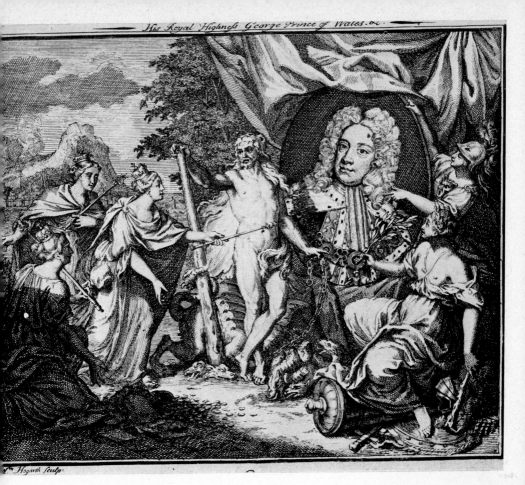

7 *His Royal Highness George, Prince of Wales* by Hogarth, 1720?

8a *Royalty, Episcopacy and the Law* (detail), etching and engraving published 1724, by Hogarth

8b *Il Cuoco* (Personnage allégorique avec instruments de cuisine), by Guiseppe Archimboldo

Rake's Progress, he wrote some lines envisaging a collaboration between them:

> You should try your graving Tools
> On this odious Group of Fools;
> Draw the Beasts as I describe 'em,
> Form their Features, while I gibe them

But there was a world of difference between the dark despair of Swift, already nearing the end of his career, and the didactic satire of Hogarth. Swift was a Tory: for him the corruption of Hanoverian England was the putrefaction of a body politic that must die and be carted away before anything better could be born – or rather re-born, for most Tories placed their idea of the Golden Age firmly in the past. Hogarth also seems to have believed in an ideal world based on traditional values, but for him it was to be achieved by reformation rather than resurrection. In spite of his disgust at the contemporary political scene he still had some residual faith in the system on which it was based and in the eventual defeat of faction, the defeat which Harley had failed to engineer in the reign of Queen Anne and which Sunderland had failed to bring about in 1720.

The real test of Hogarth's political philosophy was to come at the end of his life, when he was to be dragged into public controversy and made to realise that the beliefs which he had thought to be above party were after all part of a party creed. At this stage, however, his politics were important not because they involved him in public debate but because they dictated his private search for patronage. At the end of 1726 the opposition politicians launched a newspaper called *The Craftsman*, with which most of the satirical writers of the day were associated; and there has been an understandable tendency among historians and biographers to seek for some sort of link between the isolated pictorial satire of William Hogarth and the dazzling display of organised literary talent which was arrayed against the administration. No convincing link has ever been found. In November 1727, while reviewing a new production of Shakespeare's *Henry VIII* at Drury Lane, a writer in *The Craftsman* pointed out the similarity between

Henry VIII's over-ambitious minister Cardinal Wolsey and the present King's hated minister Sir Robert Walpole. Some months later – possibly not until the beginning of 1729 – a print was on sale in which Hogarth showed Wolsey gloomily contemplating his imminent fall from power now that Henry had become infatuated with Anne Boleyn. In the autumn of 1727, when *The Craftsman* first pointed out this parallel, it still had some political force: there still seemed to be a chance that the new King George II, who had succeeded his father in June 1727, would do as the opposition wished and dismiss Walpole. But by the time Hogarth's print appeared this chance had gone and the political cutting edge of the Wolsey-Walpole comparison had gone with it. In any case there is great uncertainty about the precise relationship between the print and a painting of the same subject which Hogarth is supposed to have done at about the same time. By 1728 he had started to use theatrical subjects, especially scenes from Shakespeare's plays, as a training ground for his ambitions as a painter; and if this print was a mere by-product of such an exercise its political significance is diminished still further. Certainly it cannot be taken as an indication that Hogarth was lining up with the opposition politicians against Walpole. He had still not entirely abandoned his father's search for great men; and among the patrons of *The Craftsman* there was no man great enough for his purpose.

Paradoxically enough his published work, and the political commitment which it implied, had now brought him to a point where Walpole himself was his obvious patron. Sir Robert's success in surviving the death of one king and the accession of another was in fact a very considerable political achievement. It was the first time for a hundred years that a new reign had begun without a political upheaval. Ever since the English had risen up against their Stuart kings in the middle of the seventeenth century they had placed themselves in a situation of recurring political instability. In the first place they had made themselves dependent on involvement in European affairs: in the 1650s Oliver Cromwell had had to seek European allies against a threatened Stuart restoration and in the 1690s William III, the Dutch King whose name Hogarth bore, had finally convinced his English

subjects that they must fight his European wars if they wanted to prevent Louis XIV of France from imposing the exiled Stuart King James II on them again. In the second place they had made effective government dependent on the control of Parliament, which meant that the King and his ministers had to use their patronage in order to build up a party there. Inevitably heirs to the throne tended to attract politicians excluded by the reigning monarch, so that party differences were perpetuated by the polarity between those who held office in the present and those who hoped to hold it in the future. And the two causes of instability were linked together, and each made more dangerous, by the fact that European involvement was itself a major issue in party politics. Politicians whose access to confidential information while in office had convinced them that the struggle against the Stuart Pretender and his French supporters was a grim necessity, still pretended, once they found themselves in opposition, that it was nothing but a self-interested Dutch or Hanoverian piece of war-mongering. In 1720, when Hogarth had depicted the death of the hydra of discord, it had seemed for a space that these dangers and divisions might indeed be transcended. In 1727, when Walpole managed to accommodate the new King's commitments without endangering his own administration, that hope of political unity was revived. And the difference between Hogarth and the opposition politicians was that for him it was still a hope while for them it was a fear.

Within a few months of the new King's accession Hogarth did indeed receive a commission from Sir Robert Walpole. The Great Seal of England, a massive and handsome piece of silver, became obsolete on the death of a monarch; and it was customary for the minister who had had charge of it to be allowed to keep it and have it made into a silver cup or salver. In the past this had been a kind of consolation prize for a fallen minister; but now Walpole was in the unique position of retaining both the Seal of the old King and the favour of the new one. Whatever was made out of this Seal would be a triumphant symbol of continuity rather than a sad reminder of former greatness. Walpole sent for Paul de Lamerie, an eminent Huguenot

goldsmith and silversmith who was, according to one scholar, 'the inevitable artist' for his purpose.[6] The choice of an engraver was rather less inevitable: Lamerie probably knew of Hogarth through Ellis Gamble, who had done some work for him, but this was no reason to employ a renegade silver engraver who had turned his back so firmly on his old trade. In the event, however, it was Hogarth who did the engraving for the salver which Lamerie made out of the Seal. Lamerie may have needed some persuasion to make such an unlikely choice and Hogarth in his turn may have needed persuading in order to return, even temporarily, to a craft which he had already found 'detrimental to the arts of painting and engraving I have since pursued'.[7] If so, it was probably Walpole himself who did the persuading. The theory that he did so as a preliminary to using Hogarth as a paid satirist for his own political purposes seems somewhat implausible; but he may well have pointed out that he was in an unrivalled position to advance Hogarth's newly conceived ambition to be a portrait painter.

The actual design which Hogarth executed on the Walpole salver was backward looking: he returned to his old friend Hercules (see plate 3b) and celebrated the stability of 1727 with an allegory similar to that he had conceived for the reconciliation of 1720. This, indeed, is the strongest reason for attributing the engraving on the piece to him in spite of the doubts that have been expressed about it.[8] But his reasons for undertaking the commission looked forward to a new phase in his career, a phase which would cut him off not only from Hercules but from the whole emblematic world over which Hercules presided. And in the other world which he was now to enter, the world of unreliable patrons and impatient sitters and family vanity, he was to have plenty of chances to test the value of great men's promises.

CHAPTER V
Married and turned painter
of portraits

When Hogarth came to look back on his early life he saw his marriage and his venture into portrait painting as twin aspects of the same turning point, the turning point between the carefree gaiety of a bachelor life and the serious business of providing for a family. 'Engraving in the first part of my life till near thirty did little more than maintain myself in the usual gaieties of life, but in all a punctual paymaster,' he wrote, 'Then married and turned Painter of Portraits in small conversation pieces and great success – but . . . that manner of Painting was not sufficiently paid to do everything my family required.' He then proceeded to give a series of reasons for his subsequent decision to abandon portrait painting in favour of 'painting and engraving modern moral subjects, a field unbroke up in any country or any age'.[1] They were confused and sometimes contradictory reasons and they were closely involved, both in the *Autobiographical Notes* and in the *Apology for Painters*, with his attacks on his enemies and his retrospective justification of his own career; but they were all connected in one way or another with the enhanced sense of responsibility which marriage had brought with it. The light-hearted and pleasure-loving printmaker, poking fun at London life and living from one scandal or sensation to the next, apparently disappeared once and for all when William Hogarth went out to Paddington church on 23 March 1729 to marry Jane Thornhill, the only daughter of the man whose history paintings had been running in his head for so long and

whose support could mean so much in his new and altogether weightier career as a painter.

In fact there are so many inaccuracies and confusions in Hogarth's account of this period of his life that it is difficult to evaluate even his basic point, the link between marriage and portrait painting, let alone the more detailed implications. The beginning of his career as a painter came not with his marriage – which in reality took place more than a year after the thirtieth birthday with which he seemed to associate it – but with a commission which he received in the autumn of 1727 from a tapestry-maker called Joshua Morris. Morris wanted a painting on canvas of 'The Element of Earth', from which his workmen were to design and weave a tapestry; and Hogarth was recommended to him as being the kind of artist who could carry out this rather specialised task. The point was that tapestry cartoons had to have the linear qualities which could reasonably be expected from a painter who had originally been an engraver. It was extremely difficult to base a tapestry design on a 'painterly' picture, one in which areas of colour merged into one another instead of being contained by lines. Hogarth was adept not only at translating objects into a linear form – he himself said that his famous system of visual mnemonics was based essentially upon line – but also at translating the tonal values of a painting into the linear qualities of an engraving or etching. And yet in this case he apparently failed to exercise these skills. When the work was eventually delivered, very belatedly and in a curiously furtive manner, Morris' workmen – 'some of the finest hands in Europe in working tapestry' – declared that they could not produce a tapestry from it because 'it was not finished in a workmanlike manner'.[2] Morris refused to pay for it and Hogarth took him to law. The case was heard in May 1728 and the judge decided that if the picture was competent as a painting it must be paid for, even if its finish was not 'workmanlike' in the judgment of tapestry designers. Hogarth got his money and Morris was left with a painting which he averred was quite literally worse than useless, since its shortcomings had forced him to divert his men from the intended tapestry to another, which had lost him money.

This episode, which even the belligerent and litigious Hogarth

chose not to remember in later life, may well have had a greater influence on his development as a painter than his subsequent marriage to Thornhill's daughter. It taught him the usefulness of the law, a lesson which he was to improve upon some years later when he secured a special Act of Parliament to give engravers a copyright in their work. But it also had its negative aspects, aspects which have less often been stressed but which were nevertheless of crucial importance. At the time Morris ordered his picture he was part of the small army of agents and craftsmen and artists and contractors who were working on the Duke of Chandos's country house at Cannons. The commission was in fact Hogarth's first opportunity to enter the world of history painting for which he had so long yearned. It was a comparatively small and enclosed world in which everyone knew everyone else and work was passed on down the line, from architects and designers to agents and contractors, on the basis of personal recommendation. And nobody would be anxious to recommend again an artist who did a bad job and then sued for his money. Thornhill himself had a reputation for doing this kind of thing and Hogarth may have thought that he would draw attention to himself by following his example; but the point was that Thornhill was sufficiently in demand to get away with it while Hogarth was not. However satisfying the outcome of the law suit may have been there was no disguising the fact that Hogarth had thrown away his first chance to become a history painter. If he wanted to turn from engraving to painting he must follow some other path. The small conversation pieces were the outcome of necessity as well as choice.

Morris' rejection of the tapestry design had its effect on Hogarth's style as well as on his career. Since the cartoon itself has been lost there is no way of deciding whether or not Hogarth did in fact do a bad job; but it is certainly true that the things Morris and his workmen said about *The Element of Earth* could also be said about *The Carpenter's Yard* and *The Doctor's Visit*, two pictures which have been attributed to Hogarth and which he probably painted – if he painted them at all – shortly before the cartoon. There is a lack of definition in these paintings, as well as an ignorance of linear perspective and other

technical devices, which suggests that as a painter Hogarth, at this stage of his life, was deficient in precisely those qualities which his work as an engraver might have been expected to develop in him. It was almost as if painting was for him a refuge from drawing rather than an extension of it: in the exhilarating feel of a loaded brush he could forget his nagging doubts about his proficiency as a draughtsman. In painting, where form can be suggested by colour rather than by line and where uncertainties and even carelessness have a kindly habit of merging into apparent logic when viewed from the right distance, it is sometimes possible for the beginner to delude himself into thinking that precise draughtsmanship is irrelevant. Everything that Hogarth is said to have painted before 1728 – and in some cases the stylistic and other evidence for attribution is quite convincing – makes it appear that he was a beginner of this sort.

If so, the Morris affair was a salutary shock. The first thing that it seems to have taught him was the need for those preliminary drawings which he affected to scorn. Having prided himself on 'retaining in my mind *lineally* such objects as fitted my purpose best', he now found his work as a painter criticised precisely because of its lack of linear exactitude. The argument he used later in life was based, like so much of his thinking, on a comparison between linguistic and visual means of communication. He insisted that painters who copied objects directly and then built their pictures from their drawings were like scribes who copied out in beautiful handwriting documents they had never bothered to understand. He, on the other hand, had mastered the actual language of objects, the grammatical structure of the physical world. While others blindly copied he really understood the truths he transmitted.[3] But this theory, convincing though it may have been to the mature Hogarth when he looked back, could do little for the young and aspiring Hogarth in 1728. By refusing to copy he had made himself uncopiable – a laudable achievement for a master painter, but one which was inadvisable for an engraver who was making his first foray into the world of painting and who must take such work as he could find. He therefore had the good sense to put his idiosyncracies aside, at any rate for the time being, and return to the

practice of making preliminary drawings. Several of these drawings, all on identical sheets of paper and reputedly taken from one single sketch-book, are now in the Royal Library at Windsor. Their similarities help not only to date the various works which he did in 1728 but also to make clear the extraordinary change which came over his art in that year. It was a year which he subsequently chose to forget, just as he suppressed the memory of the law suit which dominated it. He seemed to want to bring together his thirtieth birthday and his marriage and to ignore what came between them; and yet it was precisely this period, from the autumn of 1727 to the spring of 1729, that made it both necessary and possible for him to enter what he later referred to contemptuously as 'the nest of Phizmongers'.[4]

His reasons for pinning this uncomplimentary label on his fellow portrait painters were made clear in the *Apology for Painters*. There he argued that of all the branches of the art of painting, portraiture was 'the only one by which a money lover can get a fortune and a man of very middling talents may easily succeed'. This was because 'nine parts in ten of such picture . . . is the work of the drapery man', but 'all the reputation is engrossed by the phizmonger for what is only contained in an oval of about five inches long'.[5] Here, at any rate, his bitterness and contempt were not merely retrospective. He had always despised mere portrait painters for their neglect of the language of painting as a whole and their concentration on the mechanical business of catching likenesses. Joseph Vanacken, one of the most talented and widely employed of the drapery painters, was a friend of his; and when Vanacken died Hogarth is said to have produced an ironic picture of his funeral procession, with all the portrait painters of London mourning the passing of one who had brought them so much fame at so little cost – for the drapery man, as Hogarth pointed out bitterly in the *Apology*, got only one tenth of the pay for doing nine-tenths of the work.[6]

His own proud boast was that his particular form of portrait painting, which consisted of comparatively small pictures containing groups of figures 'from 10 to 15 inches high', was genuinely his own, both in conception and execution: 'it could not be made like the former a kind

of manufacture carried on by a sort of Journeymen called Background & Drapery painters whose work by the by is not only the much the greatest part of the Picture but often the most meritorious'.[7] This was the reason for its enormous but short-lived success and also for the venom with which it was attacked by the other inhabitants of the nest who felt their phizmongering activities threatened by it. At the same time Hogarth did not conceal the financial disadvantages of having to do his own drapery and background work. It made his work into 'a kind of drudgery' and meant that in spite of his rapid and dazzling success he had to do more work for less money than his more conventional rivals. Both his greatness and his limitations were those of the outsider, the lonely and stubborn man who would not enter – except on his own terms – either the organised world of the history painters or the equally compartmented world of the portraitists.

The actual moment at which he stormed these two citadels, gaining acceptance for his own individual art form which claimed to transcend the efforts of both of them, is difficult to determine. The list which he drew up a few years later of 'all the pictures that remain unfinished – half payment received'[8] included three commissions which dated from 1728; but none of these was for a patron of any great social consequence. One was for Thomas Wood, who was probably a fellow member of a drinking club which met at the Bedford Arms tavern. Later Hogarth was to paint Wood's daughter and also his dog Vulcan, which he knew well because of its habit of meeting its master after his drinking bouts with a lantern in its mouth to light him home. Another was for Christopher Cock, an auctioneer who was a near neighbour. The only one which might have got Hogarth known among men of fashion was a family group ordered by John Rich, the manager of the Lincoln's Inn Fields theatre. Rich had scored an enormous success with his production of John Gay's *Beggar's Opera* on 29 January 1728 and his acquaintance was now sought by many important and influential people whose patronage might be useful to an aspiring portrait painter. Yet his picture, which could have done Hogarth a lot of good if it had made its appearance in the theatre manager's drawing-room promptly, was still uncompleted more than two years after it had been commissioned.

It would seem that such success as Hogarth had achieved in 1728 had been limited, even parochial, and that it had then been overtaken by a sudden widening of his horizons during the following year. Not only the commissions of his friends and neighbours but also the potentially important commission from Rich had been elbowed aside by subsequent orders from more powerful patrons.

Some of these patrons may have been attracted by Hogarth's picture of the *Beggar's Opera*, the earliest of his works to reflect the changes brought about by the Morris affair. He had done a first drawing quite early in the play's run and had then worked it up into a painting of which he produced no less than six versions, each one carrying his double-edged allegory and carefully contrived composition a stage further than the last. Both colour and line were now used in order to explore the relationship between reality and emblem, between the imaginary world which the actors were portraying and the everyday world which they and their patrons in the audience actually inhabited. But it was not a very flattering relationship as far as those patrons themselves were concerned. The link that was being established was one between the petty rogues in the play and the great rogues in the audience, the men of power and influence who watched with inappropriate disdain the squalid end-product of the corruption and venality which they themselves nurtured for their own profit. It was perhaps not surprising that the *Beggar's Opera* pictures, impressive and topical though they were, did not lead directly to fresh commissions from new patrons, with the single exception of John Rich himself. They may have brought Hogarth a measure of fame – they certainly deserved to, for they represented a startling advance on anything he had painted before – but they did not apparently bring him any new business.

That new business came in the following year, as a result of his painting of the Gaols Committee. At the end of February 1729, a month before William Hogarth and Jane Thornhill were married, the House of Commons set up a Committee to inquire into complaints of cruelty and ill-treatment of prisoners in the Fleet and Marshalsea prisons. Somehow Hogarth got permission to produce a picture of one

of the visits made by this Committee to the Fleet. It was an oppor-
tunity to make up for his rather sour comments on the great men of
the realm in the *Beggar's Opera* paintings. There he had shown them
within the walls of an imaginary prison, a stage set which they came to
see merely for their own amusement and titillation; now he could
show them engaged on a genuinely humanitarian errand in a real
prison. Sir Edward Knatchbull, who went on the Committee's first
visit to the Fleet on 27 February, noted down his impressions in his
diary at some length:

> I went with the committee appointed to inspect the state of the
> gaols and the abuse of the prisoners by the cruelty of the gaolers.
> We went to the Fleet and was there by eight in the morning and
> first visited the several apartments, many of which were so nau-
> seous that we were forced to hold our noses; there were many
> poor people in a sort of dungeon without light or fire and some in
> chains and others 30 or 40 in a room packed so close that it was
> likely in hot weather to breed a distemper; the poor wretches
> were overjoyed when we came in and with a general God bless
> us we were saluted. We then proceeded to examine Mr Bam-
> bridge, the warden . . . being asked how many were in irons he
> said one for stabbing his man, viz. Sir William Rich, and for an
> escape; so the committee proceeded to examine Sir William
> Rich, having ordered his irons to be knocked off during his
> examination (they weighed 15 lb.) which proved a very cruel
> usage of him, and then Mr Erle and I went away.[9]

Sir William Rich's irons soon became one of the most notorious
aspects of the inquiry, especially since Bambridge ordered them to be
replaced as soon as the Committee had left. 'Upon some of the com-
mittee to inspect the gaols having been this day at the Fleet again,'
wrote Sir Edward the next day, 'they found Sir William Rich's irons
had again been put on after the committee went away yesterday and he
loaded with treble the weight and so close that his hands and arms
were swelled greatly and he had been in torture all night.'[10] Hogarth
therefore built his picture around these sinister fetters, which form the
pivot of the composition both in his preliminary sketch (plate 9a) and
in the painting which he worked up from it (plate 9b). But Sir William

Rich was not the only prisoner to be fettered; nor were fetters the only inhuman punishment about which complaints were made and investigations undertaken. Men who had been unable to pay the exorbitant fees demanded by the Warden had been put in specially constructed dungeons over the sewers of the prison; some had even been confined in company with the dead bodies of prisoners who had died of the smallpox. One man who had been foolish enough to publicise his overwhelming fear of the disease was treated in this way and died as a result.

From Hogarth's own point of view the really embarrassing thing was that there was more than one man under examination. As well as Thomas Bambridge, the present Warden and the man whose treatment of Sir William Rich so shocked the Committee, there was also John Huggins, the man who had held the office of Warden from 1713 to 1728 and had then sold it to Bambridge for £5,000 a few months before the scandal broke. Huggins – against whom there were charges just as atrocious as those levelled at Bambridge – was an unscrupulous and highly successful solicitor who haunted the shadier corners of the corridors of power in order to get lucrative offices for himself and for his associates. And one of those associates was Hogarth's future father-in-law Sir James Thornhill. Thornhill had already survived one dangerous friendship, that between himself and the Cashier of the South Sea Company, Robert Knight: Knight had finished up in exile but Thornhill had preserved his reputation even though he had been sufficiently in the know to sell his holding of South Sea stock, some £2,000, at the very top of the market just before the crash.[11] His association with Huggins, which was rumoured to be responsible both for his knighthood and for his appointment as Sergeant Painter, was now to prove something of an embarrassment. Thornhill was not elected to the Gaols Committee, even though he was by this time a fairly well-known member of the House of Commons.

In spite of these facts there has been a long-standing tendency among Hogarth biographers to assume that the Gaols Committee picture was undertaken with Thornhill's encouragement and assistance. It has been suggested that Thornhill was the man who obtained for

his future son-in-law an authorisation to sketch the Committee in session in the Fleet – even though it is the finished painting, not the preliminary sketch, which is set in the prison and even though Thornhill himself did not sit on the original Committee. It was not until several weeks later, after Huggins's friends in Parliament had begun to recover and organise an operation to concentrate all the blame on Bambridge, that Thornhill won a place on another and less important committee. When the marriage between Hogarth and Jane Thornhill took place towards the end of March the tide of public opinion was still setting fiercely against Huggins. 'Great endeavours to save Huggins from Newgate,' reported Sir Edward Knatchbull three days before the wedding, 'but the torrent was so strong it would not do.'[12] The torrent might even have appeared threatening to Thornhill himself: once details of jobbery started to be made public there was no knowing where they might end. There was enormous public excitement about the whole business and very soon the Committee came under pressure to extend its inquiries to prisons throughout the realm. Samuel Wesley, father of the founder of Methodism, went so far as to produce an ecstatic verse epic entitled *The Prisons opened, a poem occasioned by the late glorious proceedings of the Committee appointed to inquire into the State of the Gaols of this Kingdom*.[13] It is hard to believe that either Thornhill or any of Huggins' other associates would have been anxious to have Hogarth's particular brand of pictorial publicity added to the already unwelcome literary publicity which was proliferating all around them. Whoever got Hogarth into the sessions of the Committee was not Sir James Thornhill, who had neither the means nor the motive.

The other odd thing about this episode is that nobody seems to have connected the Huggins affair with the persistent tradition, starting with George Vertue, that Hogarth married Jane against her father's wishes. Vertue, an engraver who was also an amateur historian and was busy collecting material for a history of art in England, is the source for a good deal of our information about Hogarth at this time. Shortly after the wedding, when Hogarth was just beginning to make a reputation as a painter, Vertue wrote as follows:

Mr William Hogarth first learnt to grave arms on Silver plate etc., from thence study'd in the Academy of St Martins lane some time having a quick lively genius made several Charicatures, prints etch'd afterwards the designs and plates of Hudibras but finding it more agreeable to his mind took up the pincill & applyd his studyes to painting in small conversations or fancyes, wherein he now has much reputation & lately married to ye daughter of Sr James Thornhill without his consent.[14]

This would seem to suggest that the reputation for 'small conversations or fancyes' was already established by the time the marriage took place; but *The Craftsman*, reporting the wedding in early April, still referred to Hogarth as 'an ingenious Designer and Engraver'.[15] Hogarth had been a friend of the Thornhill family for some time, frequenting Sir James' house in Covent Garden and going on drinking bouts with John Thornhill, his future brother-in-law. The fact that he was only an engraver does not seem to have impeded the friendship, though it is of course possible that Sir James expected more from his daughter's future husband than from his son's drinking companion. He may even have helped Hogarth's career as a painter during 1728 and the beginning of 1729 in order to turn him into a suitable son-in-law. Nichols, who placed the wedding in 1730 and spoke of Jane as a mere girl, thought in terms of some kind of romantic elopement: 'This union, indeed, was a stolen one, and consequently without the approbation of Sir James, who, considering the youth of his daughter, then barely eighteen, and the slender finances of her husband, as yet an obscure artist, was not easily reconciled to the match.'[16] Yet there is nothing to suggest that Hogarth asked for Jane's hand in marriage and was refused it: merely that an apparently happy relationship with the Thornhill family was suddenly interrupted at the time of – but not necessarily because of – the wedding at Paddington church.

At first sight it would seem that a possible reason for the interruption is revealed in the pictures Hogarth did of the Gaols Committee. On the preliminary oil sketch the words 'Huggins the keeper' are written underneath the person being examined, while in the finished picture – or, rather, in the copy of it which is all that we now have left

– a different figure has been substituted, a figure which was accepted as a likeness of Bambridge. Some years later Hogarth painted a portrait of Huggins, a portrait which bears a closer resemblance to the face of the man under examination in the preliminary sketch than that face itself bears to the picture of Bambridge. The sketch itself was never put on the market: Hogarth kept it by him until long after both Thornhill and Huggins were dead and in the end he gave it away – something which was relatively unusual in a man known all over London for his sharpness in business and his determination to get high prices for his work. The recipient was Horace Walpole, who later published an enthusiastic account of it – and especially of the 'Huggins the keeper' figure – in his *Anecdotes of Painting in England*: 'On the other hand is the inhuman gaoler. It is the very figure that Salvator Rosa would have drawn for Iago in the moment of detection. Villainy, fear and conscience are mixed in yellow and livid on his countenance ... If this was a portrait it is the most striking that ever was drawn: if it is not, it is still finer.'[17] Subsequent editors of Walpole's work told their readers confidently that the figure referred to was Bambridge: they took their information from Nichols, who was probably working from the picture and not from the sketch. Modern writers on Hogarth have followed Nichols's lead, ignoring the writing on the sketch and refusing even to consider the possibility that Hogarth offended Thornhill by sketching the examination of Huggins rather than that of Bambridge. Ronald Paulson sees the marriage and the sketching of the Gaols Committee (which he calls, significantly enough, the Bambridge Committee) as working together to mould Hogarth's future, rather than jarring against one another: 'in one coup he would acquire a new father and exorcise his memories of the Fleet and the darker days of his youth'.[18] But the hard fact is that the new father was closely associated – and continued to be closely associated – with the things that needed to be exorcised.

Closer examination of the preliminary sketch reveals certain difficulties. According to Nichols, John Huggins was already into his seventies by the time the Gaols Committee caught up with him, whereas the figure drawn by Hogarth is of a younger man. On the

other hand the portrait of Huggins, which was almost certainly done more than a decade later, does not look like a man nearing ninety. If Nichols was right then either Hogarth was unusually flattering or Huggins was remarkably well preserved for his age. Then again, there is no evidence that the writing on the sketch is by anyone particularly well-informed; but, whoever he was, he certainly pointed to a puzzle that cannot be ignored.[19] The connection between Hogarth's marriage and his emergence as a portrait painter may have been stormier and more complex than he cared to remember. Certainly the changes which he made when he came to turn his sketch into a picture look as though they were intended to placate Thornhill as well as attract potential patrons. The identity of the prisoner was changed along with that of the person under examination: he became a swarthy and foreign-looking figure, as though he was intended to represent Jacob Mendes Sola, a Portuguese who had been one of Bambridge's favourite victims. The dramatic confrontation between accuser and accused was abandoned altogether. Instead, the prisoner was turned in the opposite direction and made to kneel at the feet of a member of the Committee, thus allowing an uninterrupted row of heads to run right across the picture. The heads themselves were quite clearly intended to be interchangeable, supreme examples of that phizmongering art which Hogarth was later to condemn. It was a large Committee – there were nearly a hundred members of the House of Commons, as well as a sizable delegation from the Lords – and Hogarth obviously hoped that many of its members would pay good money for a version of the painting with their own faces and those of their friends inserted in the large number of oval spaces he had provided.

At the same time he transferred the scene of the Committee's proceedings from a light and airy room to a dungeon-like chamber which seemed to be deep in the bowels of the prison itself. Even if he had not in fact received permission to visit the prison in company with the Committee he was going to make it look as though he had. As to sales prospects, he had powerful support: what did it matter if Sir James Thornhill had turned his back on him if he could count Sir Robert Walpole himself among his patrons? The first commission that can

definitely be linked with the Gaols Committee came in November 1729 from Sir Archibald Grant, who ordered copies of both the *Gaols Committee* itself and the *Beggar's Opera* picture.[20] Sir Archibald was not only a prominent member of the Committee but also a trustee of the Charitable Corporation for the Relief of the Industrious Poor, an institution whose funds he shamelessly embezzled until he was finally found out and expelled from the House of Commons. He was never able to take delivery of his pictures, but before their disgrace he and his fellow swindler John Thomson did much to publicise Hogarth's work among their rather raffish but nevertheless quite influential friends.

Meanwhile the Gaols Committee had served to introduce Hogarth to other and more stable patrons. Its members included Lord Paulet, whose elder brother the Duke of Bolton had already figured in the *Beggar's Opera* paintings, as well as representatives of other aristocratic families which were later to provide patronage. Particularly important was the future Earl of Cholmondeley, who at this time sat in the Commons as Viscount Malpas and was a member of the Committee. He and his wife – who was a daughter of Sir Robert Walpole – were painted by Hogarth in 1731–2, together with their childern and a brother of the Viscount. It was a sad little picture, for by the time it was completed the Viscountess was dead and had to have heavenly cherubs inserted above her head in order to show that her portrait was posthumous.

For Hogarth, however, the Cholmondeley patronage was anything but sad since it brought him in touch with the royal family itself. As a leading member of the Household of Frederick, George II's elder son and the new Prince of Wales, Malpas was well placed to secure for his protégé the highest prizes of all. Another member of the Committee, John Conduitt, was in a position to offer equally promising patronage. Although his office was only the comparatively humble one of Master of the Mint his children moved in very exalted circles and in 1732 they performed a play before the Duke of Cumberland, George II's younger son, and his sisters. Hogarth was commissioned to produce a painting of the occasion and as a result of it he subsequently did a portrait of

the Duke of Cumberland on his own. Cumberland was a boy of eleven at the time and the newspapers never tired of commenting on his well-judged mixture of boyish charm and princely attainments. Early in May 1732 'a man dwarf brought from Denmark, not quite three feet high, was presented to their Majesties: he stood under the Duke of Cumberland's arm, which mightily pleased his Highness'. Then, a few days later, 'the Duke of Cumberland's young Company of Grenadiers performed an exercise at arms in the royal garden at St James's'.[21] Hogarth's picture captured both sides of the boy's character, just as *The House of Cards* and *A Children's Party*, both painted some months earlier, managed to convey a genuine sense of the transience and exuberance of childhood. Lady Hesketh, daughter of Hogarth's friend and patron Ashley Cowper, said many years later that her father believed that Hogarth 'had an aversion to the whole infantine race, as he always contrived to make them hideous – and indeed though many children are introduced among his various groups I do not remember ever to have seen a pretty one'.[22] The children in the early paintings certainly seem slightly forbidding, solemn miniature adults rather than the sentimentalised darlings who later became fashionable among both painters and poets; but they had a sturdy reality about them which looked ahead to the superb child portraits of Hogarth's mature years. And whatever Ashley Cowper may have thought, it was Hogarth's ability to paint children in a manner acceptable to the 1730s that helped to bring him to the notice of the King and Queen themselves. Towards the end of 1732 he was invited to prepare sketches for a conversation piece of the royal family itself.

By this time the network of influential and aristocratic patronage stemming from the Gaols Committee picture stretched right the way down from the members of the King's court to Hogarth's own friends and neighbours. The Duke of Cumberland's tutor, Sir Andrew Fountaine, a well-known collector of pictures as well as a promoter of the work of the Gaols Committee, ordered a picture of himself and his family looking at a painting presented to him by his son-in-law Christopher Cock, the auctioneer who had commissioned a picture from Hogarth back in 1728 (see plate 10a). The pressure of work was

overwhelming: 'Mr Hogarth's paintings gain every day so many admirers,' wrote George Vertue, 'that happy are they that can get a picture of his painting.'[23] The man who had stumbled so badly on the threshold of the history painters' world in the spring of 1728 had now made for himself, within a remarkably short time, an alternative and brilliantly successful world. Even Vertue himself, usually somewhat niggardly in his praise of other artists, had to admit that Hogarth's work was exceptionally good as well as exceptionally fashionable. He reported that as well as the Gaols Committee picture the artist had produced 'many other family pieces & conversations, consisting of many figures done with great spirit, a lively invention & an universal agreableness'. By the beginning of 1730 he was speaking of Hogarth as 'a Master'; and the picture of the Wollaston family (see plate 10b), done later that year, seemed to him 'really a most excellent work, containing the true likeness of the persons, shape, air and dress – well disposed, genteel, agreable – and freely painted and the composition great variety and Nature'.[24]

And then, almost as suddenly as it had begun, it all fell to pieces. In November 1733 the newspapers carried announcements to the effect that the chapel and gallery in St James's Palace had been closed to the public because of 'the great number of people who come there daily and hinder the workmen from their business'; and among the great numbers thus excluded was William Hogarth. According to Vertue, Hogarth had 'made application to some lady about the Queen that he might have leave to make a draught of the ceremony' – the ceremony in question being the forthcoming marriage of George II's eldest daughter to the Prince of Orange, the cause of all the workmen's preparations and of all the public interest which hampered them.[25] The man in charge of the preparations was Hogarth's old enemy William Kent, the man whom he had satirised in *Masquerades and Operas* and on several subsequent occasions. Kent's influence over the Queen proved to be more powerful than that of Hogarth, who lost not only his permission to sketch the royal wedding but also his commission to paint the royal family: 'this also has been stopt,' reported Vertue, 'so that he can't proceed'. Aristocratic patronage dried up

almost as suddenly as royal patronage. Within a matter of months the ingenious Mr Hogarth found himself reduced once again to painting portraits of friends and neighbours. For the rest of his life his portrait painting hovered precariously on the edge of respectability: those of his sitters who were well-born were seldom fashionable and those who were fashionable were seldom well-born. 'These are sad mortifications to an Ingenious Man,' concluded Vertue, not without a trace of gloating satisfaction.[26]

Among courtly patrons only the Prince of Wales preserved some condescending semblance of fidelity. He was by this time falling into the standard Hanoverian pattern of filial rebellion, so that he was glad to favour those whom his father and mother had been seen to reject. But even his patronage was no longer on a particularly munificent scale. A few months after Hogarth's ejection from the Chapel Royal, the Prince and his Master of Horse, the Earl of Cholmondeley, took delivery of a painting of themselves and four companions out hunting. It cost £246 15s.: £157 10s. to John Wootton for the figures and the background, £57 15s. to the framer and £31 10s. 'to Mr Hogarth for painting six faces in the picture at five guineas each face'.[27] The man who had invented a triumphant new art form to confound the phiz-mongers was now reduced to phizmongering himself.

In the *Autobiographical Notes* the end of the years of triumph was passed over almost as quickly and cryptically as their beginning. Hogarth would not admit that the fashionable customers for his con-versation pieces had left him: on the contrary, he had left them. 'I therefore recommend those who come to me for them to other pain-ters,' he wrote, falling into the historic present, that most unmanage-able of tenses, 'and turn my thoughts to still a more new way of pro-ceeding.'[28] Indeed, the whole story of this dazzling phase of his career was compressed into a few lines, squeezed in between an explanation of what he had done before and a justification of what he was to do later. One of the saddest paradoxes of Hogarth's life was the fact that the period of his greatest success was precisely the period which he later recalled with the least enthusiasm and upon which he seems to have put the least value. Looking back it seemed to him that it had been

little better than an aberration, something that had interrupted the broad flow of his ambition as it moved on majestically from the youthful dreams of history painting to the mature achievement of 'painting and engraving modern moral subjects'. He had gone into it for mercenary reasons, to provide for his family once he accepted the responsibilities of a married man, and he had abandoned it for reasons equally practical and down-to-earth: 'that manner of painting was not sufficiently paid to do everything my family required'.[29] But in fact neither the requirements of his family nor the reasons for his change of course were quite what they seemed.

CHAPTER VI
Everything my family required

Marriage provides a man with a multiplicity of excuses. In a dynastic age it can turn greed into altruism, ruthlessness into fair dealing: what is inexcusable in the individual becomes justifiable and even laudable if it is undertaken on behalf of future generations. In a sentimental age it can justify lethargy and timidity: retreat into the cosiness of the domestic circle becomes the ultimate victory instead of the ultimate surrender. Hogarth, though he lived in an intensely dynastic age, had no children to vindicate his single-minded pursuit of riches. 'Mr Hogarth is often projecting schemes to promote his business in some extraordinary manner,'[1] wrote George Vertue tartly; and the exasperation of the art world at the allegedly sharp practices of Hogarth the businessman remained undiluted by any sympathy for the responsibilities of Hogarth the father. As far as domesticity was concerned he was very much a man of his time: like most men of fashion or ambition in eighteenth-century London he spent the greater part of his leisure away from home, forwarding his career and advertising his talents in the taverns and clubs in which artists and their patrons gathered. There is no reason to think that his marriage was unhappy or unfulfilled; but it certainly did not produce exceptional paternal burdens or exceptional domestic ties. And yet he saddled it with responsibility for the most important decision of his career, the decision which led him away from the brilliant successes of his conversation pieces towards an entirely new and unprecedented kind of art. It seemed to him, in retrospect at least, that he had taken this momentous step simply in order to be sure of doing 'everything my family required'.

To some extent he was merely pouring into the mould of family life a concern for appearances, a determination to assert his rightful place in the social hierarchy, which he had always possessed even as a bachelor. Many of the anecdotes which Nichols collected about Hogarth's early life reflected this concern. One informant recalled the painter saying, in later life: 'I remember the time when I have gone moping into the city with scarce a shilling in my pocket; but as soon as I had received ten guineas there for a plate I have returned home, put on my sword and sallied out again, with all the confidence of a man who had ten thousand pounds in his pocket.'[2] There were plenty of men in eighteenth-century London who had considerably more than ten thousand pounds but who would still have hesitated before appearing in public wearing a sword, which was essentially the mark of gentle birth rather than acquired riches; but Hogarth apparently delighted in wearing one to boost his confidence and to enhance his own rather dashing and swashbuckling image of himself. Other stories told of him wearing his hat at a rakish angle in order to display the scar down his forehead which he later made much of in his self-portraits. He was not particularly tall – Vertue included him in a list of prominent artists who were all 'five foot men or less', short even by eighteenth-century standards[3] – and this may have accentuated his desire to cut a figure as a devil-may-care gentleman rather than a mere plodding practitioner of the arts. And when in later life he determined to provide his family with a properly decorated carriage, a properly fashionable address and all the other signs of worldly success, he was obeying instincts he had always had rather than requirements that had come only with marriage.

In any case the phrase he used had a variety of possible meanings. Since he and Jane never had any children, the household they established was entirely adult and very soon became as much a business enterprise as a domestic unit, especially after his sister Anne joined it in 1742 to help with the management of his affairs. This little group of adults growing old together had requirements very different from those of a family with children to provide for. Their concerns were linked with the past as much as the future, with the families from which they

had come as well as with the one which they themselves formed. When Hogarth established himself in Leicester Fields in 1733 his mother and sisters followed him, Anne and Mary moving their drapery business from its previous home in the City of London to a shop in Cranborne Alley, close to Hogarth's own original place of work back in 1724. Their mother was there with them in 1735 when a disastrous fire broke out and she was killed. Hogarth himself seems to have been deeply affected by this tragedy; and his portrait of his mother, done in the last few months of her life, was inscribed 'his best friend'. When Jane welcomed her sister-in-law Anne into her home in 1742, after the death of Mary and the closing down of the drapery business, she was only giving permanency and proximity to influences which had shaped her husband's life intermittently for many years past. No man with a widowed mother and two unmarried sisters could be a stranger to the requirements of a family, whether he was himself married or not.

Then there was Jane's family, whose requirements were directly related to the shaping of Hogarth's art and not just to the accumulation of money by means of it. After a couple of years in lodgings or in the houses of their friends – Ronald Paulson suggests that the 'Broad Cloth Warehouse in the Little Piazza, Covent Garden', where the two seem to have been living in December 1730, was the home of Hogarth's friend William Tothall[4] – they moved into Sir James Thornhill's splendid house on the other side of Covent Garden, in the Great Piazza. It was a fashionable address, especially for an artist: 'inhabited by Painters – a Credit to live there', wrote Vertue of the Great Piazza.[5] Sir James had once established a free academy for artists in an extension specially built at the back of his house; and the memory of this institution, now more or less defunct, still gave a certain aura to the building. Hogarth was moving into a home which had once been an important artistic centre and which would be so again if the Thornhill family had their way. Sir James himself had lost his old supremacy in the world of history painting and was forced to watch younger rivals with more influential patrons getting the commissions he thought he should have had; but his son John was determined to restore the family reputation – if only to ensure that he inherited his father's lucrative

sinecure as Sergeant Painter – and for this purpose he had need of his newly acquired brother-in-law. The years spent in Thornhill's house, from 1731 to 1733, brought new kinds of involvement as well as an enhanced status. Hogarth helped Sir James with projects intended to win back the good graces of his old patrons, while at the same time both men plunged into the internecine squabbles, the fierce rivalries between one artists' club and another, upon which the fortunes of history painters were thought to depend. The requirements of this family went far beyond the mere provision of worldly goods.

George Vertue, looking down on these efforts from his own supposedly Olympian heights, considered that the connection with Thornhill was doing Hogarth more harm than good. He himself belonged to the Club of St Luke, reputedly founded by the great Van Dyck in the previous century and now regarded by its members as 'the tip top Club of all, for men of the highest character in Arts and Gentlemen Lovers of Art'.[6] Thornhill had other connections, particularly with freemasonry, which were rather less reputable in the eyes of men determined to cling to the existing political and social establishment at all costs. The cautious Vertue considered that 'Sir James Thornhill, whose daughter is married to Mr Hogarth, is blended with interest & spirit of opposition'[7] and that this blend was part of the reason for Hogarth's fall from favour at court. Whether or not freemasonry could still be regarded as a hotbed of opposition politics, there were certainly masonic lodges which emerged as rivals to the Club of St Luke in the politics of the art world. Thomas Slaughter, a prominent freemason who chose Hogarth as his successor when he retired as a steward of his lodge, ran a coffee house in St Martin's Lane whose habitués were the open adversaries of the Club of St Luke on almost every issue. When they were not attending masonic dinners and other scheduled functions they were holding unscheduled meetings in order to drink confusion to the Club of St Luke and dream up new clubs and circles of one kind or another in order to oppose it more effectively. Hogarth and his friends were among the most enthusiastic promoters of these endless evenings of conviviality and conspiracy. It was typical of the social life of eighteenth-century London that his involvement with the Thornhill

family should lead him constantly to neglect the one member of it to whom he was married.

Some twenty years earlier James Puckle had published a book called *The Club*, in which a disillusioned son discussed with his sceptical and world-weary father the characters whom he had met at a club. The work proved immensely popular, going through edition after edition throughout the eighteenth century and gaining recognition as an abbreviated glossary of clubmen and their sins. The stock figures described were squeezed into a rather artificial alphabetical mould, starting with Antiquary, Buffoon and Critic and ending with Xantippe, Youth and Zany; but among them they displayed most of the absurdities and knaveries of which human nature – or at any rate male human nature – was capable. Hogarth was to make these failings the principal subject of his art: indeed, Puckle's book in due course became almost as much a commentary on the world of Hogarth's prints as on the world of the London clubs which it originally set out to satirise. Much of the conversation at Slaughter's Coffee House, and at the clubs and taverns and masonic lodges associated with it, must have been about the need to revive the glories of traditional English history painting and combat the fashionable foreigners who were eclipsing its greatest practitioner, Sir James Thornhill; but what in the end came out of all the discussion was the creation by Thornhill's son-in-law of a new kind of history painting altogether. The figures and groupings he had seen in the London streets earlier in life had never quite conquered the allegorical personages whom he took from the pattern books: his prints, however much they portrayed the real world, had still been emblematical prints in the old tradition. But now, in the more exuberant and yet more intimate world of the artists' clubs, the welding of reality and symbol began to take place at a more subtle and successful level. The verbal stock figures provided by Puckle and his many imitators were to provide an important complement to the visual images of the emblem-writers.[8]

The earliest products of this plunge into conviviality were, naturally enough, pictures done for Hogarth's own friends and drinking companions. Christopher Cock, the auctioneer, was said to be among those

represented in *A Club of Gentlemen*, painted in 1730 or 1731, and also in a much less restrained painting of a drunken orgy done at about the same time and published later as an engraving with the title *A Midnight Modern Conversation* (see plate 11). Within a very short time Hogarth gained a reputation as a painter of indecent and bacchanalian pictures suitable for men's clubs rather than ladies' drawing-rooms. Sir Archibald Grant's shady friend John Thomson apparently ordered 'two little pictures called Before and After' as early as December 1730,[9] though he fled to France with his pockets full of embezzled money before he had a chance to collect them. These paintings, discreetly ignored by Victorian writers on Hogarth, are far too delicate and charming to be called pornographic; but their representation of the physical aspects of sexual anticipation and satisfaction was clearly intended to titillate. The Duke of Montagu also ordered 'two little pictures' around this time and it seems probable that these were the other versions of *Before and After*, in which Hogarth moved the scene indoors and told his story by means of allusion and symbolism instead of straightforward description. Even in this humdrum task of painting erotic pictures to please lubricious patrons, Hogarth's natural tendency was to move from straightforward representation to a more complex allegorical form, from pictures that were merely looked at to pictures that needed to be read.

This tendency was made even more explicit when the etched and engraved version of *A Midnight Modern Conversation* was published in March 1733. The picture itself had been altered very little, except for changes in some of the faces apparently intended to make them anonymous; but the caption underneath it summed up succinctly the direction in which Hogarth's work was moving:

> *Think not to find one* meant Resemblance *there*
> *We lash the* Vices *but the* Persons *spare*
> Prints *should be* prizd *as* Authors *should be* read
> *Who sharply smile prevailing Folly dead.*

The printmaker turned painter had returned to his old vocation of satirist, but with some significant differences. In his earlier prints he

had been hard put to it to produce recognisable likenesses: John Heidegger had been an easy subject, since his notoriously ugly features could hardly be mistaken, but most of the other characters in the etchings and engravings of the 1720s had had to be identified by their costumes, by something they were saying, or by the context in which they were placed. Now, with several years of successful portrait painting behind him, Hogarth's problem was not to display the identity of his subjects but to conceal it. He had always said that his conversation pieces 'gave more scope to fancy than the common portrait'[10]; and now it took his fancy to use a particular sort of conversation piece in order to produce a modern allegory with a moral lesson attached to it. Like Puckle, he was concerned not to lampoon individuals but to categorise and satirise the vices which they exemplified. The spectator must read the print as attentively as he would read a moral tract or a book of characters like Puckle's. Not content with conquering the two very different worlds of pictorial satire and fashionable portraiture, the ingenious Mr Hogarth was feeling his way towards a new art form which would transcend them both and give him the authority of a writer as well as the visual appeal of an artist.

The caption did not of course mean what it said. Indeed, its ingenuity was such as to make it totally disingenuous. Like a teller of ghost stories who warns his hearers not to listen in case they are too frightened, Hogarth's intention was to provoke curiosity and not to quench it. The traditional trick of the satirist, one which Hogarth himself occasionally employed, was to place letters or figures against the people in his print and then provide a key in which they were identified either openly or in a disguised fashion; but Hogarth had already learnt that it was far more subtle – and far more profitable – to give people the pleasure of working out the identification for themselves from a mixture of visual and occasionally verbal clues – likenesses or partial likenesses, well-known gestures or habits, pieces of paper with quotations or allusions written on them, even paintings on the walls which revealed and identified their owners. As soon as *A Midnight Modern Conversation* was published the game of identifying the people in it became sufficiently fashionable to ensure that sales of

the print soared. Like Puckle before him, Hogarth had managed to titillate curiosity about particular clubmen by pretending to turn them into anonymous generalisations.[11] His friends and drinking companions had emerged relatively unscathed, but the world in which they moved had been profitably exploited by means of the showman's oldest trick – downright ribaldry masquerading as moral disapproval.

There were other sins more notorious and more serious than drunkenness that could be exploited equally effectively and with less need for pretended concealment. Back in 1724 Sir James Thornhill had gone to Newgate prison to draw Jack Sheppard, the robber whose astonishing escapes had inspired the Drury Lane pantomime and Hogarth's satire on it; and now, in March 1733, there was another prisoner there who could be relied upon to arouse just as much public interest. Her name was Sarah Malcolm and she had been found guilty of a particularly brutal triple murder. This time it was Hogarth who did the sketching, though Sir James apparently went with him. 'On Monday last the ingenious Mr Hogarth made her a Visit,' reported the *Daily Advertiser*, 'and took down with his Pencil a very exact Likeness of her, that the Features of so remarkable a Woman may not be unknown to those who could not see her while alive.'[12] Five days later, on the Saturday, prints of Sarah Malcolm were on sale at sixpence each, 'engraved by Mr Hogarth from a picture painted by him two days before her execution'. Since she had been hanged on the Wednesday, this presumably meant that the preliminary drawing had been worked up into a painting as soon as Hogarth got back from the prison and that an engraved copy had then been made of it before the paint was even dry. It is of course extremely unlikely that things were in fact done in this order: the painting, which is now in the National Gallery of Scotland in Edinburgh, is more than a mere reversal of the engraving and it does not look as though it was painted at one single sitting. But the fiction contained in Hogarth's advertisement, the insistence that he was still a respectable portrait painter who deigned to provide the general public with engraved copies of his pictures after he had painted them, was of great importance to him and also to his father-in-law. Thornhill was still hoping to make his come-back as a

great history painter, while Hogarth himself was still high in favour at court. Neither of them wanted it to be thought that the needs of their families were such that they had to set up in business as mere print-sellers.

Yet this was precisely what was happening. Hogarth had discovered many months earlier, perhaps almost as soon as he came to live in Thornhill's house, that his particular method of painting conversation pieces could be adapted in order to get money from people other than the sitters themselves. *The Christening* and *The Denunciation*, two small paintings he had done back in 1729, had aroused much interest because the people represented in them were in the public eye: the first picture showed a child being christened by Orator Henley, the renegade preacher who had set up his own chapel on a commercial basis, while the second was of the famous Bow Street magistrate Sir Thomas de Veil hearing a case in which a pregnant woman accused an old man of being the father of her child. 'A small piece of several figures representing a Christening being lately sold at a public sale for a good price got him much reputation,' wrote Vertue.[13] Some years later both pictures were engraved for Hogarth by Joseph Sympson the younger and profitably sold.

This procedure, the disposal of the painting itself at a public sale and the subsequent marketing of prints taken from it, was an obvious way of increasing the profitability of a certain sort of picture. But what sort? Private patrons who allowed Hogarth into their houses in order to produce acceptable paintings of themselves to hang on their walls would hardly expect to have the results carted off to auction sales and then engraved for the delectation of the general public. Sarah Malcolm was in no position to defend herself from this kind of exploitation, but richer and more respectable sitters would certainly do so. If they refused to pay for the paintings they had commissioned they could of course be threatened with this kind of public exposure in order to get the money out of them. Hogarth is said to have used these tactics against one nobleman who refused either to collect his portrait or to pay for it: 'If therefore his Lordship does not send for it in three days, it will be disposed of, with the addition of a tail and some other little

appendages, to Mr Hare, the famous Wild-Beast man; Mr H having given that Gentleman a conditional promise of it for an Exhibition-Picture, on his Lordship's refusal.'[14] This particular threat apparently worked: the patron paid for his picture and then burnt it because it revealed his own ugliness. But this kind of thing could not be allowed to grow into a habit. Men of power and influence would not put up with a painter who first refused to flatter them and then tried to make profit in public from the insolence he had shown in private.

Thus the pictures destined for public sale or exhibition and for subsequent reproduction as engravings could not be expected to come from the fashionable world of private patronage. On the other hand they would not be very profitable if they were completely divorced from that world and portrayed none of its inhabitants. 'Mr Hare, the famous Wild-Beast man' would have had little interest in putting on exhibition a picture of some anonymous model, however intriguing its 'little appendages' might have been; and his reluctance might well have been shared by the promoters and frequenters of public sales, as well as by the vendors and purchasers of public prints. If Hogarth wanted to 'deal with the public in general' and take 'small sums from many', as he later averred in the *Autobiographical Notes*,[15] he would have to offer prominent characters as well as prurient plots. The scenes of revelry and debauchery which were so popular in the private world of his friends and drinking companions would have to be populated with recognisable figures from the wider world into which his business as a portrait painter took him.

His first successful rendering of this combination was based upon the figure he had adapted from the emblem-writers, the figure of Carnal Pleasure with her whip transmuted into a common prostitute with her birch rod. Some years before he had done a drawing of a particularly sad and broken down harlot, old before her time and surveying the inevitable accompaniments of her profession: dirty contraceptives waiting to be washed out for future use, medicines from the quack doctor, bandages for a venereal sore, a comb with broken teeth, articles of men's clothing strewn about the floor. Her servant or 'bunter', a heavy old woman with a wooden leg, seemed utterly

9a (Above) *A Prisoner of the Fleet being examined,* sketch, by Hogarth, 1729

9b (Below) *The Fleet Prison Committee,* painting, 1729, studio of Hogarth

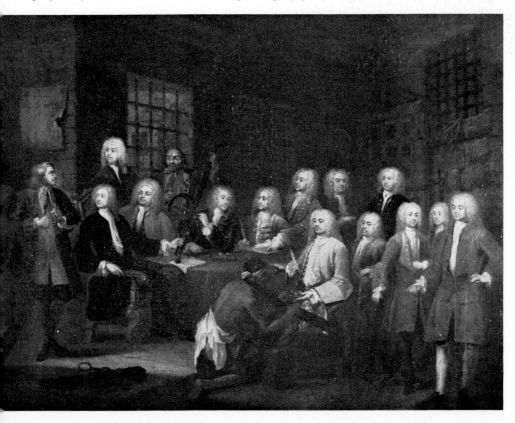

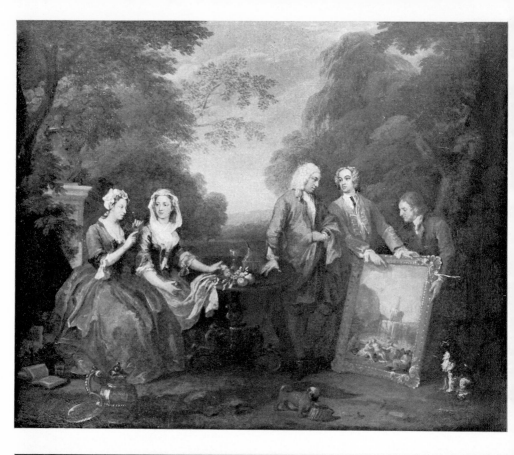

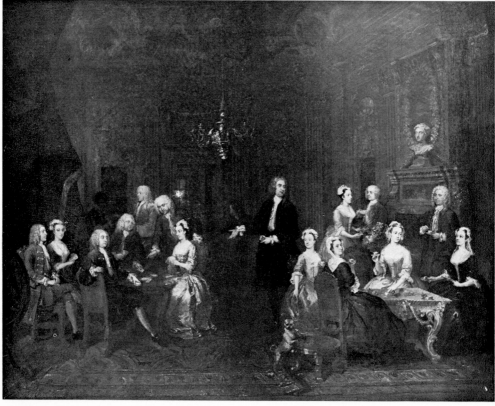

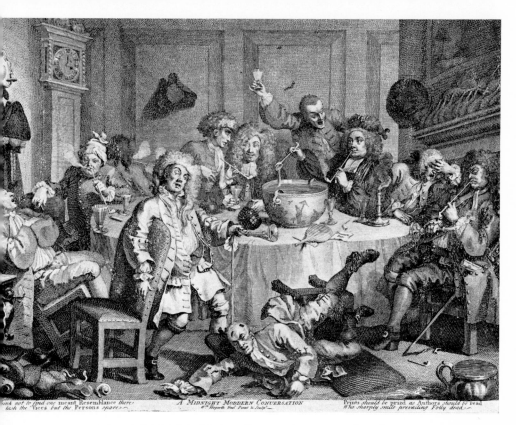

11 (Above) *A Midnight Modern Conversation,* engraved version,
by Hogarth, first state, 1733

PLATES OPPOSITE
10a (Above) *The Fountaine Family,* c. 1730, by Hogarth

10b (Below) *The Wollaston Family* by Hogarth, 1730

ABOVE 12a (Top) *Garret Scene*, sketch, by Hogarth, 1730?; 12b (Bottom) *The Harlot's Progress*, plate 3, by Hogarth, 1730

OPPOSITE 13a (Top) *The Beggar's Opera*, version 6, 1729–31, by Hogarth; 13b (Bottom) *Lord Hervey and his Friends*, by Hogarth, 1738?

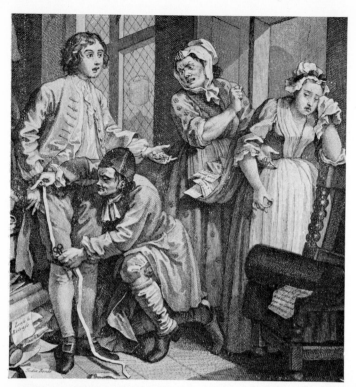

14a (Left) *The Rake's Progress,*
plate 1 (detail), by Hogarth,
1735

14b (Below) *The Rake's Progres*
plate 2 (detail), by Hogarth,
1735

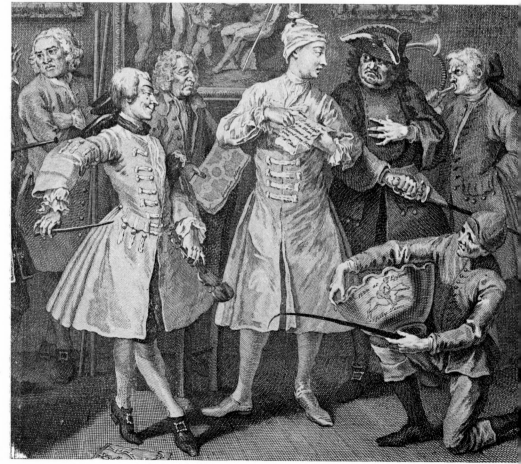

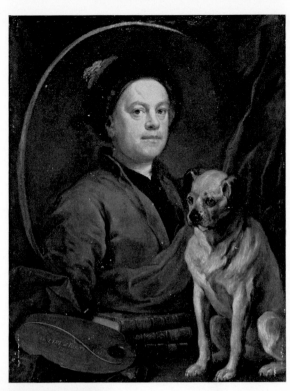

The Painter and his Pug, self portrait
[pain]ting, 1745, by Hogarth

15b *The Painter and his Pug,*
engraving, 1749

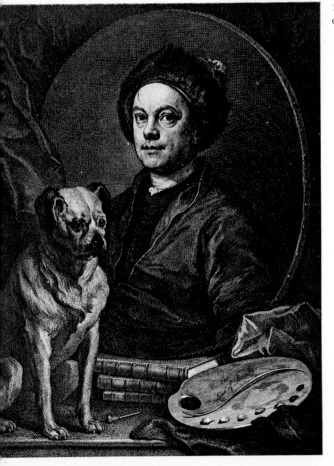

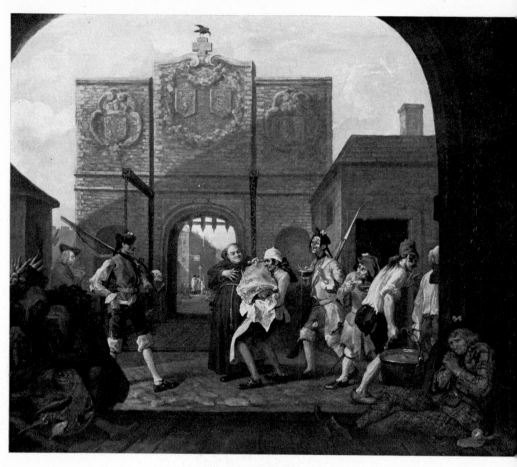

16 *O the Roast Beef of Old England (Calais Gate)*, 1748, by Hogarth

incapable of making any inroads into the prevailing squalor (see plate 12a). Soon after moving into the Thornhill house Hogarth started to work up this drawing into a painting. Vertue's account makes it clear that even at the outset the conception was now much less sordid: 'he began a small picture of a common harlot, supposed to dwell in drewry lane, just rising about noon out of bed and at breakfast. A bunter waiting on her – this whore's deshabille careless and a pretty countenance and air'[16] (see plate 12b). Nobody could have suggested that the whore in the drawing had 'a pretty countenance and air'. The girl in the painting was altogether happier in her circumstances: her bunter was no longer maimed, her room was comparatively clean and tidy and her belongings were properly looked after. Even the birch rod had been gathered up from the floor and hung neatly on the wall over the bed. These changes were not intended to glamorise or sentimentalise the harlot's trade, but they were intended to show that Hogarth was engaged on an undertaking every bit as lofty as the history painting of his father-in-law. This was his 'new way of proceeding, viz. painting and engraving modern moral subjects, a field unbroke up in any country or any age'.[17]

Modern moralising on the subject of prostitution was softening a little: a doctor who wrote to the *Universal Spectator* in January 1731 declared that 'a Woman of the Town is the most unfortunate and pitiful object' and that it was usually a man who was 'the infamous author of the misery of these wretches'. 'He who debauches a Maiden and then exposes her to want and shame is arrived to such a monstrous height of villainy that no word in our language can reach it,' concluded the indignant physician.[18] Hogarth made his harlot an unfortunate and pitiful object and he made her corruptors, both male and female, recognisable as well as villainous; but at the same time he kept a subtle balance between reality and allegory and he also took care to echo accepted classical themes in the actual composition of his paintings. Those who came to see his work must be persuaded that it maintained to the full the dignity of the house in which it was being executed.

His visitors, 'persons of fashion and artists' according to Vertue, lived up to all his expectations. When they saw his original picture they

encouraged him to do a companion piece; and when he produced not just two paintings but a series of six they were delighted with his 'fruitful invention'. Best of all, they provided the encouragement and the means to have the paintings engraved without his having to go to a printseller. Even Vertue himself, who was later to become sharply critical of Hogarth's shameless touting for custom, had to admit that on this occasion 'he did all this without courting or soliciting subscriptions, all coming to his dwelling in Covent Garden – where he lived with his father-in-law Sir James Thornhill – & it's probable he might have had more'.[19] Those who came to look at the paintings, which were now collectively entitled *A Harlot's Progress*, could pay half a guinea and be given a receipt which entitled them to collect the full set of six engravings in return for a further half-guinea. The receipt itself was surmounted by a design which was elaborately allegorical: while a goat-legged figure of infantile sexuality lifted Nature's skirts in order to peer at her private parts, other and purer children restrained him and put down her beauties on canvas instead. Hogarth too would transform prurient curiosity into moral instruction by the power of his own special blend of allegory and reality. The Latin tag on the receipt was a quotation from Horace hinting at the allowances which must be made if this entirely new art form was to be understood; and even the curiously well-endowed figure of Nature herself had its part to play in this artistic declaration of intent. It was taken from a painting by Rubens, which Thornhill then owned and which thus symbolised the line of descent Hogarth was claiming, via his father-in-law, from the classical schools of history painting.

When this discreet and gentlemanly subscription scheme was first launched, probably in the spring or early summer of 1731, things looked very promising: subscriptions were coming in fast enough to ensure a good return on the engravings – Vertue understood that there were nearly 1,500 names down within a year, which at a guinea a time meant at least as much as the paintings themselves would have commanded if they had been commissioned in the usual way. By acting as his own publisher Hogarth was cutting out the need to pay a slice of his profits to the printsellers and he was also preventing these same middlemen from swindling him in the way they had done in 1724,

when he had first brought out *Masquerades and Operas*. On that occasion, as he later recounted bitterly in the *Autobiographical Notes*, the printsellers connived at the piracy of his print, so that unauthorised copies came on sale at half the price, and then told him that he would have to take his own copies back as unsaleable unless he let them bring the price down to match that of the pirated ones. This time he had ensured his profits in advance, while at the same time leaving himself free to authorise cheap copies if it suited him to do so and if the return on them was good enough. And all this had been done without stooping to public advertisement or any of the other commerical devices in which the booksellers would have involved him: he had kept for future use not only the paintings themselves but also his dignity and reputation as a painter.

By the beginning of 1732, however, he was beginning to run into difficulties. He could not find engravers to copy the paintings to his satisfaction and so he had to engrave them himself – the first step in the dangerous road downwards from gentlemanly painter to commercial purveyor of engravings. The next step followed on naturally from the first: subscribers had to be informed of the change of plan, and the inevitable resulting delay, by means of notices in the newspapers. These were at first very dignified, communications from one gentleman to another rather than business advertisements, but they were sufficient to destroy the atmosphere of gentlemanly amateurism which had hitherto surrounded the engraving venture. Then came the undignified business of fighting off the pirates. Advance payment had guarded the subscription profits from the dangers of piracy, but these dangers still had to be faced if Hogarth was to seek further profits by authorising printsellers to issue copies of his work. In April 1732, hardly a week after the prints had finally been delivered to the subscribers, Giles King of Drury Lane was advertising copies engraved by permission of the artist. These were promptly countered by unauthorised pirate copies, some of them artistically superior to the rather coarse prints produced by King. Hogarth had kept his paintings for himself; he had even kept the original engravings within the charmed circle of an allegedly private subscription; but if he wanted to go further and 'secure my Property to myself' – that is, insist on his right to a profit

from any sale of his work by whomsoever made – he would have to abandon the pretence of gentlemanly amateurism and enter the world of commerce in his own right.

In 1733 he did so. It is for this reason that *A Midnight Modern Conversation* and *Sarah Malcolm*, both on sale during the first few months of that year, mark the real turning point in his career. *A Harlot's Progress* had brought him wider fame than anything he had done to date, but it had not itself pushed him into 'dealing with the public in general'. It had presented him with an invitation, potentially a very lucrative invitation, to shift the centre of gravity of his work. In 1733 he accepted that invitation, turning himself into a printseller who did preliminary paintings rather than a painter who did subsequent engravings. The announcement of *A Midnight Modern Conversation* kept up the old pretences: he said that he engraved the painting 'in order to preserve his Property therein and prevent the Printsellers from graving base Copies to his Prejudice', and he invited his readers to come and see both painting and engraving 'next door to the New Play-house in Covent Garden Piazza [i.e., at Thornhill's house], where Subscriptions are taken in'.[20] The advertisements for the *Sarah Malcolm* print, which were more widely distributed, made no effort at gentlemanly concealment: the prints were on sale to all comers at sixpence each and that was an end on the matter. All that remained of the old pose was the polite fiction that the print had been engraved from the painting, instead of both of them having gone their separate and possibly simultaneous ways from the same preliminary drawing. All that remained of the old diffidence was the refusal to sell sixpenny prints on the actual doorstep of the Thornhill residence. Sarah Malcolm's likeness was 'to be sold at Mr Regnier's, a Printseller in Newport Street, and at other Print-shops'.[21] Hogarth had now gone too far to turn back: he was no longer a painter grown too large for his studio but a printseller in need of a shop.

By the time he issued his next advertisement he had taken one. Early in October 1733 the *Daily Advertiser* announced that 'Mr Hogarth being now engraving nine Copper Plates from Pictures of his own Painting, one of which represents the Humours of a Fair; the

other eight the Progress of a Rake ... Subscriptions will be taken in at Mr Hogarth's, the Golden Head in Leicester Fields, where the Pictures are to be seen'.[22] The house, which soon became as much business premises as private dwelling, was at the south-eastern corner of one of the most elegant and spacious open spaces in the West End of London. Leicester Fields – or Leicester Square, as some of its more pretentious inhabitants were beginning to call it – was dominated by Leicester House, the town residence of the Prince of Wales, which lay along its northern side, close to Hogarth's old haunts of Cranborne Alley and Little Newport Street. If George Vertue was right in saying that Thornhill was 'blended with interest & spirit of opposition', then Thornhill's son-in-law was well placed to carry on his attachment to the turbulent and unfilial Prince Frederick. He was also determined to carry on with the claim to supremacy in history painting and with the public skirmishing against the Club of St Luke: the golden head which he so defiantly displayed above his door – actually it was made of gilded cork – was a representation of Sir Anthony Van Dyck. This was to be no ordinary printseller's shop.

Nor was there anything ordinary about his business methods. In spite of his assertion that he was already engraving his nine copper plates in October 1733, those who subscribed to this new venture were destined to wait for the best part of two years before they received what they had ordered. The picture of a fair was completed by the end of 1733 and there is some evidence to suggest that the engravings from it were delivered fairly promptly; but the other eight paintings, the series which was to be known as *A Rake's Progress*, were still being altered and retouched a year after the original advertisement. Hogarth announced in the newspapers that the delay was because he had 'found it necessary to introduce several additional characters in his paintings' and he assured his subscribers that the prints were 'in great forwardness'. In fact he was still having difficulties in getting the series engraved; but the real reason for the postponement of publication had nothing to do with changes of character or technical problems. It was made clear in an anonymous pamphlet which came out during the winter of 1734–5 entitled *The Case of the Designers, Engravers, Etchers*

&c stated. In a Letter to a Member of Parliament. Hogarth clearly had a hand in its production and the arguments it put forward were those which he himself later used in the *Autobiographical Notes*: 'When the Artist returns to make Enquiry into the Number of his Prints that are sold, and expects a Return suitable to his Labour and Expense; He is told, with an insolent and careless Air, "His Prints have been copied – The copies sell as well as the Originals – Very few of his have gone off" and is presented with a large Remainder, which he is forced to take home with him.'[23] The situation could only be remedied, urged the pamphlet, if engravers were given the same legal protection as writers. In February 1735 Hogarth and several other artists petitioned Parliament for a Copyright Act for engravers on the lines of the one for authors already passed during the reign of Queen Anne. Within a fortnight a committee of the House of Commons had investigated the complaints of the petitioners and had recommended that a Bill for their relief should be brought in. The Bill passed through both Houses very rapidly and on 15 May 1735 it received the royal assent.

As soon as the Bill was through both Houses Hogarth told his subscribers why they had been waiting: 'Mr Hogarth was and is obliged to defer the Publication and Delivery of the abovesaid Prints till the 25th June next, in order to secure his Property, pursuant to an Act lately passed both Houses of Parliament.'[24] The Engravers' Act, which came to be known as Hogarth's Act because of the leading part he had played in securing it, provided that from and after 24 June 1735 artists should have a fourteen-year copyright in their work and that anyone infringing this copyright should be fined. There were of course ways of getting round the Act – unscrupulous printsellers sent spies to Hogarth's studio to memorise the details of his paintings and then published pirate engravings of them before the Act came into force – but for all its faults it introduced a new concept of the artist's status into English law and into English society. The days of the pure creator's supremacy were numbered. The connoisseurs and the collectors might still think in terms of the unique art object and despise those artistic creators who hoped, like the original and archetypal Creator, that their creatures would increase and multiply; but now for

the first time there was a reasonable chance that the process of multiplication would provide an artist with a livelihood. The time might even come when a man might live by reproduction alone.

Hogarth himself was not concerned with any of these far-reaching possibilities. He was still a painter and he proposed to remain one. His fall from favour at court at the end of 1733 was a serious blow, but its effects might yet be remedied. In spite of his insistence, in the *Autobiographical Notes*, that once he embarked on 'modern moral subjects' he sent would-be patrons on to others, the truth was that his practice as a portrait painter continued and even revived in the late 1730s. *Lord Hervey and his Friends* (see plate 13b), probably painted in 1738, was one of his most charming and inventive conversation pieces. As well as Hervey himself, an important figure at court, it included the Duke of Marlborough and the two Fox brothers, both of them very influential socially and politically. The younger, Henry Fox, remained at the centre of politics for the rest of Hogarth's life and was to be one of his last sitters. And in any case the inheritance which Hogarth had prepared for himself by means of the Engravers' Act was complemented by another which had fallen to him just before the campaign for that Act got under way. Sir James Thornhill had died suddenly at the end of April 1734 and within a matter of months Hogarth was seeking to assume the mantle of England's greatest history painter: already the newspapers had announced that 'the ingenious Mr Hogarth is to paint the Great Stair Case in St Bartholomew's Hospital'[25] and in 1735 the murals were begun. The first, *The Pool of Bethesda*, was completed in 1736 and it was already one of the sights of London by the time fresh crowds arrived in the summer of 1737 in order to watch him at work on the second, *The Good Samaritan*. By the late 1730s Hogarth's success was so impressive and many-sided that the particular part of it represented by the Engravers' Act seemed relatively minor, a mere business venture into which he had been tempted in order 'to do everything my family required'. In fact, however, it was by far the most important thing in his life. It helped to change not just the nature of his own art but the nature of all art. The balance between creation and communication would never be quite the same again.

CHAPTER VII
As if in a mirror

In January 1732, just as Hogarth was putting out his first announcements about the *Harlot's Progress* engravings, some of the London newspapers ran an article about the moral value of stage plays. 'The Drama,' asserted the writer, 'is to hold a Looking Glass to Life, to reflect the true Image of Men's Minds; to soften the Rigours of Morality, and to give a Smile to the Face of Virtue. Wisdom wears the Mask of Pleasure, and lures the Audience insensibly to admire her Precepts.'[1] The old allegories and emblems still kept some of their power: Pleasure still had her mask, even if it had been temporarily appropriated by a worthier lady. But the increasing popularity of the theatre meant that the old symbolism was steadily being superseded by this new form of manipulated reflection. Clearly it was not simply a looking-glass, since what the audience saw was dictated by the 'precepts of Wisdom' rather than by the laws of direct reflection. Nevertheless the theatre was beginning to get a good deal closer to ordinary life than the emblem books had ever done: George Lillo's tragedy *The London Merchant, or the History of George Barnwell*, produced at Drury Lane in 1731, was hailed as a brilliantly successful innovation because it made apprentices and harlots into tragic figures. It was, said the *Gentleman's Magazine*, 'a difficult task to excite terror and pity from characters so low and familiar in life', yet the play succeeded in doing so. 'So delicate is the texture of its composition,' wrote one anonymous lady, 'that none but a common prostitute can find fault with it.' Even the Queen sent to Drury Lane for a copy of the play so that she could read it for herself.[2]

The Beggar's Opera had of course done something similar three years

before; but it had not claimed to be tragedy and it had not simply por-
trayed 'characters low and familiar in life'. The thieves and gaolers and
informers who made up its cast were clearly intended to be taken as
universal and almost allegorical figures, mirroring in their petty crimes
and heartless betrayals the far deeper evils which lay at the heart of
the society that sustained them. The final version of Hogarth's
Beggar's Opera picture (see plate 13a) was surmounted by two Latin
mottoes: *Utile dulci*, a quotation from Horace indicating that the best
writers were those who gave useful instruction and pleasure at the same
time, and *Veluti in speculum*, meaning 'as if in a mirror'. Together they
anticipated the remarks made by the writer of 1732; but the picture
itself made a further comment, one particularly suitable to this play,
by placing the characters in the drama and the principal members of
the audience in one single plane as though they were all taking part in
one united charade. Lavinia Fenton, the actress who played Polly
Peachum, no longer gestured inwards towards the stage lover, Mac-
heath, for whose life she was pleading in the play. Instead, both her
eyes and her hands were turned outwards in the direction of her lover
in real life, the Duke of Bolton, who stood gazing at her behind the
back of her stage father. The carved figures who now supported the
curtains – and especially the one on the right, the fiercely lascivious
satyr above Bolton's head – were clearly intended to link the audience
to the play and not to separate them from it. It was as if Hogarth was
laying claim to another and more panoramic looking-glass, one which
would reflect all mankind and turn the whole world into a stage.

For more than a quarter of a century he continued to sustain this
claim. In the *Autobiographical Notes*, written in the early 1760s, he
spoke proudly of 'the Prints I have published within these thirty years
past' and prophesied that they would be 'instructive and amusing in
future times, when the customs, manners, fashions, characters and
humours of the present age in this country may be alter'd and perhaps
in some respects be otherwise unknown to posterity, both at home and
abroad'.[3] His earlier satires seemed to be excluded from this boast: the
only one he mentioned was *Masquerades and Operas* (calling it by his
own and more appropriate title, *The Taste of the Town*) and even this

was said to have lashed 'the then reigning follies', as though the period it described was remote and in some way different from 'the humours of the present age'.[4] From what he wrote it seemed that 'these fine prints', of which he was so proud to be the author, had begun with the *Harlot's Progress* series in 1732. From that time onwards he had held up his mirror to the world, peopling his pictures with men and women who had bridged the gap between allegory and reality as effectively as Lavinia Fenton's eyes and hands had brought together actors and audience. His harlot had been an archetypal figure, with a clear descent from the old emblems of carnal pleasure, but she had also been an ordinary country girl arriving as hopefully in London, in the first plate of the series, as many of the tavern wenches who waited on Hogarth in real life and studied his prints. Her surname, Hackabout, described her trade – it meant a vehicle which plied for public hire – but it was also one which had been given to a real prostitute, Kate Hackabout, who had been arrested in 1730 by a real magistrate, Sir John Gonson. The magistrate who had apprehended Hogarth's harlot had looked like Gonson, just as the bawd who had ensnared her in the first plate had looked like the notorious procuress Mother Needham. Mother Needham had also been convicted by Gonson, in April 1731, and had been sentenced to stand in the pillory. She had died a few days later from the injuries received there. Colonel Francis Charteris, the indefatigable rapist and fornicator portrayed on the right of the first plate, was also dead by the time the series appeared: his influential connections had enabled him to get a pardon after he had been convicted of rape, but when he had died of natural causes in 1731 his dead body had been subjected to a posthumous pillorying as vicious as that which had caused Mother Needham's death.[5] These characters, and others equally recognisable, had been brought in from the audience to play their parts in Hogarth's drama, standing in attitudes which had reflected both their behaviour in real life and the traditional allegorical themes around which the series had been built.

'My picture was my Stage,' recalled Hogarth, 'and men and women my actors, who were by means of certain actions and expressions to exhibit a dumb shew.' These actors were dressed, he went on to say,

'for the sublime genteel comedy, or same in high or low life'.[6] The harlot had had precious little opportunity to taste the joys of high life: her brief moment of fashionable success, when she had been kept by a rich Jew in the second plate of the series, had been dark with symbols of transience and insecurity. But Hogarth's next series set out deliberately to contrast the pleasure of the rich and the poor and at the same time to investigate the links between them. The picture of a fairground which was put on offer in 1733 with the eight plates of *A Rake's Progress* was not just a makeweight: it depicted a world of unsophisticated and unfashionable pleasures which seemed to be diametrically opposed to the genteel diversions of Tom Rakewell and yet had underlying affinities with them. The nature of those affinities was suggested by the subscription ticket, a print which came to be known as *The Laughing Audience*. It showed a group of people in the pit of a theatre laughing uncontrolledly while above them in a gallery men of fashion flirted with the orange-sellers and ignored the play. Those in the lower half of the print lived in the world which Hogarth portrayed in his first picture, *Southwark Fair*: they came to see rather than to be seen and they were perfectly content to be taken out of themselves by the antics of the actors on the unseen stage.[7] Yet the same actors, the same projection of unreality onto reality, provided the necessary context for the men about town who paraded their fashionable clothes and their fashionably carnal appetites in the gallery. The world of the other eight pictures, the world which Tom Rakewell strove so desperately to enter and which in the end destroyed him, was as dependent on fantasy as the world of the fairground. The significant difference was that the fun of the fair did not claim to have much to do with real life, whereas the absurdities of fashion pretended to be even more real than the realities from which they offered an escape.

The saddest thing about *A Rake's Progress* was that its central character never seemed at any point to be enjoying himself. His anxious young face, peering hesitantly out of the first plate (see plate 14a) as he was measured for the new clothes which were to be his passport to the world of fashion, only became more anxious as each expensive aspect of that world gave way to the next. The cautionary

verses under this first plate gave the reason for his unhappy plight:
they warned the dead father that because he had thought more of
money than of personal relationships, because he had failed to be a
friend to his son as well as a father, his hard-won riches were now to
be sacrificed to the insecurity and friendlessness of the son whom he
had neglected. The second plate showed what happened when 'the
unprovided Mind' of this lonely youth sought reassurance from those
who would make a gentleman of him. He surrounded himself with all
the hangers-on that fashion demanded: a music-master, a dancing-
master, a fencing-master, a landscape gardener and a bevy of men to
help him with his sporting pursuits (see plate 14b). But instead of
acceptance all he got was exploitation. He turned for consolation to the
tavern whores of Drury Lane, among whom Hogarth's harlot had
also lived and died; but by this time his extravagances had caught up
with him and he was arrested for debt. He tried the two standard
remedies for this situation – marriage to an ugly but rich old woman
and then a last desperate throw in a gaming house – but neither of
them could save him. His only escape from the debtors' prison was to
the madhouse, where the last plate of the series was set. The verses
under it were addressed once more to the miserly and unfeeling father
at whose door all this misery was to be laid:

> O Vanity of Age! here see
> The Stamp of Heaven effac'd by Thee –
> The headstrong Course of Youth thus run,
> What comfort from this darling Son!
> His rattling chains with Terror hear,
> Behold Death grappling with Despair;
> See Him by Thee to Ruin Sold,
> And curse thy self, & curse thy Gold.

There were in fact two unseen villains in *A Rake's Progress*: the
dead father, to whose posthumous remorse both the beginning and
the ending of the sad story were addressed, and society itself, which
required that men should act out a part in order to gain its acceptance.
There was also a heroine, by no means unseen but constantly excluded
from Tom Rakewell's presence by the parasites and charlatans who

surrounded him. Her name was Sarah Young and it seemed that before the series started, while he was still an undergraduate at Oxford, he had got her with child and had promised to marry her. In the first plate she was to be seen leaving his house in tears while he offered money to her infuriated mother. She appeared again in the fourth plate, offering a purse of her hard earned money in an attempt to save him from arrest for debt; and she tried in vain to get into the church in plate five in order to stop him from marrying his ageing heiress. In plate seven, the scene in the debtors' prison, she was shown in a state of collapse as if overcome by her own and Rakewell's miseries; but she recovered herself sufficiently to comfort him in the madhouse in plate eight, when everybody else had deserted him.

It is dangerous to read too much into the plot of *A Rake's Progress*, since Hogarth was quite consciously following up his earlier success: the progress of a rake was an obvious sequel to the progress of a harlot and the title had already been suggested to him months before by the literary hacks whose ballads and broadsheets tried to cash in on his first series.[8] Nevertheless, the ways in which Hogarth's story departed from the usual moral tracts of the time undoubtedly had some personal and professional significance. The emphasis on parental duty and on the simple devotion of a good woman came naturally enough from a newly married and happily married man whose views about parenthood were sharpened and perhaps over-idealised by his increasing fears that he might not be destined to experience it. And the fact that Tom Rakewell's ruin was precipitated by a longing for social acceptance, rather than by mere carnal appetites, reflected Hogarth's own hatred of the connoisseurs and other fashionable charlatans who sought to dictate the tastes of gentlemen and the aspirations of artists. Even as early as the 1730s it was becoming clear that Hogarth's looking-glass was not quite as impartial and as objective as it claimed to be.

When he came to review his 'fine prints' in the *Autobiographical Notes* the only mention he made of *A Harlot's Progress* and *A Rake's Progress* was that the original paintings had been destroyed in a fire, of which the most memorable feature was 'that a most magnificent clockwork organ in the house, being set a-going by some accident, was

heard in the midst of the flames to play a great variety of pleasing airs'.[9] In fact the fire, at William Beckford's house at Fonthill in 1755, had only accounted for the first of the two series: *A Rake's Progress* was rescued from the flames and is now in Sir John Soane's Museum in London. Hogarth's failure to comment further on the two series was as surprising as his inability to find out accurately what had happened to the paintings. They were after all his earliest excursions into 'modern moral subjects' and they had established that reputation for social commentary of which he was now so proud. Yet he said nothing further, either about them or about the other products of the 1730s. Some of these, such as the issue of prints from the second version of *Before and After*, were of only passing interest; but there were others which were an integral part of his 'sublime genteel comedy', his puppet show of mankind. *The Distressed Poet*, painted sometime in the mid-1730s and published as a print in March 1737, was full of allusions to literary quarrels and scandals that were soon forgotten; but its central image, that of the poet starving in a garret, passed into the visual language of the time and served as a warning for countless cautious fathers to wave in front of sons who wanted to be men of letters.

There was of course a technical reason for Hogarth's neglect of his early prints in his reminiscences. The original aim of the *Autobiographical Notes* was to provide an introduction and commentary for a proposed collected edition of his works; and the early series, which had been published in limited editions by subscription, could not legitimately be included in such an edition. But the reminiscences soon went beyond their original intention, just as the prints themselves had long ago ceased to be the private preserve of those who had subscribed to them. In 1744, allegedly after many requests from subscribers who had 'lost or otherwise disposed of their prints', Hogarth had produced a second impression of *A Harlot's Progress*; and in the following year he had caused something of a sensation by selling at auction the original paintings of many of his 'modern moral subjects'. The *Autobiographical Notes* soon became a defence against charges which had arisen out of these and other business practices. He was in fact doing much more than introducing those prints which he could legitimately reproduce

again: he was defending the whole business of reproduction, the whole record of a lifetime devoted to the moral instruction of the public rather than to the acquisitive instincts of the art collectors. And justification of this sort necessitated a full account of his looking-glass and of all the varying ways it had been used in the course of thirty years. He got as far as saying that 'the Prints here spoken of are all that I have Published within these thirty years past, so that the reader may be assured whatever others have passed for my doing within the time mentioned are spurious and an imposition';[10] but in the event the only prints he got round to describing were those produced in a relatively short space of time, between 1747 and 1751: *Industry and Idleness, The Roast Beef of Old England, Beer Street and Gin Lane* and *The Four Stages of Cruelty*. All the rest of his prints were either ignored completely or given only brief or indirect mention. In spite of the original and stated aim of the *Autobiographical Notes*, this most ambitious and successful of puppet masters in the end brought on only a tiny proportion of his characters to take their final curtain call.

The reason was obvious enough: so much generalised self-justification came flooding out in the *Autobiographical Notes*, so much bitterness against his enemies and so much anxiety about his own final place in the history of art, that death overtook him before he had time to pass on to the calmer task of parading all his work in systematic review before him. He began in the middle and he never got to the end, let alone the beginning. He piled argument upon argument, metaphor upon metaphor, in order to prove that he was the most objective and Olympian of social commentators: he represented himself as the only scribe who understood the document he was copying, the only showman who could turn all the world into a stage, the only artist whose personal *camera obscura* would reflect the whole of mankind.[11] Yet when he came to give instances of his art he turned not to the 1730s and early 1740s, when his reputation for holding a mirror to mankind was first established, but to a later period when it was already beginning to come under attack. The prints he mentioned were those in which he had deliberately turned away from art-loving private subscribers and had sought instead a wider audience. There had in fact been

another turning point in his career in the late 1740s, one which he failed to identify directly, in the way he pin-pointed his marriage and his career as a portrait painter, but which he nevertheless hinted at indirectly by taking it as a starting point for the prints he chose to discuss.

The truth of the matter was that *Veluti in speculum*, the motto over the *Beggar's Opera* picture, came some twenty years too early. Contemporaries accepted the Hogarth looking-glass willingly enough – the abbé Leblanc, a Frenchman who published his *Letters on the English and French ñations* in 1747, reported that while in England he had not seen any house of note which did not have Hogarth's prints on its walls[12] – but in fact it was not quite what it seemed to be. The personal and polemical elements already discernible in *A Harlot's Progress* and *A Rake's Progress* grew steadily more intrusive until they reached a climax in *Marriage à la Mode*, perhaps the greatest of all the 'modern moral subjects', in 1745. If the prints of these years were like an optical instrument at all it was a burning-glass rather than a looking-glass: they contained more concentrated heat than reflected light. They can only be understood in terms of the fierce rays that they gathered together and the enemies they were intended to consume.

The optical metaphor was in any case curiously appropriate for a man who was determined to be both a painter and an engraver. A print is inevitably a mirror image of the plate from which it is made: left becomes right and right becomes left. Paintings carefully composed in order to lead the eye in a particular direction fall to pieces, their whole structure and balance turned inside out. People appear with their coats buttoned on the wrong side and their swords held in the wrong hand. There are even greater difficulties for an artist who deals, as Hogarth did constantly by the very nature of his professional preoccupations, with the device of the image within an image. He liked to surround his characters with paintings which symbolised their failings and reflected their aspirations; but if these pictures were to be recognisable in the engraved version they would have to be painted back to front in the first instance. In practice of course they were not: instead, the engraver was expected to re-draw them, just as he was

expected to put swords into the correct hands and make coats button on the correct side.[13] But when Hogarth engraved his own paintings he took very little care over the process of reversal. In *Southwark Fair*, the print which accompanied *A Rake's Progress*, there were several back-to-front garments and even as vital a character as the mounted swordsman in the foreground was allowed to become left-handed. On the other hand the self-portrait of 1745, which was engraved some years later as a frontispiece for his collected works, was carefully treated because it was intended as a trademark and a challenge as well as a record of himself (see plate 15): he reversed the painting but took care to move such details as the scar on his forehead, of which he was so inordinately proud, in order to convey the desired image of himself as a typically pugnacious and independent Englishman. When he and his assistant Charles Mosley engraved *The Roast Beef of Old England* (see plate 16) at about the same time they turned the whole picture round when they cut the plate, with the result that in the print left and right were the same as they had been in the original painting. This was partly because Hogarth himself appeared in the picture, busily sketching the reactions of starving and enslaved Frenchmen as a side of beef was carried to the English tavern in Calais; and it was widely known that he had in fact drawn this particular scene on the spot and had been arrested for his pains by the French authorities. It was one thing to make a fairground broadsword fighter left-handed, but it was quite another to do the same to the artist himself or let his favourite scar appear on the wrong side of his forehead. The mirror effect of the engraver's art could not be allowed to operate indiscriminately.

The dilemma of the engraved mirror image, and the various ways in which it was solved, epitomised the problems which underlay Hogarth's art as a whole by this time. He was portraying reality, which had to be recognisable if it was to make its point, but he was also inventing a world of his own. Men who were known to be right-handed could hardly be depicted with their canes or their pens in their left hands, any more than famous buildings could be turned back to front; and yet the whole elaborate structure of allegory and invention could

not be allowed to disintegrate for the sake of this particular kind of verisimilitude. The technical problem of reversal was symptomatic of something that lay much deeper. The paintings, the unique art objects which Hogarth created in order that they should be owned by individual collectors and patrons, were difficult to reconcile with the infinitely reproducible images turned out by the engraver. This was perhaps another reason why Hogarth found it easier in the *Autobiographical Notes* to concentrate on the series produced between 1747 and 1751, in which there were no original paintings to be disposed of, no private collectors or patrons or subscribers to be conciliated, no tension between two opposing types of art with totally different functions. What he was in fact describing was the period of resolution, the years during which he worked out a solution to this problem of the general public on the one hand and the private collector on the other. What he was ignoring was the period of uncertainty, the years during which the most well-known artist in England stood poised between two interpretations of the artist's function in society. Like the painting and the engraving, these two views seemed at first sight to be totally compatible but revealed themselves on closer examination as diametric opposites.

The deeper problems, like the technical ones that lay on the surface, are best understood in terms of Hogarth's own image. The stocky and uncompromising figure of the painter himself did not actually appear in the great series of the 1730s and early 1740s in the way it appeared in *The Roast Beef of Old England*; but its unseen presence nevertheless dominated the pictures in a way quite different from the aloof detachment suggested by the looking-glass metaphor. Hogarth's private life during these years is unchronicled, but it is not entirely unknown. No diaries or sustained series of letters have survived, nothing on which any kind of narrative can be based; but there are glimpses that reveal something about the sort of man he was and the sort of relationship he was building up with his work and with his public. At the end of May 1732, when it was clear that he had scored a tremendous success with *A Harlot's Progress*, he set off on an impromptu trip down the Thames with a group of friends. They had been drinking together in the Bed-

ford Arms in Covent Garden and they suddenly decided to go off on a jaunt instead of going home to bed. There were five of them: Hogarth himself, his brother-in-law John Thornhill, his erstwhile host William Tothall the cloth merchant, a lawyer called Ebenezer Forrest and a painter called Samuel Scott. They made their way to Billingsgate, which was at that time a dock area as well as a fish market, and they swapped dirty jokes with a porter and his womenfolk until one in the morning, when they managed to get a boat to take them down the river as far as Gravesend. There was a fierce East wind blowing and 'we had much rain and no sleep for about three hours'.[14] They cheered themselves up by drinking gin and singing bawdy songs. By the time the dawn came Hogarth was asleep: when he woke up he was anxious to tell his friends about a dream he had had, but before he could do so he fell asleep again. By the time he woke up again his dream had been forgotten. They landed at Gravesend at about six in the morning and had a quick wash, followed by a powdering of wigs and some rounds of hot buttered toast with coffee. Then, at eight o'clock, they set off to walk to Rochester, where they behaved in a manner befitting cultivated and artistic gentlemen from London: they 'survey'd the Fine Bridge, The Cathedrall and the Castle, The last well worth Observing' and they noted 'on the Front of a House four Figures in Basso Relievo after the Antique Done by Some Modern hand representing the Seasons'.[15]

It was not long, however, before the trip began to lose its atmosphere of cultured tourism. By noon they were exhausted and they lay out on chairs in the dining room of an inn to sleep for a while; then, after spending the time from one o'clock to three o'clock eating their dinner, they began to feel a little better. Dinner consisted of sole and flounders with crab sauce, stuffed and roasted calves hearts, fried liver, roast leg of mutton and green peas, 'all very good and well dressed, with good small beer and excellent port'.[16] Later they bought nine pennyworth of shrimps to eat while they wandered about the town. Hogarth and Scott played hopscotch in the colonnade under the town hall and the next day, after a good night's sleep, they turned to more vigorous sports. The whole company held a pitched battle, hurling sticks, stones and dung at one another: 'in this Fight Tothall

was the Greatest Sufferer and his Cloaths carried the Marks of his Disgrace some time, this occasion'd Much Laughter'. There was further laughter when Hogarth pulled down his breeches in a church-yard and prepared to use a grave as a lavatory. Tothall pretended to be scandalised and he made up for his earlier discomfiture by flogging Hogarth's exposed backside with bunches of stinging nettles and forcing him to 'Finish his Business against the Church Door'.[17] In the evening, while they were waiting for their supper to be prepared, they had 'Another Sharp engagement', this time substituting cow dung for the pig's droppings they had used earlier in the day. At the inn there were only three beds and when they drew lots to see who should sleep alone it was the long-suffering and much bedaubed Tothall who won. Hogarth had to sleep with his wife's brother; but he anticipated any ribaldry this might have caused by taking the initiative and treating Scott and Forrest, the occupants of the other double bed, to the bawdy rituals usually reserved for newly married couples.

And so it went on for five carefree days. When they finally got back to the Bedford Arms, at two o'clock in the afternoon of Wednesday 31 May (they had left it on the previous Friday night), they brought with them something more substantial than a collection of travellers' tales. Hogarth and Scott had been appointed in advance as the artists of the expedition and Forrest as its chronicler; and within a few nights of their return an illustrated account of the journey was being passed around among their drinking companions in the tavern. Half a century later, when all his four companions were in their graves, Forrest finally published this account. It was a revealing document as well as an entertaining one. Of the four drawings which Hogarth had done in the course of the trip, three included representations of himself, clearly distinguishable by his small stature but identified also in a lettered key (see plate 17a). In each case the effect was like that in *The Roast Beef of Old England*, as though a photographer had set the shutter of his camera and then walked back into his own picture. The fourth drawing was of the tomb of Lord Shorland in the church at Minster on the Isle of Sheppey. Scott drew the monument of a Spanish nobleman in the same church, but it was left to Hogarth to record the resting place of

the legendary Shorland, who was said to have been killed by the skull of the horse he had himself killed. According to the local story, 'That wee did not Dare to Declare our Disbelief of', Shorland had ungratefully murdered his faithful mount after it had saved his life: he had been told by a clairvoyant old woman that having performed this service for him it would also cause his death. Many years after his act of ingratitude he had kicked the beast's skull 'and Hurt one of his Toes which Mortified and kill'd him'.[18] In spite of his scepticism Hogarth was drawn to this story of aristocratic brutality and divine retribution: there was something very forceful about his rendering of Shorland's battered effigy and of the grimly satisfied horse's head at his feet.

Much more forceful, and much more revealing, were the drawings Hogarth produced as the frontispiece and tailpiece of the document. Both were visual puns: the first, a body without head or legs, was 'Mr Somebody' and the second, a head and legs without a body, was 'Mr Nobody' (see plate 17b). Charles Mitchell has traced the seventeenth-century origins of these figures and has shown that Hogarth was drawing upon a well-established literary and pictorial tradition, a kind of popular equivalent of the work of the emblem-writers.[19] Mr Nobody was a folk hero, an ordinary plain man who did no harm and enjoyed the simple pleasures of life but who was nevertheless always being blamed for the sins of pretentious and pompous people like Mr Somebody, who was too busy showing off to understand what life was really about. Hogarth's version of Mr Somebody was an antiquarian surrounded by ruins, the empty shell-like things so beloved of collectors and self-consciously 'artistic' people, while his Mr Nobody was hung about with symbols of the ordinary and unselfconscious enjoyments of everyday life. Mr Somebody looked ahead to the charlatans and self-styled connoisseurs who were to destroy first Tom Rakewell and then, even more insidiously, the Squanderfield family in *Marriage à la Mode*. As for Mr Nobody, he presumably represented the adventurous five themselves, rollicking their way through northern Kent like red-blooded freeborn Englishmen rather than posturing and pretentious connoisseurs. Some years later, in January 1735, they displayed their red-blooded and freeborn qualities even more dramatically, founding

a club called The Sublime Society of Beefsteaks, devoted to the pec-
uliarly English practice of imbibing the strength and the sturdy inde-
pendence of the bull by means of eating his flesh in its most succulent
form.[20]

The satirical overtones of all this were obvious enough. Even the
grandiose title of the steak-eating club was a parody of the connois-
seurs and the aesthetic theorists, who had been obsessed for many
years past with attempts to define 'the sublime' in literary and artistic
terms. Like so many other things Hogarth disliked, this obsession had
been imported from France: Boileau's French translation of *Longinus
on the Sublime,* a Greek tract of the first or second century AD, had in
its turn been translated into English in 1698 and had sparked off just
the sort of pretentious philosophical debate that Hogarth loved to
ridicule. One of the participants in the debate, Jonathan Richardson,
remarked in an unguarded moment at Slaughter's coffee house that he
was able to theorise about paintings he had never seen and classical
works he could not properly understand by using his son, who was
more expert in these matters, as 'his Telescope'. Hogarth's comment
on this was as earthy as his mockery of the perambulating antiquaries
in Kent, or his enjoyment of sublime slices from a bullock's rump: he
produced a drawing of the younger Richardson standing on a table
with his breeches pulled down while his father thrust a telescope up
his backside. According to Samuel Ireland Hogarth destroyed the
original drawing once he realised that Richardson had been genuinely
distressed by it; but etchings based on it were soon in circulation.
Some years later a crudely etched print called *The Charmers of the
Age* appeared, in which the craze for foreign dancers was mocked in
terms as obscene as those used against Richardson's infatuation with
foreign aesthetic sublimities. A ballerina was shown with her legs
wide apart and a dotted line leading up to the point where they met.
'Prick'd lines shew the rising height', said the caption with elaborate
ambiguity. It seems that Hogarth was not encouraged to work up this
idea into a properly finished print and publish it under his own name,
even though Jane Hogarth did find it worthwhile to authorise a re-issue
in 1782.

It was typical of Hogarth that he should cast his satires in these terms and it was equally typical that he should show surprise and even remorse when they gave offence. There was still something of the schoolboy about him, scribbling *graffiti* in his exercise books and delighting in his powers of mimicry. 'All men mimic,' Shaftesbury had written thirty years earlier, 'else no speech, no manners. And here the Egyptians made a monkey the hieroglyph of learning and modern painters use it for universities.'[21] Hogarth, a brilliant mimic since childhood, had other uses for this simian symbol of his talent. In *Strolling Actresses Dressing in a Barn*, painted in 1737 and published as a print the following year, he showed a monkey as the only adult male creature in a world of women and children. Its position in the picture was something like the one he was himself to take up in *The Roast Beef of Old England*, but the activity which pre-occupied it was rather different: it was busy urinating into a stage helmet. It seemed that the world of the unreal could not escape such attentions from harsh and irreverent reality. The tawdry stage properties of third-rate actresses, themselves pre-occupied with personal metamorphosis into classical gods and goddesses, were as vulnerable as the skirts of fashionable dancers and the hindparts of pretentious connoisseurs.

The Four Times of Day, painted at about the same time and published as prints in the same subscription as *Strolling Actresses*, contained similar allusions. In the first one, showing early morning, a frigid spinster walked to church oblivious of the cold that chilled the warm-blooded frequenters of 'Tom King's Coffee House', an establishment which was by that time a brothel. The second, *Noon*, was filled with references to the contented gluttony in which the English on one side of the picture were about to indulge, while their French counterparts on the other side of the street concerned themselves solely with fashion and ostentation. In the third picture, *Evening*, the typical London citizen tried to escape to the rural delights of Sadler's Wells, only to be reminded – by the cow's horns appearing over his head – of the way in which he was being cuckolded by his would-be fashionable wife. At night the comedy became coarser: a drunken magistrate in masonic regalia had urine poured over him as he staggered

homeward. He was said to represent Sir Thomas de Veil, whose personal habits belied his public condemnation of drunkenness and who was reputed to have sipped urine on one occasion because he had been told that it was illicit gin.

So far the carefree coarseness of Hogarth's own personal life and the steadily increasing ferocity of his warfare against the art pundits had been kept in separate compartments. Even the famous outburst in the *St James's Evening Post* in June 1737 against the 'peddling Demi-Criticks' and the 'Picture-Jobbers from abroad', with their 'Ship Loads of dead *Christs*, *Holy Families*, *Madona's* and other dismal Dark Subjects', had little impact on his popular reputation, even though it stored up a lot of trouble for him in the art world itself.[22] In December 1737 the fashionable French portrait painter Jean-Baptiste Vanloo settled in London and had an immediate success: two months later the newspapers reported that he was 'painting in the Portrait Way most of our English Nobility'. From that time until he finally left England in October 1742 he was faced with the implacable hostility of Hogarth: 'This Monopoly was aggravated by being a foreigner, I exhorted the painters to bear up against this torrent and to oppose him with spirit, my studies being in another way. I spent my own in their behalf which gave me enemies among his espousers.'[23] It was still just about true to say that Hogarth's own work was 'in another way' and that his attacks on the foreigners and the connoisseurs, attacks which were still mainly verbal, could be kept from affecting it. Nor was it affected as yet by the aggressively earthy Englishness with which Hogarth reacted to foreign foppishness and affectation. The private Hogarth, the Hogarth who threw dung at his friends and amused them with Rabelaisian drawings, had not yet invaded either the charming conversation pieces of Hogarth the painter or the morally uplifting prints of Hogarth the engraver. But he could not be kept out much longer: already, in 1741, an otherwise ordinary portrait of a gentleman in a red coat had been signed defiantly *W. Hogarth Anglus pinxit* – W. Hogarth, an Englishman, painted it. The artist was pushing his way into his own picture, elbowing aside as he came the allegedly objective metaphors of stage and looking-glass which had never really had a chance of keeping him out.

CHAPTER VIII

Such a sight as they have never seen

Hogarth himself knew only too well what it was that gave him lifelong unease and prevented his work from becoming an integrated whole. It was the simple fact that he painted for the few and engraved for the many: try as he might there seemed to be no way of uniting the requirements of these two worlds. Like most other artists of his time he idealised the city states of ancient Greece, where he thought there had never been any distinction between the many and the few, between art in public and art in private. 'These arts were carried to their greatest heights in Greece,' he wrote in the *Apology for Painters*, 'they were politically considered and encouraged as necessary to the making great and good and religious. They spoke to the eye in a language every one understood. There gods were painted and carved and virtuous actions and bravery were depicted in their public places.'[1] The nearest approach to this idyllic state of affairs in modern times was of course to be found in Roman Catholic countries, where painting was indeed 'politically considered and encouraged', both by priests and by kings, and where paintings commissioned by the few were constantly seen – and even venerated – by the many. It was all very well for the French and Italian masters whom the connoisseurs praised so extravagantly: they could create unique art objects in the knowledge that these creations could speak to all mankind without losing their uniqueness. Hogarth, on the other hand, could not break out of the world of private collectors except by consigning his work to the hazardous and often distorting processes of mechanical reproduction. And the work itself was limited by the fact that it had to serve two different purposes. The titles he invented for it – 'modern moral subjects', 'comic history

painting' – had a truculent as well as a triumphant ring to them. They could never quite conceal the fact that they had been coined in order to give respectability to an uneasy compromise. It was not that easy to square the demands of the general public with those of the connoisseurs.

Hogarth would not of course admit that Catholicism might possibly be beneficial to the arts. In 1747 he had a hand in founding yet another artists' dining club, which met on the Protestant festival of 5 November in order to drink toasts to liberty as the parent of the fine arts; and he did not doubt that popery, particularly the popery of the Jacobites and their French backers, was the principal threat to that liberty. Many years earlier, in 1725, he had been quick to exploit William Kent's discomfiture when the parishioners of St Clement Danes church secured the removal of an altarpiece he had painted for them. The Bishop of London had ordered it to be taken down after he had been told that it was not only Italianate and idolatrous but also politically dangerous: it was said to contain a recognisable portrait of the Pretender's wife, which attracted a steady stream of delighted Jacobites to the church. Hogarth's satirical burlesque of the picture, published soon after it had been taken away, had been chiefly concerned with pointing out Kent's alleged incompetence as a painter, but it had also served as a freeborn Englishman's comment on ecclesiastical patronage and on the sort of art it might be expected to produce.

More than thirty years later, when he came to write the *Autobiographical Notes* and the *Apology for Painters*, Hogarth was still acutely conscious of the drawbacks of Protestantism from the painter's point of view, but he spoke of them as much with pride as with regret: 'Our Religion forbids, nay doth not require, images for worship or pictures to work up enthusiasm. Reading books is common now even amongst the lowest. Pictures and statues now are only wanted for furniture.'[2] And there was even greater pride in his account of his own share of such church patronage as there was:

> To shew how little it may be expected that history painting will ever be required in the way it has been on account of religion abroad, there have been but two public demands in within the

forty years, one for Lincoln Inn hall the other for St Mary Church at Bristol for both which I was applied to, and did them and as well as I could recollected some of these Ideas that I had pick'd up when I vainly imagined history painting might be brought into fasheon.[3]

It was perhaps a little strange that he should have had to 'recollect' the principles of history painting, which he had assimilated so early and upon which he had built such hopes. The altarpiece for St Mary Redcliffe in Bristol, an enormous triptych consisting of an *Ascension* flanked by two scenes at the Holy Sepulchre, was painted in 1756; but *Paul before Felix*, intended for Lincoln's Inn Chapel but finally placed in the Hall instead, was commissioned as early as December 1747 and finished a few months later. A year or so earlier he had completed *Moses brought before Pharaoh's Daughter*, painted to hang in the Foundling Hospital of which he was a governor; and before that there had been several superb group portraits, conceived and executed in something very close to the 'grand style' of history painting, which had in their turn followed closely on the spectacular pictures in St Bartholomew's Hospital. There were few painters in England who could boast such a continuous series of commissions for history painting or something closely approaching it. And the six paintings of *Marriage à la Mode*, though they were small in scale and topical in their subject matter, made extremely sophisticated use of the allegorical and emblematic techniques of the history painters. There was more bitterness than truth in Hogarth's conviction that the public and the connoisseurs between them had driven him away from history painting and that it had become for him a half-forgotten art form which he recollected with difficulty in his old age. It was, on the contrary, the central theme in all his work and the thing which gave it coherence and continuity. It was allegory, not mere reflection or representation, that dictated the nature of his best work both for the general public and for the connoisseurs. The causes of his discontents lay in the differing requirements of the two markets rather than in any abandonment of history painting itself.

Throughout the 1730s and the early 1740s the real dilemma before

him had been concealed by the use of the subscription system, which
seemed to give the best of both worlds. Vertue noted that *A Harlot's
Progress* 'captivated the Minds of most People, persons of all ranks &
conditions from the greatest Quality to the meanest';[4] and in cash
terms this first subscription brought in well over a thousand pounds.
With the protection given by the Engravers' Act later ventures pro-
bably did even better – and the original paintings were still in his pos-
session, waiting to fetch high prices when public interest was at its
peak. It only remained to make some dramatic gesture, some public
declaration that he meant to bestride the narrow world of the con-
noisseurs like a colossus and dwarf them all by virtue of his appeal to a
wider audience. There was no time to be lost: already, according to his
subsequent account in the *Autobiographical Notes*, 'the whole nest of
Phizmongers were upon my back, every one of whom has his friends
and all were taught to run 'em down, my women harlots and my men
caricatures'.[5] Now that he had moved away from his small conversa-
tion pieces to portraiture on a grander scale, his rivals were determined
to damn him by reference to his 'modern moral subjects' and insist
that he was only capable of painting comic pictures and scenes from
low life.

In the autumn of 1742 he took the opportunity of Vanloo's departure
to publish an attack on the phizmongers in the *London Evening Post*.
'This piece of Wit or sarcasm,' wrote Vertue angrily, 'is said to be the
work of Ho, a man whose high conceit of himself & all his opera-
tions puts all the painters at defiance, not excepting the late famous Sr
Godf. Kneller – & Vandyke amongst them.'[6] By this time Hogarth
had indeed told his friends quite openly that he could paint as well as
Van Dyck: in view of the effigy of that painter which he used as his
sign it was a claim that meant a lot to him, and in the *Autobiographical
Notes* he said that it was 'about 20 years ago' – that is, in the early
1740s – that he first asserted it publicly at the Academy in St Martin's
Lane.[7] It was met with ridicule and even with anger. He would have
to act quickly, with deeds rather than words, if he was to forestall a
violent reaction against his increasingly lofty pretensions.

The next move was the announcement in April 1743 of 'SIX

PRINTS from Copper-Plates, engrav'd by the best Masters in Paris, after his own Paintings; representing a Variety of *Modern Occurrences* in *High-Life*, and call'd MARRIAGE A-LA-MODE'. Never before had the ingenious Mr Hogarth taken such pains to impress the fashionable private collectors and convince them that he was something more than a mere caricaturist. The advertisement assured them that 'Particular care will be taken, that there may not be the least Objection to the Decency or Elegancy of the whole Work, and that none of the Characters represented shall be personal', and within a month he had indeed set off across the Channel in order to recruit 'the best Masters in Paris' to do his engraving for him – although, as he had assured the public already, the faces in the prints were to be engraved by Hogarth himself, 'for the better Preservation of the Characters and Expressions'.[8] He was determined to rebut once and for all the charge that he was a caricaturist, even if it meant acting as his own phizmonger when it came to the engraving. The subscription ticket for the series further underlined this determination: it was called *Characters and Caricaturas* (see plate 18a) and it purported to illustrate the differences between these two methods of conveying a likeness. It also contained a direct literary cross-reference unusual in Hogarth's work. '*For a farthar Explanation of the Difference Betwixt* Character & Caricatura *See ye Preface to* Joh Andrews', ran the caption. *Joseph Andrews* had first appeared more than a year before; but the third edition, which was the first to identify the author as Hogarth's friend Henry Fielding, had only just come out, in March 1743. 'He who should call the ingenious Hogarth a burlesque painter,' declared Fielding's preface, 'would in my opinion do him very little honour.' The gist of his argument throughout the preface was that caricature and burlesque, which were based on deliberate distortion, were greatly inferior to the true comedy of manners, to which both he and Hogarth aspired and which was based upon 'the exactest copying of Nature'.

Hogarth, however, could not allow it to become too exact. 'None of the Characters represented shall be personal,' his advertisement had promised; and it was for this reason, as much as for the avoidance of caricature, that he was engraving the faces himself. He was beginning

to learn one of the most important lessons that the earlier series had
had to teach him. Private patrons would not be attracted to his studio
if they suspected that they might be sitting in front of a two-way
mirror, through which the public in general might eventually be
invited to laugh at them. However much 'decency and elegancy' he
might achieve, however many fashionable Parisian engravers he might
recruit, he would not reconcile his two markets unless he preserved the
privacy of the one from the curiosity of the other.

In the event the recruitment of engravers in Paris proved more
difficult thàn he had expected: nothing is known about the trip itself,
but whatever agreements it produced were soon put in jeopardy by
worsening relations between England and France. Even while Hogarth
was still in Paris the King of England was preparing, with the diplo-
matic sophistry so typical of the eighteenth century, to lead an army
against the King of France even though he was still nominally at peace
with him. The fiction of peace was preserved for a few more months, as
English troops supposedly assisting one German potentate fought
French troops supposedly assisting another; but by the autumn of
1744 Hogarth had to tell his subscribers of a change in plans:

> In the month of June 1743 the following French Masters, Mess.
> Baron, Ravenet, Scotin, Le Bas, Dupre and Suberan, had
> entered into an Agreement with the Author (who took a Journey
> to Paris for that sole Purpose) to engrave the above Work in their
> best Manner, each of them being to take one Plate for the Sake
> of Expedition; but War with France breaking out soon after, it
> was judged neither safe nor proper on any Account to trust the
> original Paintings out of England, much less to be engrav'd at
> Paris: And the three latter Gentlemen not being able, on Account
> of their Families, to come over hither, the Author was neces-
> sitated to agree with the three former to finish the Work here,
> each undertaking two Plates.
>
> The Author thinks it needless to make any other Apology for
> the Engravings being done in England, than this true State of the
> Case, none being so weak as to imagine these very Masters, (who
> stood in the first Rank of their Profession when at Paris) will
> perform worse here in London; but more probably on the con-
> trary, as the Work will be carried on immediately under the
> Author's own Inspection.[9]

It was hard to believe that such an announcement could have been made by the man who had signed himself so defiantly 'W. *Hogarth Anglus*' only three years earlier. In order to conciliate the francophile connoisseurs he had been prepared to admit not merely the superiority of French engravers but even the superiority of work done in France over similar work done in England; and now, when the French were openly at war with England and were threatening to launch an invasion to put the Pretender on the English throne, he still felt it necessary to produce explanations and apologies for the fact that the engraving was after all to be done in England. The publication of the *Marriage à la Mode* prints, which finally took place in the spring of 1745, might be a bid for artistic supremacy, a sequel to the arrogant gestures Hogarth had been making since the departure of Vanloo, but it was not without its own form of humility. Hogarth the Englishman was seeking to bestride the art world, one foot planted among the connoisseurs and one among the public in general, but he was at the same time retracting some of his earlier chauvinism. If the connoisseurs would admit that England produced the best painters – or at any rate the best painter – then it could be conceded that France produced the best engravers. Hogarth was jettisoning the craft which had once been 'his utmost ambition', consigning it to the province of the hated French, in order to re-assert the supremacy of the English in the realm of painting.

And yet the prints themselves mounted a devastating attack on the very form of painting which he still valued most highly and on the men who patronised it. They told the story of Viscount Squanderfield, eldest son of the Earl of Squander, who was married to a rich alder-man's daughter in order to recoup the debts his father had incurred in building the Italianate palace which could be seen through the window in the first print. Every detail in this first print showed the arrogance and extravagance of the Earl, the desperate social ambitions of the alderman and the helplessness of the young couple who were about to be chained together as cruelly and as inexorably as the two dogs at their feet (see plate 19a). When they set up house on their own after their marriage they surrounded themselves with the same kind of

Italianate ostentation that had already brought the Earl to the brink
of ruin. Never before had Hogarth made such extensive and effective
use of the picture within the picture: each one of the many frames
which crowded the walls in these prints made a sardonic comment on
the sheep-like connoisseurship of the English propertied classes and
on the disastrous consequences which might be expected to spring
from it. Other and more conventional forms of nemesis were also sug-
gested: in the first plate the young Viscount had a patch on his neck
as though he suffered from a venereal sore and in the second the
evidences of a night's whoring were falling from his pocket (see plate
19b). In the third print he was seen consulting a quack doctor about
the disease he had contracted, and in the fourth his wife, now the
Countess since he had succeeded to the earldom, was preparing for a
little adultery on her own account (see plate 20a). In the end it was
illicit love that destroyed the marriage, for the Countess's lover killed
her husband in the fifth plate and she herself committed suicide in the
sixth (see plate 20b). For good measure the child who was lifted up to
kiss her dying mother in this final scene was shown in leg irons, the
innocent victim of the disease which adultery and excess had brought
into the family.

But the real subject of *Marriage à la Mode* was not lust but vanity.
The old Earl and the alderman were both its victims, the one with a
pedigree and no money and the other with money and no pedigree.
Between them they conspired to sacrifice their children to the twin
deities of dynasticism and property. 'Pictures and statues,' Hogarth
was to observe later, 'now are only wanted for furniture'; but it
seemed that they were wanted so badly that their owners were them-
selves reduced to the level of furniture in their own homes. People
existed for the sake of houses, not the other way about. And Silver-
tongue, the lawyer who seduced the Countess and finally led her to
suicide, did so by appealing to her anxiety to be fashionable rather than
to her carnal desire. The fourth plate, in which he had persuaded her to
launch herself into a new career as a patroness of all the arts, was as much
the turning point of this series as the arrival of the fashionable para-
sites had been in the life of Tom Rakewell. Ever since Hogarth had

sued Joshua Morris in 1728 he had been the enemy of the whole 'improvement' industry, the network of artists and contractors and self-appointed professional connoisseurs who preyed upon the proper-tied man's passion for 'improvement'. No landed family could rest content unless its property was improved – gardens and parks fashionably landscaped, houses rebuilt and extended, interiors stuffed with choice specimens of whatever sort of art happened to be in fashion – so as to outshine all neighbouring properties. When the neighbouring properties were themselves improved in their turn the business had to start all over again. It might seem silly to Hogarth, but it was extremely lucrative to his fellow artists. For nearly two decades he had been ranged against them, restricting his attempts at sublime history painting to such institutions as St Bartholomew's Hospital and the Foundling Hospital. Now, in this new series which had been heralded so ambitiously and which he said was to 'gratify the world with such a sight as they have never seen equalled',[10] he had declared war not merely on the history painters themselves but on the whole morality of property and conspicuous expenditure which enabled them to earn a living.

His attitude had economic and social implications far beyond the confines of the art world. Just as dynasticism and property held up the whole social order, so conspicuous expenditure was thought to be essential for the economic life of the nation. If rich men did not live extravagantly, how could poor men be assured of employment? God had put the rich man in his castle in order that he should constantly improve it so as to provide work for the poor man at his gate. Labour-ing men often rioted in the eighteenth century; but in most cases their discontents could be traced to frustration rather than envy. They wanted their betters to enjoy themselves in order to employ them, rather than deny themselves in order to emulate them. The sort of inverted economic and social morality which Hogarth was preaching was not entirely new – it had become very fashionable in France, where philosophers and men of letters generally were busy deciding whether or not *la luxe* was the lynch-pin of economic activity – but it was by no means entirely acceptable either. Ironically enough, the

French tended to put forward England as an example of a country which was failing to make the best of its commercial opportunities because of its puritanical distrust of luxury. The abbé Leblanc was shocked to hear the English 'rail at luxury' and tried to point out to them that while it was 'incontestably dangerous to a small state, deprived of the advantages of commerce', it was of inestimable benefit to richer countries. 'Luxury does not only promote commerce,' he concluded, 'but it also contributes, as the English themselves find by experience, to make arts and manufactures flourish . . . what value do the wools we purchase out of England and Spain acquire at the Gobelins and at Beauvais!'[11] Hogarth's economic reasoning in the *Apology for Painters*, when he argued that a readiness to buy luxury goods from abroad was 'a proof rather of the good sense of this country',[12] would have seemed very perverse to Leblanc; but at least it was better than a puritanical treatise which attacked luxury as the enemy of domestic bliss and the agent of dynastic nemesis. Hogarth had resolved, he later insisted, to live by 'dealing with the public in general' and obtaining 'small sums from many'; but among these generalised and somewhat idealised customers there were those who themselves lived by obtaining large sums – or small shares of large sums – from the few. Appealing to the public in general over the heads of the connoisseurs was not as simple as it seemed.

The appearance of *Marriage à la Mode* was accompanied by other and equally dramatic appeals. In February 1745 Hogarth distributed engraved tickets headed '*The Bearer hereof is Entitled (if he thinks proper), to be a Bidder for* Mr Hogarth's Pictures, *which are to be Sold on the Last day of this Month*'. According to Vertue the tickets were only given to 'Gentlemen, Noblemen & Lovers of Art' – artists themselves were excluded from the sale.[13] The subject of the engraving was a battle of pictures, challenging comparison with a satire which Swift had published in the year of Hogarth's birth and which had described a 'battle of the books' between the Latin and Greek classics and their modern counterparts. Swift had portrayed the old writers as the better of the two armies, but Hogarth's picture showed the old masters beating in vain against a small but select cohort of his own

paintings. When the sale took place he got nearly £500 for some twenty or so pictures – a total which Vertue thought quite enough, the result of Hogarthian impudence and ingenuity rather than a true reflection of the value of the works, but which Hogarth himself regarded as an insult. He would not be satisfied until he could be sure of selling anything he cared to paint for at least as much as the average price paid for an old master. This would mean something well over £100, as opposed to the average price of £25 or so paid at the 1745 sale.

In spite of Vertue's indignation and Hogarth's own dissatisfaction there could be no doubt that the auction of February 1745, followed within a matter of weeks by the long-delayed publication of *Marriage à la Mode*, marked a new and triumphant stage in Hogarth's progress. There was awe as well as envy in Vertue's summary of his career, written just after the sale:

> As this remarkable circumstance is of Mr Hogarth, whose first practice was as an apprentice to a mean sort of Engraver of coats of arms, which he left & applying to painting & study drew and painted humorous conversations. In time with wonderful success – & also small portraits & family pieces, &c. From thence to portrait painting at large (& attempted History) thro' all which with strong and powerful pursuits & studies by the boldness of his Genius – in opposition to all other professors of Painting, got into great Reputation & esteem of the Lovers of Art, Nobles of the greatest consideration in the Nation & by his undaunted spirit despised under-valued all other present & precedent painters.[14]

This chaotic and ungrammatical catalogue of achievements summed up very appropriately the story of a man who was himself notoriously prone to false starts and contradictory inconsistencies. Nevertheless, there was now a consistent and recognisable pattern emerging at last. From the vantage point of 1745, as Hogarth brought his warfare against the connoisseurs into the centre of his work and made it the subject of a series designed to appeal to individual patrons and general public alike, it seemed that everything he had done before had been a preparation for this final gesture. His concern for the Foundling Hos-

pital, which he had helped to establish in 1739–41 and for which he was about to paint *Moses brought to Pharaoh's Daughter*, could be seen by the cynical as a calculated attempt to secure a prestigious free exhibition hall, and by the more charitable as a way of linking history painting to public benefaction instead of to private greed. He had also been one of the first artists to see the possibilities of Vauxhall pleasure gardens as a place to show off paintings: Jonathan Tyers, the lessee and manager of the gardens, was so grateful for Hogarth's help in making them profitable that he sent him a gold medallion entitling him to bring a coachload of friends to Vauxhall whenever he chose.[15] Hogarth was a good and loyal friend to Tyers and to the sad little creatures who were taken in at the Foundling Hospital; but this did not stop him mixing business with pleasure, self-advertisement with genuine kindness. And his particular form of self-advertisement presupposed the discomfiture of all rivals: well might Vertue say that Mr Hogarth had 'got into great Reputation and esteem . . . in opposition to all other professors of painting'.

Later in the year 1745 another challenge and another puzzle was produced for those professors of the art who happened to visit the studio in Leicester Fields. Hogarth put on show a painting of himself in all his uncompromising Englishness, flanked by a palette and a pug dog (plate 15a). He kept a succession of these dogs for many years – the earliest record of one dates from December 1730 – and he seemed to think that there was some innate connection between pug dogs and Englishmen. He described the breed as 'Dutch dogs' and he may have seen in them the same dogged determination and independence of spirit that his namesake Dutch William had brought to the English throne in 1688, when he had defended the liberties of both Englishmen and Dutchmen against the ambitions of Louis XIV of France. In reality Dutch culture and society were in many ways similar to French; but in the writings of Dutch publicists and the engravings of Dutch caricaturists it seemed as though the seven United Provinces which went to make up the Dutch Republic were the home of freedom and toleration and social equality, of commerical and scientific and intellectual progress, while in France the arrogant absolutism of king

and priest perpetuated an obscurantist and backward-looking way of life. Hogarth had been born in the year of Dutch William's first great diplomatic triumph over Louis XIV, the Peace of Ryswick, and his whole cast of mind had been deeply affected by this apparent identification of Dutch and English interests and virtues against the foppish enslavement of the French. His conversation piece of the Strode family, painted in 1738, showed a pug dog on one side of the room gazing with calm contempt at an angry and Frenchified dog on the other. And in *Captain Lord George Graham in his Cabin*, probably painted shortly after the self-portrait, the pug was made to put on a wig in order to mock at foppishness and over-ostentation of all kinds.

The image of Hogarth himself seemed to be a reflection in an oval mirror which was balanced on a pile of books between the pug and the palette. The device was not very convincing, since the position of the artist's scar made it clear that this was a picture of a picture rather than a picture of a reflection; and in any case the books – volumes of Shakespeare, Milton and Swift – were there to emphasise Hogarth's Englishness rather than to get the mirror to the right height. The palette, too, was a gesture rather than a record: this was not a painter in the middle of his daily work but a painter announcing that he was about to transcend it. The palette was clean except for a serpentine line with the inscription 'The LINE of BEAUTY, W.H. 1745'. What could this mean? Hogarth said later that he painted it in order to find out whether his fellow artists had any real notion of what it was that made a picture beautiful, what was the *Je ne sais quoi* that the connoisseurs raved about and claimed to be able to recognise. He was not impressed by the reaction he got:

> The bait soon took; and no Egyptian hieroglyphic ever amused more than it did for a time, painters and sculptors came to me to know the meaning of it, being as much puzzled with it as other people, till it came to have some explanation; then indeed, but not till then, some found it out to be an old acquaintance of theirs, tho' the account they could give of its properties was very near as satisfactory as that which a day-labourer who constantly uses the lever could give of that machine as a mechanical power.[16]

Painters, it seemed, could only apply the rules of visual composition as uncomprehendingly as the labourer used his lever. Connoisseurs and collectors, on the other hand, wrapped up the whole subject in pretentious nonsense and took refuge, when they were really pressed, in a phrase that summed up their twin faults of ignorance and francophilia: *Je ne sais quoi*. Some greater man, towering over connoisseurs and fellow painters alike, would have to reveal the truth about beauty. And that man would be William Hogarth.

But not yet. There must first be time for the art world of London to be suitably intrigued. Discussions on the nature of the sublime and the beautiful in art were rife at the time and it was not long before Vertue noted the gossip about Hogarth's theory, based on 'the inimitable curve or beauty of the S undulating motion line' as opposed to Giles Hussey's contention that all good pictures were built up from triangles.[17] Hogarth's friends listened patiently to his dissertations on the subject and one of them even dug out for him an 'old Greek Fragment' which purported to record a pronouncement by the Delphic oracle to the effect that 'the Source of Beauty should never be again rightly discovered, till a Person should arise whose Name was perfectly included in the Name of Pythagoras; which Person should again restore the ancient principle on which all Beauty is founded'. There followed a short demonstration of the fact that in Greek letters the name Hogarth was indeed 'perfectly included in the Name of Pythagoras'.[18] The whole thing may well have been intended as a joke; but Hogarth himself seems to have taken it perfectly seriously, for he kept the slip of paper by him until his dying day. He was not to be daunted either by the secret amusement of his friends or the open hostility of his enemies. One day, when his appeal to the public in general was wide enough and successful enough to show that he was overcoming the connoisseurs and not merely running away from them, he would fulfil the prophecies of the oracle.

There was still a certain disparity between the Hogarth his friends knew and the Hogarth whose claims to artistic and aesthetic supremacy were becoming so unrestrained. In some ways he was like an actor, his grandiose gestures before the public contrasting sharply with his

everyday life. Shortly after completing the self-portrait he painted a picture of his friend David Garrick acting the part of Richard III. Within the past few years Garrick had established himself as a new kind of actor, one who could make the previously flamboyant and exaggerated heroes of the stage into real and credible people. The painting was thus yet another gesture: the artist who already combined the simplicity of an ordinary Englishman with the profundity of an aesthetic philosopher could bridge the gulf between sublimity and reality as successfully as the actor he depicted. Hogarth was delighted when the painting was sold for the record price of £200; and for the rest of his life he was liable to quote this figure, even to the most casual inquirers, at the slightest provocation.[19] Hogarth the man was less successful in the business of dramatic representation. He had never lost his childhood love of 'Imitation and mimickry', but his verbal memory was not good enough to make him an actor. In July 1746, just after *Garrick in the Character of Richard III* had been published as an engraving, he and Garrick both took part in amateur theatricals at the house of John Hoadly, a mutual friend. Hogarth played the part of the devil's cook, threatening the other characters with the removal of their most private parts in order that these might be served up to his master. The general atmosphere seems to have been as hilarious as it had been in northern Kent fourteen years earlier; but according to the accounts of his friends Hogarth had immense difficulty in remembering his lines.[20]

John Hoadly and his elder brother Benjamin were both learned and scholarly men: if Hogarth was able to straddle the gap between the word and the image it was partly because of their help. John had composed the verses for *A Rake's Progress* and Benjamin was later to be of great assistance to Hogarth when he came to write down his theories about the nature of beauty. Their father, who was Bishop of Winchester, had been painted by Hogarth in the early 1740s. James Townley, a schoolmaster who was later to write a highly successful play, probably came into Hogarth's life at about the same time, as did Thomas Morell, who wrote the words for some of Handel's most famous oratorios. Other literary friends dated from an earlier and even

more contentious period: James Ralph, the influential political jour-
nalist, had defended 'the ingenious Mr Hogarth' against the connois-
seurs as long ago as 1732. And Henry Fielding, who had once been
deeply involved in the theatrical rivalries Hogarth had satirised in the
1720s and early 1730s, was now a close personal friend as well as a
powerful literary champion. Meanwhile Hogarth's personal ascendancy
in the artists' clubs was more marked than it had ever been before. It
was by now clear that his efforts at the Foundling Hospital, however
much they might have been prompted by genuine philanthropy, had
also provided the painters of London with the first permanent art
gallery the city had seen. It was extremely fashionable to visit it and
it was often highly rewarding to exhibit in it. The Foundling artists, of
whom Hogarth was one of the undisputed leaders, now formed a kind
of unofficial academy; and when they met formally for the first time
on 5 November 1747, a few days before Hogarth's fiftieth birthday, his
position among them was outstanding. He had flung down his chal-
lenges, he had made his dramatic gestures, he had surrounded himself
with powerful friends from all the worlds he proposed to conquer,
and his new weapons had already been uncovered. *Industry and Idle-
ness*, the first undisguised and unalloyed appeal to the public in general,
had been published three weeks earlier.

CHAPTER IX

Dealing with the public in general

Industry and Idleness was the most straightforward and least contro-versial piece of work Hogarth had done for many years. This time there were no preliminaries, no advance notices or subsequent apologies or subscription tickets. There were not even any paintings: each of the twelve plates which made up the series was engraved directly from drawings, so that there were no technical problems about reversals or mirror images and no business problems about the best way of disposing of the original paintings after the subscription was over. Indeed, there was no subscription: the prints were simply offered to the general public at twelve shillings a set, with an offer of alternative copies on better paper at fourteen shillings for those who cared to buy them directly from Hogarth's shop in Leicester Fields. These fourteen-shilling prints were all that the gentlemanly visitors to the shop could expect to find there. There was no longer any ques-tion of inspecting original paintings, signing subscription lists, specu-lating about the symbolism of the subscription ticket, wondering who or what would be attacked in the final engravings. There was no problem about caricature, or about the faces in the series being recog-nisable, since almost everybody shown was a member of the inferior classes and therefore a suitable subject for caricature and even for open identification. One contemporary pamphleteer told how he went from one print shop to another soon after the publication of the series, listening to excited customers telling one another who the various characters in the series were in real life; but it did not occur to him that any of these beadles or Methodist preachers or other humble per-sons who had been depicted would be in the position to make things

unpleasant for the artist.[1] This was something very different from the hazardous portrayals of the world of wealth and power which Hogarth had previously produced. Potential patrons as well as present ones had examined the scenes through which Tom Rakewell and the Squander-field family had moved with some anxiety, in case they saw themselves or their friends there. Even *A Harlot's Progress* had taken Moll Hackabout close enough to the world of fashion to permit some reflec-tions on the real people who inhabited it. But with the possible exception of Plate 8, in which civic dignitaries and their guests were portrayed as ill-mannered gluttons, there was nothing in *Industry and Idleness* to give this kind of offence.

There was not even anything to give offence to the connoisseurs. Tom Rakewell and the Squanderfields, like Moll Hackabout's Jewish protector, had hung their walls with pictures in order to give Hogarth an opportunity to taunt his artistic enemies. Even Moll herself had put prints up in her lodgings so that her creator could use them for his own satirical purposes. But Goodchild and Idle, the two apprentices whose interlinked and contrasting fortunes formed the subject of the new series, lived out their lives in rooms hung with nothing more controversial than moral exhortations and royal portraits. Only in the final plate, when the industrious apprentice Goodchild had been chosen Lord Mayor and was putting on one of those 'shews of all sort' which had delighted Hogarth as a boy, was there any extensive use of the 'picture within a picture' device. And even here it was concerned with the emblematic imagery of the City companies rather than the fashions of the art world. Nor were there any of the dangerous social and economic overtones which had been present in *Marriage à la Mode*. The story was a simple one, based upon the standard pious myths put out by eighteenth-century men of property for the benefit of the labouring classes. It showed how Idle's assorted vices led him steadily downhill, bringing him eventually to the gallows at Tyburn, while Goodchild's industrious attention to his master's business – and to his master's daughter – ensured that he finished up as Lord Mayor of London, having had an unpleasant moment on the way when he had to condemn his erstwhile fellow apprentice to death. Even in the

Autobiographical Notes Hogarth betrayed no consciousness of the ironic differences between his moral tale and the realities of life. He merely concluded, with some satisfaction, that the prints were 'calculated for the use & instruction of those young people (i.e., apprentices) wherein everything necessary to be convey'd to them is fully described in words as well as figures'.[2] Whereas earlier series had conveyed a savage sense of the corruption and graft of eighteenth-century London, *Industry and Idleness* told the inferior orders only what was good for them and preserved to the bitter end the polite fiction that success was based on honesty and hard work. The truth was that Hogarth's appeal to the public in general, far from being a truculent reaction against the gentlemanly world of his private patrons, was precisely what that world most wanted to hear.

In 1748 the war with France was brought to an end; and without further delay Hogarth prepared to take up again the threads he had been forced to drop when it had broken out. He set out for Paris, this time in the company of several other artists associated with the Foundling Hospital and with the academy in St Martin's Lane, and when he got there he was, according to one of his companions, 'clamorously rude' about almost everything he saw. Later he described life in France as 'a farcical pomp of war, parade of religion and bustle with little, with very little, business – in short poverty slavery and insolence with an affectation of politeness'.[3] These may have been his impressions on his earlier visit as well; but it is hard to resist the conclusion that five years of apparent success as the self-appointed champion of English painting had given him new confidence in his dealings with the fashionable but foppish art of France. Such business as he did transact in the French capital seems to have been more concerned with selling his own works abroad than renewing his contacts with French engravers. He had already arranged for the publication, two years earlier, of Rouquet's *Lettres . . . pour expliquer les Estampes de Monsieur Hogarth* and now he was glad to find that the popularity of his prints in France had grown despite the war. The original intention of the trip may have been to find new ways of getting French engravers to London, but by the time it was over he was more interested in new ways

of getting his own works put on sale in Paris. He now had sufficient confidence to export English values to France instead of importing French fashions into England.

On his way back through Calais he stopped to make a drawing of the gate there. It is not clear what form this drawing originally took; but he had never been very concerned about architectural detail and French military architecture was of particularly little interest to him. He was probably already meditating some sort of satire on French life, possibly featuring the leather-faced fishwives and the 'soldiers ragged and lean' whom he later mentioned as being typical of the country.[4] He was taken for a spy and hauled before the commandant of the garrison, who told him that if it had not been for the treaty between the two countries he would have been hanged from the ramparts. Hogarth was said to have been very sensitive about this episode, taking offence whenever it was mentioned; but he nevertheless lost no time in working it up into a painting as soon as he got back to England. The result was one of his finest works, a picture glowing with colour and combining more successfully than ever before the comic style to which his enemies said he was limited and the serious style to which he himself aspired. It was also a supreme example of his self-confessed determination to turn the world into a stage: the spectator looked at one gateway through another, the far one as two-dimensional as a back-cloth and the near one as divisive as the proscenium arch of a theatre. Between them they cut the picture into a series of separate planes. In front there were the leathery fish women and a starving Scotsman – 'I introduced a poor highlander fled thither on account of the Rebellion year before, browsing on scanty French fare'[5] – who between them framed the scene in the way that the carved supporters of the curtains had done in the final version of the *Beggar's Opera* picture. Then came a line of principal actors: a cook carrying a side of beef to the English tavern, some suitably lean and ragged soldiers, two men carrying a cauldron of the pitifully thin soup on which the French were supposed to live, and a fat monk eyeing the beef with the gross gluttony which was the prerogative of the clergy in this priest-ridden country. Behind them upstage was Hogarth himself, sketching

busily and apparently unconscious of the soldier whose hand was already closing upon his shoulder. In the distance, glimpsed through the far gate, was the 'parade of religion' which Hogarth disliked so heartily (see plate 16).

In the spring of 1749 the picture was published as an engraving with the caption *O ! the roast Beef of Old England &c*. This was the title of a popular song – one of the many with which Hogarth and his friends in the Sublime Society of Beefsteaks celebrated their sturdily carnivorous appetites – and in the *Autobiographical Notes* Hogarth was apparently reminded of it when he mentioned the 'great variety of pleasing airs' played by the clockwork organ as his *Harlot's Progress* paintings burned*. But it proved too cumbersome as a title for the print, which came to be known as *The Gate of Calais*. The self-portrait with the pug dog and the palette was also published as an engraving early in 1749. Both pictures included images of the artist himself – hence the care taken to ensure that he appeared the right way round in the prints† – and they also had something else in common: each in its different way recalled the year 1745, the zenith of Hogarth's career and also the year of the Jacobite rebellion from which his 'poor highlander' had fled and which had done so much to harden anti-French sentiment in England. Hogarth was also starting work in 1749 on another reminder of that year, a painting which showed the troops preparing to defend London as Prince Charles Edward, grandson of the deposed James II, marched down from Scotland in his bid to overthrow the Hanoverians. The picture was called *The March to Finchley in the Year 1746*, although in fact the incident it portrayed, the progress of the volunteers and regular troops up the Tottenham Court Road towards the encampment at Finchley, had taken place in December 1745. Hogarth seemed to have forgotten the details of the campaign, just as he had apparently forgotten that the continuance of his precious English liberties was the result of it. With the usual ambivalence of the Englishman he celebrated the victory over the would-be enslavers while at the same time satirising the army that had won it. Like his love of roast beef and his defiance of French fashions,

* See above, pp. 109–10. † See above, p. 113.

this double-edged attitude to military men was typical of the independent country gentlemen to whom he wished to appeal.

He moved a step nearer to them in real life on 13 September 1749, when he took a copyhold on a house in the Thames-side village of Chiswick. It was a modest building, some forty feet wide by twelve feet deep, and there was comparatively little land attached to it; but at least it was now given over 'to the Use and Behoof of William Hogarth of Leicester Fields in the Parish of Saint Martin in the fields in the County of Middlesex, Gentleman, his heirs and assigns for ever'.[6] Thomas Morell later asserted that the Hogarths had moved out to Chiswick soon after their marriage; but if he was right – which seems unlikely – they must have lived in rented property. Now they were the next best thing to freeholders, living in a house which they could pass on to their children and protected by an agreement which recognised Hogarth himself not as a tradesman but as a gentleman. Unfortunately there were still no children to pass the house on to: the family which moved into the new house that autumn consisted of Hogarth himself and four attendant ladies. He brought with him his sister Anne, now in her late forties, and his wife was accompanied by her widowed mother, Lady Thornhill, and by a young cousin called Mary Lewis. Since the house contained only two principal bedrooms – the other upstairs room, which boasted an elegant bay window looking out to the west, was apparently used as the best parlour – one or more of the ladies must have slept on the second floor where the servants' bedrooms were situated.

Hogarth's enemies produced occasional sneers about the rather unusual composition of his household and about the emotional climate it might be expected to generate: one newspaper remarked archly that his painting of *Sigismunda* was perhaps based on 'his own wife in an agony of passion – but of what passion no connoisseur could guess'.[7] And Samuel Ireland felt it necessary to defend Hogarth against the charge that he had once painted Mary Lewis as 'an ancient virgin . . . corpulent even to shapelessness'.[8] In fact, however, the life of the Hogarth family seems to have been perfectly harmonious: 'I will own if the postman should knock at the door in a week's time after the

receipt of this,' wrote William to Jane in the only one of his letters to her that has survived, 'I shall think there is more musick in't than the beat of a Kettle Drum, & if the words to the tune are made by you, (to carry on metafor) and brings news of your all coming so soon to town I shall think the words much better than the musick.'[9] This was when he was at the Leicester Fields house, apparently working on *The March to Finchley* – hence the speed with which the metaphor of the kettle drum came to mind – and it is significant that he looked forward to them all coming to town, not just to the appearance of his wife. He was clearly not resentful – or at least not openly so – of the circle of women by which he was surrounded. The room in which he was said to have slept in the house at Chiswick still has an ingenious brass device on the door, whereby nobody could enter until the occupant of the bed had pulled a string and released the catch; but this was a normal eighteenth-century defence against tactless servants rather than the last desperate invention of a beleaguered man.

Only the aged Lady Thornhill and the young Mary Lewis were able to spend the larger part of their time at Chiswick. The others were all involved, directly or indirectly, in the business which was carried on at the house in Leicester Fields. Dealing with the public in general meant having a base in London, even if the possession of a house in the country did make possible a more evenly matched contest with the connoisseurs. And this particular house only made the contrast between Hogarth's frugality and the connoisseurs' lavishness more obvious still, for it was less than half a mile away from Lord Burlington's spectacular neo-Palladian Chiswick House. William Kent, the man whom Burlington had loved to honour and Hogarth had loved to hate, had died in 1748; but the Italianate magnificence he had done so much to encourage was still displayed at Chiswick House, built for show and for occasional grandiose entertainments rather than for ordinary day-to-day living. Burlington continued to use his splendid Chiswick house from time to time until his death in 1753, but the Hogarths for their part concerned themselves with less aristocratic neighbours. James Ralph, Hogarth's champion among political journalists, lived in Chiswick; and John Ranby, an army surgeon with some

influential royal connections because of his reputation for dealing with gunshot wounds, had a house down by the river which Hogarth could see from his window. Even the servants in the Hogarth household reflected its lack of pretensions: there were six of them, a very small number for a fashionable painter with two houses to maintain, and they were strictly forbidden to accept 'vails'. The custom of 'vails', or tips for the slightest service performed, could make a poor man's visit to a rich man's house into a misery. In the great houses such as the Earl of Squander was trying to build servants could be as haughty as their masters and a good deal more grasping. Hogarth resolutely refused to allow this kind of behaviour and the painting which he did of his servants a few years after the move to Chiswick showed a group of dignified but quite unassuming people.[10]

Hogarth's professional establishment was as modest as his domestic one. He steadily refused to take apprentices – a practice which was in any case dying out among painters by this time – and he would not even take boys as pupils by the year. He told inquirers that this was out of his concern for the boys themselves – 'Painters are now grown so numerous that it is become an uncertain profession'[11] – but the decision also sprang undoubtedly from his own peculiar brand of defiant isolation. He saw himself as a unique phenomenon, owing nothing to his own apprenticeship and having nothing to pass on in his turn. He once remarked that genius was nothing but 'labour and diligence';[12] but this verdict, if he really believed it, was strangely at odds with his own methods of work. Other men might labour away with their collaborators and pupils, their drapery men and background men and all the other ingredients into which mere talent could be broken down; but he for his part must pursue his own transcendent and incommunicable vision. The only people he ever offered to teach were amateurs, and even then the offers were not very serious. He once told Mrs Pendarves that he would give her 'some rules of his own that he says will improve me more in a day than a year's learning in the common way'; but there is no record of the instruction ever having been given.[13] In spite of his readiness to pose as a typically down-to-earth commonsense Englishman, Hogarth could also behave sometimes

as though he were the guardian of some ultimate mystery which was
not for the eyes or ears of ordinary men. One day he would give his
secrets to the whole world; but in the meantime he would not entrust
them to the throngs of helpers and hacks with which other painters'
studios were crowded. He worked alone or almost alone, probably
getting one of his house servants to help with the printing of his
engravings and the general running of his studio.

By this time the final revelation, the ultimate appeal to the public
in general, was in active preparation. He had decided to put his ideas
on the nature of beauty into book form and his literary friends were
kept busy providing him with references and discussing with him the
form that the book should take. Like the Greek philosophers of old,
like Archimedes seeking his fixed point outside the universe or Dio-
genes squatting contemptuously in his barrel, Hogarth wanted to
demonstrate his detachment from the world he was about to instruct
and uplift. Actual physical detachment was impossible: the business
he ran from his house in Leicester Fields demanded his constant
attention and Chiswick was at best only a place of occasional retreat.
But he could at least detach himself even more conspicuously from the
art world and its quarrels. *Industry and Idleness* had gone some way in
this direction, but both *The Gate of Calais* and *The March to Finchley*,
popular and successful though they both had been, had revived the
old sneers. The picture of Hogarth himself among the Frenchmen had
been an obvious challenge to his francophile enemies among the con-
noisseurs, while the King himself had apparently taken offence at the
element of satire and caricature in *The March to Finchley*. The result
of this royal displeasure had been the dedication of the print to the
King of Prussia as 'an Encourager of Arts and Sciences' – another
open challenge to those artists who had the good fortune to be pat-
ronised by George II of England. What was needed was new subject
matter, sufficiently universal in its appeal to be free from imputations
of self-interested propaganda, and a new art form – an art form which
would kill once and for all the suggestion that the ingenious Mr
Hogarth was merely a caricaturist. Both these things Hogarth found
in *Gin Lane* and *The Four Stages of Cruelty*, the prints which he later

saw as his most significant work and which provided an essential pro-
logue to the publication of his book. More powerfully than anything
else he had ever done, more powerfully even than the prints which later
accompanied the book itself, these prints showed how misguided were
the charges that had been brought against him and how inadequate
were the aesthetic theories of the time.

Officially *Gin Lane* was the second of two contrasting prints: the
other, *Beer Street*, purported to show the happy consequences when
honest wholesome ale was substituted for gin. But when the two prints
were published, on 15 February 1751, it was made clear that they
were intended to 'reform some reigning Vices peculiar to the lower
Class of People'; and Hogarth himself, in the *Autobiographical Notes*,
confirmed that the condemnation of gin drinking had been the main
object of both prints. *Beer Street* was not really a subject in its own
right, a kind of liquid equivalent of *O ! the roast Beef of Old England*.
It was merely a negative image created as a necessary complement to
the positive one of the other print. And it showed it: *Beer Street* had
none of the power of *Gin Lane* and it meant very little on its own.
There was nothing in it that could not very soon be forgotten. On the
other hand few people who saw Hogarth's image of the gin-sodden
mother with her baby falling from her arms ever forgot it (see plate
21a). To this day it remains one of the most enduring and familiar of
all our glimpses of eighteenth-century life. It was of course a caricature,
a grotesque: even the most grudging connoisseur would not have
denied that this form of representation was suitable for 'the Vices
peculiar to the lower Class of People'. The French Academy, most
respected of all the connoisseurs' oracles, had laid it down long ago
that painters should adapt their style according to the status of the
person depicted: 'the dignity with which people of condition are
invested makes their actions more restrained, their movements more
composed, whereas the common people for the most part abandon
themselves more freely to their passions'.[14] And yet out of this deli-
berately exaggerated caricature Hogarth had created something which
came nearer than anything else in his work to that elusive quality of
'sublimity' which exercised the aesthetic theorists so much. All the

argument about the sublime soon took a new turn: John Baillie's *Essay on the Sublime*, published in 1747, had already stressed the extent to which the concept of sublimity was associated with horror and fear, with that process of 'purging by pity and terror' which ancient Greek writers had seen as the essence of tragic art. Edmund Burke's extremely influential *Philosophical Enquiry into . . . the Sublime and Beautiful*, published in 1757, was to push this idea a good deal further and was to reach a definition of the sublime which was more relevant to *Gin Lane* than to the kind of pictures which normally went under the name of 'sublime history painting': 'Terror is in all cases whatsoever, either more openly or latently, the ruling power of the sublime . . . I am convinced that we have a degree of delight, and that no small one, in the real misfortunes and pains of others.'[15] At last there was some intellectual and aesthetic justification for those who made great art out of the sufferings of real people rather than the posturings of allegorical figures.

The other powerful image in *Gin Lane* was a starved ballad seller sitting on the steps below the mother with the falling child. His skull-like face and emaciated body made him a reminder of death rather than life; and just as in this print the eye was led inexorably down to an image of ultimate decay and emptiness, so in *The Four Stages of Cruelty* all the themes converged upon the final horror of the dead body on the dissecting table, its mouth hanging open as if in agony as the surgeon plunged a knife into its eye socket (see plate 21b). Hogarth took greater pride in *The Four Stages of Cruelty* than in anything else he ever did: though the four prints were announced at the same time as *Beer Street* and *Gin Lane* and published only a week later he seems to have looked back on them as a separate and more significant offering. Their intention, he said in the *Autobiographical Notes*, was to 'prevent in some degree that cruel treatment of poor Animals which makes the streets of London more disagreeable to the human mind than anything whatever, the very describing of which gives pain'.[16] He had a great affection for animals and he kept the graves of his various domestic pets carefully and lovingly – when in 1874 the London *Graphic* reported the deplorable state into which his house had been allowed to

fall, it was the desecration of these graves which seemed the worst scandal of all. Yet the real force of *The Four Stages* lay not in the first two prints, where the main character was seen torturing animals for pleasure when he was a boy and then belabouring them for a living when he grew up, nor even in the third print, where he was being seized for the cruel murder of the girl he had seduced and corrupted. It lay in the fourth print, with its dramatic contrast between the impassive figure of the presiding surgeon and the convulsive horrors that were taking place in front of him. Even the skeletons on either side of the picture raised their thin arms in some kind of salutation. Here it was death and death's attendants that acted out the drama, while life looked on like the audience in a theatre. 'My Picture was my Stage,' wrote Hogarth, 'and men and women my actors, who were by means of certain Actions and expressions to exhibit a dumb shew.'[17] Never before had his dumb players performed such an unforgettable charade.

In spite of these glimpses of ultimate reality, the six prints published in February 1751 were for the most part reassuring and socially acceptable. *Beer Street* showed what pleasures the labouring classes could safely be permitted and *Gin Lane* depicted those which must now be denied to them: after many years of indecision, during which the propertied classes had weighed the disadvantages of gin against its advantages as a means of disposing of grain too rotten to be sold for other purposes, it was decided at long last in 1751 to pass an effective measure to restrict its sale. *The Four Stages* were a little eccentric, in that they suggested that it was cruelty to animals, rather than the cardinal sin of insubordination, that led to a life of crime. From an employer's point of view *Industry and Idleness* was the better series: the gallows should be used as an argument against lethargy at work rather than exuberance at play. But at least the severity of man's retribution was made clear; and in the first print it was a well-dressed lad – some said a representation of the young Prince George, future George III – who tried to restrain the natural brutality of the lower orders. In the third print a gentleman's residence, presumably the house from which the maidservant had stolen in order to please her

lover and future murderer, looked down on the apprehended criminal as implacably as the surgeon was to look down on his tortured corpse in the final scene. Whatever else was mocked in these prints it was not the sacred principle of private property and social subordination. Hogarth himself even explained the apparent coarseness of the engravings by reference to the didactic purpose they were meant to serve: 'neither great correctness of drawing or fine engraving were at all necessary, but on the contrary would set the price of them out of the reach of those for whom they were chiefly intended'.[18] There would have been little point, it seemed, in devoting the same care to instructing the lower classes as would have been needed to placate the connoisseurs.

And yet Hogarth found that his own argument led him almost immediately to shift his ground, to move from a negative attempt to explain the coarseness away to a positive attempt to justify it and even take a pride in it. 'What is most material even in the very best prints,' he wrote, 'viz, the Characters and Expressions, are in these prints taken the utmost care of and I will venture to say farther that precious Strokes that can only be done with a quick Touch, would be languid or lost if smoothed out into soft engraving.'[19] In fact these prints had given him new confidence: they had shown him that his crudities, perhaps even his tendencies to burlesque and caricature his subjects, were advantages which could be built upon rather than faults which must be forsworn. For years he had struggled to mark out his pathway to the 'grand style' of painting and to prevent his comic painting turning into a blind alley. Now he saw that the grand style itself might begin on the far side of caricature. But he was still not convinced: he still felt a desperate need to show that he understood the difference between the sublime and the ridiculous, between serious painting and caricature, and that the choices he made between these two forms were intentional and not accidental. He was already meditating the distinctions he would make in his book, between the kind of lines that were comic and the kind that were beautiful, and he determined to provide a practical illustration of his theories in advance. Londoners already had the chance of seeing examples of his sublime history painting at

St Bartholomew's, at the Foundling Hospital and at Lincoln's Inn; now he would give them also the opportunity of possessing two of these paintings, *Paul before Felix* and *Moses brought to Pharaoh's Daughter*, in engraved form. And to make sure that they appreciated his dual greatness, the breadth of vision that enabled the sublime history painter to be at the same time the creator of *Gin Lane* and *The Four Stages*, he would deliberately modulate his sublimity into caricature and issue a burlesque of *Paul before Felix* as a subscription ticket.

It was a disastrous decision. The ticket, which claimed to be 'designed and scratch'd in the true Dutch taste by Wm Hogarth', was intended as a satire on Rembrandt; but in the event it turned out to be perilously close to a satire on William Hogarth. It was crude and obscene, as different as Hogarth could make it from the original painting (see plate 22a). But it was not different enough. Various devices had been used to mock Rembrandt's alleged vulgarity and thus by contrast to emphasise the sublimity and restraint of Hogarth's original painting. Instead of Felix showing his disquiet by the expression on his face, as in the painting, he was made to lose control of his bowels, with results which clearly disgusted those around him (see plate 22b). But when subscribers received their engravings, early in 1752, there must have been many who wondered whether the sublime Felix, like the burlesque one, had physical as well as spiritual reasons for his slightly comical look of apprehension. Indeed, Hogarth's own engraving of his painting introduced into the composition several new elements which pushed it nearer to caricature. An alternative version, engraved by Luke Sullivan, kept more closely to the original; but it is not clear which version was issued to subscribers. In the light of all this parodying even the original painting began to look less sublime: most of the faces in it, even that of Paul himself, had traces of caricature in them which could be detected by a critical observer once his attention had been drawn to them by the burlesque.

This subscription, disastrous though it was for Hogarth's artistic reputation, was very successful financially. Indeed, his business acumen had been very much to the fore in recent years and it had begun to attract some very unfavourable comment. 'Mr Hogarth . . . is often

projecting schemes to promote his business in some extraordinary manner,' wrote George Vertue.[20] One of the most extraordinary had been the subscription for the engraved version of *The March to Finchley* in the spring of 1751. It had been kept open for six weeks and during that time anyone who paid seven shillings and sixpence for the prints themselves plus an extra three shillings for a lottery ticket could have a chance of winning the original painting. When the subscription closed there were 157 of the 2,000 tickets left unsold; and these were given by Hogarth to the Foundling Hospital. By a lucky chance – some cynics suggested it was something more – one of these was the winning ticket, so that Hogarth had managed to collect an extra £276, in addition to the £700 or so he got for the prints, and still have his picture on permanent exhibition at his favourite London gallery. And of course the prints were still on offer, now priced at ten shillings and sixpence even without the lottery ticket. 'Such fortunate successes are the effect of cunning artful contrivance, which men of much greater merit could never get or expect,' wrote Vertue bitterly.[21]

The next contrivance was even more involved but far less rewarding. On 28 May 1751 Hogarth put an announcement in the newspapers saying that he intended to auction the *Marriage à la Mode* pictures, which had apparently been intended for the 1745 auction (one of them had featured in the *Battle of the Books* bidder's ticket on that occasion) but had been withdrawn. Now Hogarth laid down the following conditions for their sale:

> That each Bidder sign a Note, with the Sum he intends to give.
> That such Notes be deposited in the Drawers of a Cabinet, which Cabinet shall be constantly kept lock'd by the said William Hogarth. And as the Cabinet hath a Glass Door, the Sums bid will be seen on the Face of the Drawers, but the Names of the Bidders may be conceal'd till the Time of bidding shall be expired.
> That each Bidder may, by a fresh Note, advance a further Sum, if he is out-bid, of which Notice shall be sent him.
> That the Sum so advanced shall not be less than three Guineas each time.
> That the Time of Bidding shall continue 'till Twelve o'clock the 6th Instant, and no longer.

That on Friday the 7th Instant, the Notes shall be taken out of the Drawers, in the Presence of as many of the Bidders as please to attend; when it will appear who shall bid the most Money for the Pictures, to whom they shall be delivered, on paying the Money.[22]

These arrangements were idiosyncratic enough in themselves; but they were followed by an even more inward-turned and self-revealing paragraph, in which Hogarth explained that he had to find some way of giving his paintings the same scarcity value that the connoisseurs were prepared to put on the works of dead artists. He did not propose to die, but he did warn his patrons that *Marriage à la Mode* 'will be the last Suite or Series of Pictures I may ever exhibit, because of the Difficulty of vending such a Number at once to any tolerable Advantage'. He concluded by appealing to 'whoever has a Taste of his own to rely on, not too squeamish for the Production of a Modern, and Courage enough to avow it' to make a bid for the paintings and thus give himself the honour of holding them in trust 'till Time, the suppos'd Finisher, but real Destroyer of Paintings, has render'd them fit for those more sacred Repositories, where Schools, Names, Hands, Masters, &c, attain their last Stage of Preferment'.[23]

This apocalyptic vision of his work's ultimate fate was to haunt him in one form or another for the rest of his life. Previously he had thought of the connoisseurs of the present as his greatest enemies; now he began to realise that their power over him was as nothing compared with that of the connoisseurs of the future. And he was right: there were still centuries of injustice and misunderstanding to come. In the meantime there were the collectors and connoisseurs of his own time to be faced. When Hogarth opened his glass-fronted cabinet he found one bid only, of £120. The next day, when he appeared in his shop for the auction itself, there was nobody there. He had said that he would not admit any dealers and he had also asked his friends to keep away because he feared the room might be too crowded; and now it seemed as though his precautions had worked only too well. 'This *nouvelle* method of sale probably disobliged the Town,' wrote the pictures' ultimate purchaser, 'and there seemed to be at that time a combination against poor Hogarth.'[24] Eventually, after three hours of waiting, a

Mr Lane of Hillingdon walked in. He offered to turn the pounds into guineas – that is, to pay £126 instead of the £120 bid on paper – and this Hogarth had to accept. There was more humiliation to come: Lane generously offered to give the artist until three o'clock that afternoon to find a higher bid and still nobody came. At one o'clock Hogarth had to admit defeat and agree once more to settle for £126. The next day he tore down the gilded effigy of Van Dyck from over his door. It was intended as a gesture of defiance and contempt, but it had in it something of surrender as well. He was back in the old trap, the trap from which *Gin Lane* and *The Four Stages of Cruelty* had seemed about to release him. Instead of following them up he had returned to his obsessive task of self-justification, bringing forth his own inner doubts as unconscious hostages for his enemies. The vaunting confidence which the golden head had once symbolised was never to return.

His next public announcement was the opening of the subscription for his book, *The Analysis of Beauty*, in March 1752. Ever since he had first exhibited the 1745 self-portrait, with its enigmatic curving line, he had been convinced that when his great work finally appeared his detractors would say that his ideas were unoriginal and that they themselves could have formulated them if they had thought it worthwhile to do so. In order to warn the public in advance of sneers of this sort he decorated the subscription ticket with a drawing of Columbus standing a broken egg on its end. The story was well-known: when Columbus had been told by his dinner companions that his discovery of the New World could have been made by others if they had been so minded, his reply had been to ask them to stand an egg on its end. When they had failed to do so he had broken the egg, pointing out that this simple solution, like his voyage of discovery, seemed easy once it had been done. Hogarth's personal voyage of discovery had been as momentous in his own eyes as that of Columbus. He had brought back from it nothing less than the secret of beauty, the aesthetic talisman which would enable men to move at will from the sublime to the ridiculous, from the beautiful to the grotesque, and to know at each step precisely what boundaries they were crossing. It still did not occur to him that his real greatness might lie not in marking out yet again these unreal frontiers so beloved of the connoisseurs, but in sweeping them away.

CHAPTER X
The true genius of the nation

Those who subscribed for the *Analysis of Beauty* in March 1752 had to wait until the end of the following year before they received it. For months on end Hogarth drafted and re-drafted his comparatively short book, continually torn between his own spontaneous vision and the caution of his literary friends. As well as friends there were also disciples: John Joshua Kirby of Ipswich, a fashionable art teacher whose pupils included the heir to the throne, was anxious to publish a book of his own and sought advice – not to mention a frontispiece – from Hogarth. In return he provided unflagging praise and encouragement. His speciality, ironically enough, was linear perspective – a technique which Hogarth himself had been slow to acquire. Further encouragement came from France itself, the very fountain-head of all the punditry and stilted academicism which the *Analysis* was to attack. 'The humbug *vertu* is much more out of fashion here than in England,' wrote Hogarth's publicist and collaborator Rouquet from Paris in March 1753. 'Free thinking upon that and other topics is more common here than amongst you if possible, old pictures and old stories fare alike, a dark picture is become a damned picture as the soul of the dealer.'[1] Most important of all, there were kind words from influential men who themselves moved in the world of fashion. William Warburton, future Bishop of Gloucester and already famous as a man of letters, wrote four days after the subscription opened, asking for two copies and expressing the hope that the book would confute 'that worthless crew professing *vertu* and connoisseurship, to whom all that grovel in the splendid poverty of wealth and taste are the miserable

bubbles'.[2] From all sides there were signs that the time was ripe for a final attack on the connoisseurs.

Conscious of the controversial nature of his task, Hogarth provided a Preface and an Introduction which between them took up nearly a fifth of the whole book. They reviewed the history of painting and they reviewed in particular the attempts that had been made, from the time of Apelles in ancient Greece to that of Michelangelo in sixteenth-century Italy, to define the nature of visual beauty. There were also several references to Lomazzo's *Tracte containing the Artes of Curious Paintinge, Carvinge & Buildinge*, which had been published in English by Richard Haydocke in 1598. Lomazzo, like the Italian painters who had been his contemporaries, had been assimilated into the mainstream of aesthetic theory: the 'precepts of painting' laid down by the French academy in the late seventeenth century – and proclaimed by most connoisseurs ever since that time – owed a lot to him. There had been other treatises, equally influential in England and the Dutch Republic if not in France, which had put a point of view different to that of Lomazzo; but these, oddly enough, Hogarth did not cite. Franciscus Junius' *The Painting of the Ancients*, published in English in 1638, had declared that painting and drawing 'doe not demand an endless labour . . . verily, the whole art of painting may wondrous well be comprised in a small number of precepts . . . when there is on the contrary a great stirre kept about the first rudiments of these arts, it is very often seene that young beginners are alienated from the art'.[3] Having thus disposed of the dogmatism of the academies, Junius had gone on to recommend methods similar to those Hogarth himself had adopted: the painter, he had said, should try to understand the nature of the visual world and 'store up in his phantasie the most compleat images of beautie'. And by way of further reassurance he had reminded his readers that the 'grand style' had not been the only route to artistic fame in the ancient world: 'Calaces got himself a great name by making of little comical pictures . . . Pyreicus, although he was in his art inferior to none, yet hath hee painted nothing but barbours and coblers shops.'[4] But Hogarth was not concerned to justify his 'little comical pictures' or to identify himself with the Anglo-Dutch tradition of

painting. He was determined to carry the war into the enemies' camp and show that he could out-talk, as well as out-paint, the Italianate and francophile advocates of the 'grand style'.

This turned out to be a serious mistake. The *Analysis* itself was an effective and well-argued treatise which was well received by the critics, but the Preface gave all sorts of handles to his enemies. They could accuse him of plagiarism, using the references to Lomazzo in order to suggest that the whole book was borrowed from him, and they could make fun of Hogarth's clearly rather uncertain knowledge of the Italian and French sources. The book itself was the work of a practising painter who knew precisely what he was doing and why he was doing it; but the preliminary parade of connoisseurship seemed to have been assembled hastily for the occasion by a man who was over-anxious and over-confident by turns. Once again he had penetrated enemy lines, only to find that the hostages he had left behind him out-weighed any advantages he may have gained. The main attack, however, was a powerful one. Instead of dealing with painting under the conventional headings which most aesthetic theorists copied from the French academicians, he started by considering the extent to which the beauty of an object depended on its fitness to perform its function. This in itself put in jeopardy such cherished theories as the so-called laws about the proportions of the human body: as he was to point out later in the argument, the ideal proportions for an oarsman who spent his life using his arms must be different from those for a man whose job needed great strength in the legs.[5]

Still more academic theories were demolished as he proceeded to discuss variety, symmetry, intricacy and other qualities necessary to make an object beautiful. Step by step he showed that while straight lines could provide for simple functions, more involved shapes were needed to accommodate the full complexity of human life – both what the human body had to do and what the human eye took pleasure in seeing. Therefore the secret of beauty lay in a progression from straight lines to curved ones, from simple curves to multiple ones, from two-dimensional curving lines to those conceived in terms of three-dimensional space. The ultimate in beauty was 'the precise serpentine line, or *line of grace*, represented by a fine wire, properly twisted round the

elegant and varied figure of a cone'.[6] It was this line, rather than any of the unreal mathematical tricks propounded by earlier theorists, that underlay the beauty of life itself: 'There is scarce a straight bone in the whole body. Almost all of them are not only bent different ways, but have a kind of twist . . .'[7] Thus the human body, made in God's own image, showed forth to perfection the principles upon which the whole of creation was based.

Even in the 1750s the physical sciences had accumulated sufficient evidence to suggest that Hogarth's vision of a universe made up of spiral forms was not entirely fanciful; and subsequent discoveries, especially in the field of molecular structure, have provided further illustrations. But the real aim of the *Analysis* was to describe the ways of men rather than the blueprints of God: it quickly moved from structure to behaviour, from the bodies men had been given to the use they made of them. 'Action is a sort of language,' Hogarth observed, 'which perhaps one time or other may come to be taught by a kind of grammar rules.'[8] Later in life he was to declare that painting itself was also a kind of language,[9] thus moving back once again to the idea of a 'universal language' which had inspired his father and many other seventeenth-century thinkers; but at this stage he was chiefly interested in the ways in which movements and gestures betrayed those who made them. For his final example he reverted to his favourite metaphor, the stage: if a foreigner knowing no English went to an English theatre, 'he would judge of low and odd characters, by the inelegant lines which we have already shewn to belong to the characters of punch, harlequin, pierrot or the clown; so he would also form his judgment of the graceful acting of a fine gentleman, or hero, by the elegance of their movements in such lines of grace and beauty as have been sufficiently described'.[10] This was the final and most valuable treasure Hogarth had brought back from his voyage of discovery: a talisman to distinguish the clown from the gentleman and thus, by implication, comic and grotesque painting from the 'grand style'. Having travelled the universe and peered into the secrets of its construction, he returned once more to the categories of the connoisseurs and to the social distinctions which they reflected.

This final act of self-revelation, like the earlier ones in the Preface,

did a lot to determine the way in which the book was received and the effects which that reception had on Hogarth himself. *Burlesque sur le burlesque*, a satirical print by Paul Sandby which came out shortly after the *Analysis* itself appeared in December 1753, concentrated on two main lines of attack: Hogarth's alleged contempt for the great Italian masters and his inability to paint sublime subjects without turning them into burlesque. His artistic self, shaped more like a pug than a human being, was shown painting an obscene version of the sacrifice of Isaac while his literary self read to him, presumably from his own treatise. On the wall was a magic lantern show in which the lantern was Hogarth himself, turning nature into a grotesque parody of herself which recalled his own disastrous burlesque on *Paul before Felix*. The 'line of beauty' itself, though it was to come in for some ferocious satire in Sandby's later prints, played a comparatively small part in this first one. It was the indiscretions of the Preface, together with the return to the burlesque-sublime antithesis in the conclusion, which provided Hogarth's enemies with their earliest and most effective ammunition.

In this both the book and its detractors were symptomatic of the time. The debate about foreign influence in the arts had by this time become enmeshed in a much wider debate about foreign influence as a whole: the confrontation between Britain and France, which had become world-wide during the wars of the 1740s and was to reach new intensity with the opening of the Seven Years War in 1756, seemed to be a clash not merely between two countries, but also between two totally opposed cultures, two contrasting political and social systems, each of which sought to undermine the other and win for itself undisputed supremacy in Europe and perhaps in the world. Frederick II of Prussia, that 'Encourager of Arts and Sciences' to whom the disgruntled Hogarth had dedicated his *March to Finchley* print in 1750, spoke of France and Britain as the would-be leaders of Europe, 'the first because of her armies and her great natural resources, the second because of her navies and her commercial wealth';[11] and he for his part declined to commit himself to either of these two rival self-appointed saviours. The French claimed to be preserving European civilisation from the disruptive effects of Britain's factious politics and

the insidious results of her obsession with money; the British, on the other hand, wanted to defend European liberties against the aggressive militarism of France's absolute monarchy and the persecuting fervour of her Roman Catholic hierarchy. The King of Prussia was sceptical of both claims and so, in his own way, was his English admirer William Hogarth. At the time of the 1745 rebellion Hogarth's friend Henry Fielding had pointed out, with biting irony, that if the Pretender won the English would lose their most cherished and most widely used freedom: their right to sell themselves.[12] In the summer of 1753, a few months before the publication of the *Analysis of Beauty*, Hogarth's other literary champion James Ralph made the same point more explicitly, and at greater length, in his journal *The Protester*. He praised the efficiency of the French government, commended the patriotism and altruism shown by the *parlements* and other public bodies in France, and contrasted these things with the squalid venality and corruption which seemed to result from the vaunted liberties of free-born Englishmen.[13] It was this nagging self-doubt, this sudden scepticism about the very things which were most crucial in the great confrontation, that gave a new dimension to the 'foreign influences' controversy and to Hogarth's part in it.

His own scepticism about politics remained clear and consistent throughout his life, from the disillusionments of the 1720s to the final despairing comments of the 1760s. There is no reason at all to believe, as some biographers apparently have done, that in middle life he accepted the need for political parties and saw the conflict at Westminster as a worthwhile balance of forces, a system of 'composed varieties'.[14] Like James Ralph, he thought that the price which the British paid for their freedom was a disastrously divisive parliamentary system in which the true interests of the country as a whole were constantly in danger of being swamped by the particular interests of greedy gangs of careerists who called themselves 'parties'. 'Let what party will prevail,' he wrote in the *Autobiographical Notes*, 'patriots can be no gainer.'[15] He considered that he had himself revealed, in his prints, the real nature of the *patria*, 'the true genius of the nation';[16] but what chance was there of this genius making itself heard above the

hubbub of party conflict? Some of the party leaders did indeed call themselves Patriots; but anybody who took them seriously was being as naïve and unrealistic as Hogarth himself had been when he portrayed the hydra of discord lying dead at the feet of Hercules. Now he knew better: he maintained his detachment from politics and made sure that any reference to one party was balanced by an equally unflattering allusion to its opponent. Moll Hackabout wrapped her butter in the works of a Whig time-server and showed her gullibility by posting up a Tory demagogue alongside her picture of Captain Macheath.

In 1747, however, the search for Patriotism, for the political expression of 'the true genius of the nation', took a new turn. In June of that year a General Election was announced and Hogarth made an unexpected excursus into politics by adding some topical allusions to a picture of an inn yard and putting it on sale as 'a print representing a Country Inn Yard at Election Time'. It was the first time the country had gone to the polls since the rebellion of 1745, during which many country gentlemen who had previously been suspected of Jacobitism had shown their loyalty to the Hanoverian dynasty. Naturally enough, the professional career politicians who had formerly viewed these men with suspicion now fell over one another to woo them. The King's ministers made extravagant promises of office and influence to any country gentleman who would agree to support the administration and these promises were matched by even more alluring offers from the court of Frederick Prince of Wales, now the acknowledged leader of a formed parliamentary opposition to his father the King.

The results were dramatic. The Election of 1747, the occasion for Hogarth's first foray into political commentary since the 1720s, was also the signal for a return to the turbulent politics of those distant days. For a whole generation men had comforted themselves with the thought that however fiercely the career politicians might rage, factious office-seekers against corrupt office-holders, there was always a large body of independent men in the House of Commons who could be relied upon to hold the balance and preserve the Constitution against extremism of all kinds, whether governmental tyranny or opposition irresponsibility. But now, in the face of the promises made by the

17a *Breakfast at the Nag's Head,* sketch, 1732, by Hogarth

17b Tailpiece for the end of the manuscript of Hogarth's tour, 1732

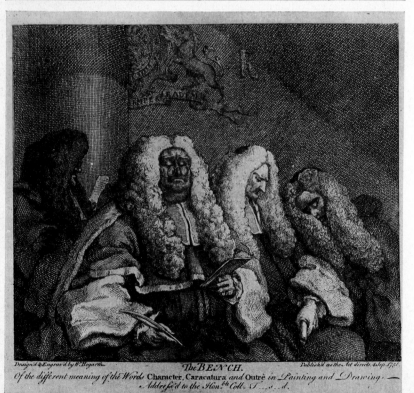

18a *Characters Caricaturas* by Hogarth, 1743

18b *The Bench*, first state, engraved version published 1758, Hogarth

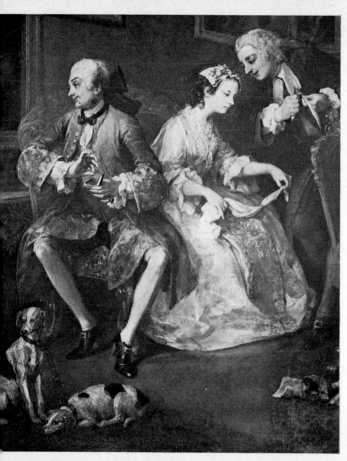

19a *Marriage à la Mode*, plate 1 (detail), by Hogarth, 1745

19b *Marriage à la Mode*, plate 2 (detail)

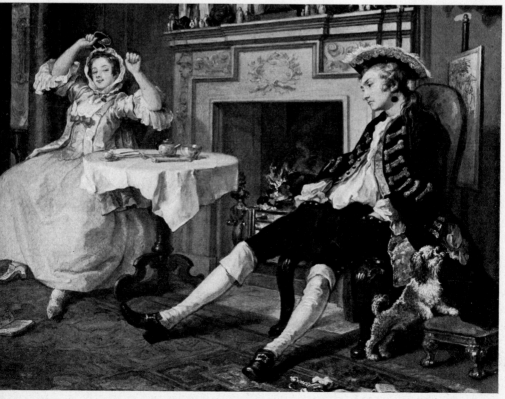

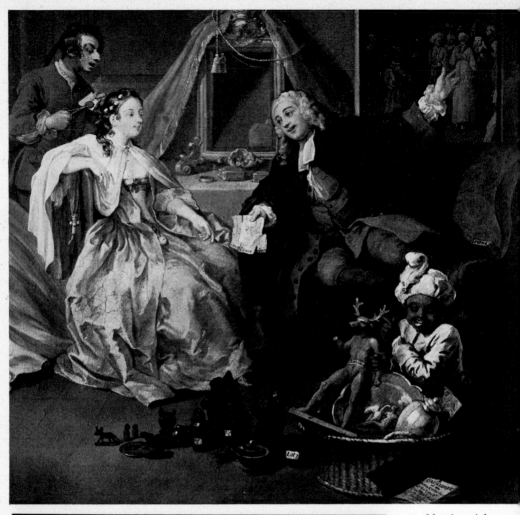

20a *Marriage à la Mode*, plate 4 (detail)

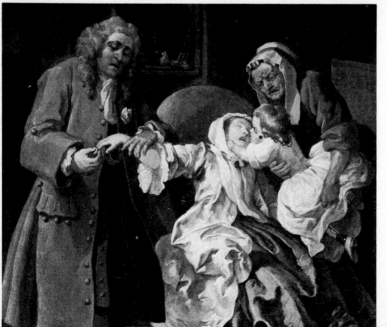

20b *Marriage à la Mode*, plate 6 (detail)

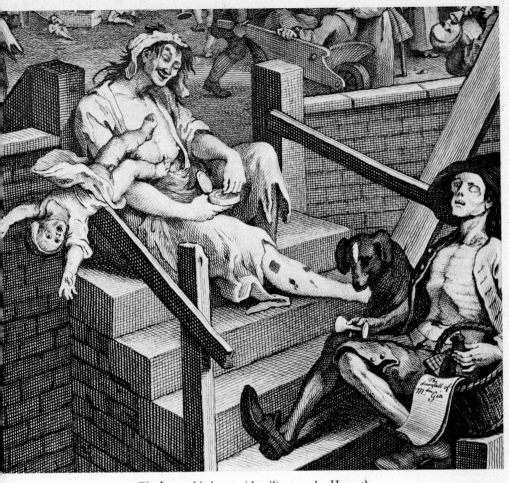

21a *Gin Lane,* third state (detail), 1751, by Hogarth

*The Reward of
elty,* engraving
ail), 1751, by
garth

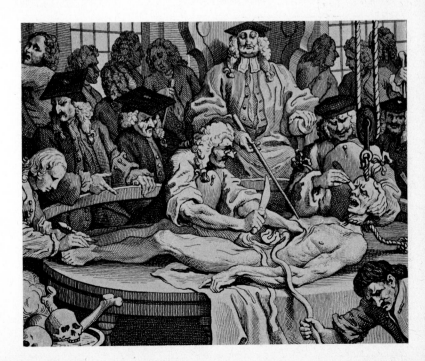

22a *Paul before Felix,* painting (detail), by Hogarth, 1748

23a (Opposite)
Invasion, first st
plate 1, 1756
Hog.

23b (Opposite) *1*
Invasion, first sta
plate 2, 1756,
Hoga

22b *Paul before Felix,* burlesqued, engraving, 1751, by Hogarth

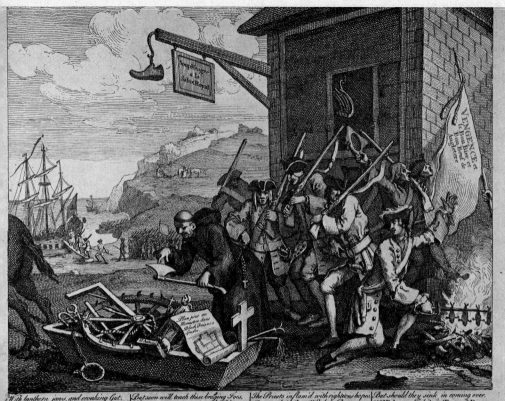

With lanthern jaws, and croaking Gut, / See how the half-starv'd Frenchmen Strut, / And call us English Dogs.
But seen we'll teach these bragging Foes, / That Beef & Beer give heavier Blows, / Than Soup & Roasted Frogs.
The Priests inflam'd with righteous hopes, / Prepare their Axes, Wheels & Ropes, / To bend the Stiff neck'd Sinner.
But should they sink in coming over, / Old Nick may fish 'twixt France & Dover, / And catch a glorious Dinner.

See John the Soldier, Jack the Tar, / With Sword & Pistol arm'd for War, / Should Mounseer dare come here.
The Hungry Slaves have smelt our Food, / They long to taste our Flesh and Blood, / Old England's Beef and Beer.
Britons to Arms! and let 'em come? / Be you but Britons still. Strike Home, / And Lion-like attack 'em.
No Power can stand the deadly Stroke, / Thats given from hands & hearts of Oak, / With Liberty to back 'em.

24a (Above) *The Lady's Last Stake,* painting, by Hogarth, 1758–9

24b (Below) *Sigismunda mourning over the heart of Guiscardo,* painting by Hogarth, 1759

ministers of the present King and by opposition politicians gathered round the future one, the myth of the independent country gentlemen started to dissolve. Sturdy squires whose reputation for Jacobitism had barred them from any advancement found themselves wooed from both sides. Their rivals in the counties, who had formerly had to pose as 'independent Whigs' in order to stand a chance against 'independent Tories', now found that it was no longer necessary to do so. On all sides there was an undignified scramble for offices and sinecures, for promises of peerages and reversions, for the chance to get commissions in the army or benefices in the Church for younger sons in need. The members for the counties, who had always been regarded as the hard core of the 'Patriots' or independent country gentlemen, now included a large number of men who were openly seeking promotion, either for themselves or for members of their family, and who were perfectly ready to line up behind the patrons and party leaders, the great lords whose carefully deployed political influence made nonsense of slogans like 'Patriotism' or 'independence'. Of the 180 county members who sat in the House of Commons between 1747 and 1768 there were only 64 who lived up to the independent gentleman's ideal and sought neither place nor patron.[17] The allegedly independent men who sat for borough seats soon followed suit. The hydra of discord was less fantastic than the creature which had been envisaged by the youthful Hogarth – at least it only had two heads, one spitting from the government benches and the other from the ranks of the opposition – but it had been given a new lease of life and a new store of venom.

By the early 1750s the venom had come to infect every aspect of public life. At Lichfield races in 1747 there was open fighting among both squires and great lords, as rival factions accused one another of destroying the traditional political independence of the counties.[18] Recriminations of this sort became even more hysterical in 1751, when Frederick Prince of Wales died suddenly and unexpectedly. His son, the future George III, was only thirteen years old; and those politicians who surrounded the boy feared – or pretended to fear – that his uncle the Duke of Cumberland would use his powers as Commander-in-

Chief of the army in order to usurp the throne from his nephew. Scurrilous pamphlets compared Cumberland to Richard III and were answered by others, equally scurrilous, suggesting that the supporters of the new Prince of Wales were 'disguised Papists, Jacobites and Tories'.[19] For a time the hydra became three-headed: one faction hoped that George II would live as long as possible, a second hoped that he would die while his grandson was young enough for Cumberland's political influence to become supreme, and a third looked forward to the young Prince coming to the throne with untrammelled powers once he had come of age. James Ralph in *The Protester*, when he was not deploring the divisive effects of the British political system and commending the patriotic unity of the French, occupied himself with elaborate ironies about the Regency Act which would give considerable powers to Cumberland if George II died too soon. 'I make bold to join with the general prayer,' he wrote in September 1753, 'that we may never be better acquainted with this provisional Act than we are at present.'[20]

In due course Hogarth was to involve himself irrevocably in these political conflicts. His 'Four prints of an Election', announced shortly after the publication of the *Analysis of Beauty*, were to provide an unforgettable comment on the collapse of the Patriot ideal; and the subscription ticket for these prints, an etching which has come to be known as *Crowns, Mitres, Maces, etc.*, was to become the vehicle for an unmistakable declaration of political allegiance. Having appeared originally with the Prince of Wales' crown in a prominent position it was altered within two months – that is, by May 1754 – in such a way as to give precedence to the crown worn by the Duke of Cumberland. In the *Autobiographical Notes* Hogarth was careful to distinguish between the attacks of his enemies in the art world, most of them resulting from the publication of the *Analysis of Beauty*, and the political invective, 'the abusive nonsense of party writers', which came later. In fact, however, aesthetic quarrels and political ones ran together and both were affected by the Franco-British confrontation of the 1750s and by the doubts which it produced. In the summer of 1753, while James Ralph was suggesting in public that British freedom

was really only faction and that French tyranny was also efficiency, he and Hogarth were having discussions in private on the *Analysis of Beauty* and on the questions to which it gave rise. One of these questions concerned the establishment in Britain of an official Academy of Arts modelled on the one which already existed in France. Would such a move mean importing French tyranny or French efficiency? Could it be adapted to British ideals of freedom without becoming entangled in typically British factions? Most important of all, could it be preserved from the corrupting influence of the party leaders, the sinister power of 'great men's promises'? Hogarth had hated and feared this power for years and Ralph had recent and very disturbing experience of it. Having used *The Protester* as a mouthpiece for his patron the Duke of Bedford, whose political position was becoming dangerously extreme and exposed, Ralph asked for assurances that he would be protected by Bedford's influence in Parliament if the government should decide to take action against him. These assurances were not forthcoming and in November 1753, the journalist was forced to change sides hastily, getting David Garrick to use his influence with Lord Hartington in order to make his peace with the ministry. Thanks to Garrick and his powerful friend – Hartington was heir to the dukedom of Devonshire and political head of the immensely influential Cavendish family – Ralph was able to settle for £300 a year from government funds, plus £200 to enable him to pay back the advances he had already received from Bedford.[21]

In the shadow of this episode, involving men who were among his closest friends and his most important links with the political world, Hogarth confronted the storm over the *Analysis of Beauty*. Within a matter of days his enemies switched their attack from the aesthetic arguments of the book to its political implications. Paul Sandby's second print, *The Analysis Besh——n in his own Taste*, showed Hogarth emptying his bowels while those around him registered their disgust at his outpourings, anal as well as analytical; and in the background, giving a new dimension to the satire, was 'a Public Academy Erecting in Spight of his endeavours to prevent it'. Hogarth later insisted that his opposition was not to the Academy proposal itself but merely to

'imitation of the foolish parade of the French academy'. In particular
he objected to the idea of older artists 'having salary, as in France, for
telling as they do there the younger ones when a leg or an arm was too
long or too short'[22]; but since he had just published a book denying
that there was a standard length for human limbs he could hardly be
said to be impartial or detached in this matter. Rightly or wrongly he
was seen as the man who had intrigued against the Academy proposal
in private and declaimed against it in public. Attempts by the St Martin's
Lane Academy artists to turn themselves into the nucleus of a Public
Academy had been frustrated in November 1753, just before the pub-
lication of the *Analysis of Beauty*; and some of these artists, convinced
that their failure was due to Hogarth's machinations, were determined
in advance to condemn his book as an arrogant and egocentric treatise
against academies. Hogarth for his part had to seek support where he
could find it: his sudden interest in politics in general and in Cumber-
land in particular was not unconnected with the fact that Prince
Frederick had been for some years the patron of the Academy
proposal.

 March 1754, the month in which Hogarth finally decided to abandon
his detachment from politics, was a season of fears and portents. Henry
Pelham, the man whose skill as First Lord of the Treasury had kept
the administration together, died at the beginning of the month and
George II was heard to remark that 'now he would have no more
peace'. After a rather unconvincing ministerial re-shuffle, which did
little to conciliate either the young Prince's supporters or those of the
Duke of Cumberland, Parliament was dissolved. For days on end
there were unprecedented blizzards which added to the general air of
uncertainty and unreality. 'Almost as extraordinary news as our political
is that it has snowed ten days successively and most part of each day,'
wrote Horace Walpole. 'It is living in Muscovy, amid ice and revolu-
tions.'[23] Hogarth, as yet unsure of the outcome of the General Election
but convinced that it would be worth recording, opened the subscrip-
tion for his proposed 'Four prints of an Election'.

 The great men of the realm, who had already discovered in 1747
how effectively their promises could undermine country gentlemen's

continual boast of independence, prepared to renew those promises on an even more extravagent scale. Counties which had regularly elected local squires as 'independent' members were suddenly faced with candidates who were avowed party men and who had the backing of powerful patrons in the House of Lords. In Oxfordshire, where local landowners had been returned unopposed for more than forty years, the Duke of Marlborough ran two Whig candidates of his own against the two Tories put up by the gentlemen of the county. He had made his intentions clear as long ago as the autumn of 1752, so that there had been ample time for passions to be stirred up on both sides – especially as the issues and events of 1753 were ideally suited to set Whig against Tory and to encourage each to pose as the true guardian of liberty and independence. Long before Oxfordshire actually went to the polls there were fights and riots throughout the county, demonstrations and counter-demonstrations, about the government's attempt to allow the naturalisation of Jews, about the new and allegedly tyrannous practice of calling the banns before allowing people to get married and even about the notorious 'lost eleven days' which the calendar reform of 1752 was said to have stolen out of people's lives. Horace Walpole's talk of possible 'revolutions' sprang from a vision of what might happen when the myth of 'independence' and the reality of oligarchic corruption grappled with one another in public and used the uninformed prejudices of ordinary people as their weapons.[24]

It was a vision that Hogarth shared. In March 1754, a month before the General Election actually took place, he was already able to tell his subscribers the titles of the 'Four prints of an Election' which they would receive: *An Election Entertainment, Canvassing for Votes, Polling at the Hustings* and *Chairing the Member*. This in itself was not surprising, since these were the obvious stages into which an eighteenth-century election campaign would be divided for satirical purposes. What was a little surprising was that each print when it appeared included allusions to the tumultuous and scandalous goings-on in Oxfordshire. Of the four paintings from which the engravings were taken, the first – *An Election Entertainment* – was almost certainly finished by March 1754 and the other three were well under way. The

first painting showed a feast which was uncannily like those to which the Oxfordshire electors were treated when they went to the polls in April; and similar visual anticipations of events in Oxfordshire and elsewhere continued throughout the series. In the last painting the chaired member, looking like the unsuccessful Whig candidate for Bridgwater but placed in the middle of a typically Oxfordshire riot, seemed to be falling from his chair even at the moment of triumph. This detail was later seen, both by contemporaries and by commentators, as a reminder of the fact that the successful Tory candidates in Oxfordshire were subsequently unseated for alleged malpractice by a Whig House of Commons; and yet the Commons decision was not known until April 1755, well after Hogarth had planned his final picture. The prints themselves were delayed because of difficulties over the engraving – the last one was not delivered until February 1758 – but as far as the original paintings were concerned the ingenious Mr Hogarth seemed to have excelled himself and brought topicality to the verge of prophecy.

Needless to say there was nothing clairvoyant about his insights into the 1754 election, either in Oxfordshire or in the country as a whole. Pre-election riots and scandals had been well publicised and allusions to them could easily be turned into aspects of the election itself. It only needed one or two neat touches like the paper in the first print, with its date '1 April 1754', to make a series of inspired guesses look like a record of actual events. As for the toppling member, he was less parochial than some commentators have imagined: he symbolised not the fate of the Oxfordshire candidates in particular but the insecurity of candidates in general, always liable to have their seats taken from them by partisan voting in the House of Commons. Hogarth's Election prints were able to achieve their unique blend of topicality and timelessness precisely because they commented on the ills of a whole political system as well as on the scandals of a particular county election. Given the course of political developments since 1747, it was relatively easy for anyone interested in politics to see in advance the form which this latest convulsion of the dying Patriot myth would take. To prepare an epitaph, whether in words or in images, it was not

necessary to be a prophet. All that was needed was a modicum of interest and an ability to diagnose the sickness.

But why should Hogarth have concerned himself with this particular diagnosis at this particular time? Why should a painter who had been viciously attacked for his ideas on aesthetics and his attitude to academies react by plunging into political complexities which he had ignored for thirty years? Ronald Paulson suggests that it was because he had been influenced by the ideas of the Patriot ideologists: 'Much that is obscure in the *Election* series and also in Hogarth's subsequent actions leading up to the political prints of 1762-3 would be clearer if one could assume that he had imbibed the popular ideas of Boling-broke's *Letters on the Spirit of Patriotism and on the Idea of a Patriot King* (published together in 1749).'[25] But these tracts by Bolingbroke did not say anything new: they merely summed up the tired old slogans which had been the stock-in-trade of opposition politicians and journalists since the 1720s. Nor did the *Election* prints commend such ideas: on the contrary, they mocked and derided them. They portrayed Bolingbroke's cherished Patriots as cheap demagogues, bucolic exploiters of senseless fears and ignorant prejudices. Nobody who studied these pictures carefully could believe that the man who composed them accepted Bolingbroke's fantasies about a body of independent men who would save the nation from the wiles of the career politicians. Hogarth in the spring of 1754 was not responding to an exciting new political ideal. He was exposing and dismissing in the bleakest terms a piece of outworn political cant which had been current among pamphleteers and caricaturists for most of his working life. To assume that he was taken in by it solves nothing.

There is, however, another and rather different assumption which may perhaps be made. During the winter of 1753-4 Hogarth the self-made man, Hogarth the doughty individualist who could stand alone against the whole artistic and political establishment of his time, had had a severe and very salutary shock. His position of pre-eminence had crumbled and the book which was to have secured it had become instead an object of ridicule. Suddenly he was desperately isolated and desperately vulnerable, the object of hostile political intrigues in the

St Martin's Lane Academy as well as of hostile caricatures in the print-sellers' shops. He needed friends, powerful friends who could offer him real protection and real prospects of advancement. It was time for the outsider to become an insider and seek the patronage of a great man. The obscurities in the *Election* prints are best explained not by assuming a conversion to Bolingbroke's Patriot ideals but by postulating quite the opposite: Hogarth at long last was ready to abandon the pious platitudes of the idealists and plunge into the harsh but lucrative world of the career politicians.[26] This was why the subscription ticket for the prints paid a compliment to the Duke of Cumberland. This was why the prints themselves, which derided the Patriot pretensions of Cumberland's enemy the Prince of Wales, were originally dedicated to Cumberland's political lieutenant in the House of Commons, Henry Fox. Hogarth had before him the example of James Ralph, who had extricated himself from a difficult situation by appealing to Lord Hartington, one of the chief links between Cumberland's men and the present administration. Hartington and Fox were close friends and by the autumn of 1755 Fox had joined the ministry as Secretary of State, and Hartington, now Duke of Devonshire, was regarded with some awe in political circles as a man powerful enough to make and unmake governments. He was certainly powerful enough to make or unmake William Hogarth.

Hogarth's collaborator in Paris, Jean André Rouquet, had already pointed out the harsh truth about the need for artists to have political patrons. His *State of the Arts in England*, the English version of which was published in October 1755, made it clear that no artist in England could hope for advancement 'if he has no right to vote at elections, or no protectors possessed of such a right'. The remark summed up neatly enough both the message of the *Election* prints and the motives that lay behind them. Rouquet's book, like almost every other contribution to the great debate about the relative merits of the British and French way of doing things, was couched in ironic terms: this custom of subordinating every aspect of national life to the needs of political jobbery was described as 'ministerial economy, founded on wise and prudent principles'.[27] In the spring of 1756 Hogarth brought his own

brand of irony to bear on the same subject, in two prints entitled *The Invasion* (see plate 23). On the face of things they presented the traditional contrast between the sinister forces of French tyranny and persecution, preparing to carry their instruments of despotism and torture across the Channel, and the courageous freedom of the British response to this threat. Yet there were uncomfortable overtones in the second print: the military preparations which were being made to meet the French invasion seemed to be vitiated by the general atmosphere of irresponsible amateurism and chaotic revelry. And why did the inn sign, a picture of the Duke of Cumberland, have the words 'Roast and boiled every day' hanging from it? It was true that any self-respecting tavern had to offer its customers good red meat, roast and boiled, every day; but it was also true that the beefy figure of the Duke of Cumberland was satirised almost daily in the journals run by the Patriot opposition parties. Was Hogarth rebuking the so-called independent country gentlemen yet again for the self-deluding anarchy which they encouraged and for the scant respect they showed towards their brave Commander-in-Chief? Or was he already beginning to regret his choice of patron?

There was probably some truth in both these interpretations. Cumberland had indeed become extremely unpopular, especially as he and Fox had been given wide powers under the Regency arrangements made when George II left the country to negotiate subsidy treaties with the princes of Germany. These treaties in their turn had been violently attacked in Parliament as being part of the Hanoverian militarist machinations for which Cumberland was held responsible. Horace Walpole, who had already made some very barbed comments about the Regency provisions, told his friends in December 1755 that even the invasion rumours were just another governmental device: 'With regard to the invasion . . . it is quite gone out of fashion again, and I really believe was dressed up for a vehicle (as the apothecaries call it) to make us swallow the treaties.'[28] By the time Hogarth's *Invasion* prints came out in March 1756 the invasion scare was back in fashion again but the ministry that had exploited it, the uneasy coalition between Cumberland's men and those of his father the King, was

beginning to fall apart. If the prints had indeed been part of a government-inspired propaganda drive to justify Cumberland and rebuke the irresponsible country gentlemen, then they had already become politically unadvisable.

Hogarth seems to have spent the summer of 1756 in Bristol, painting his altarpiece for the church of St Mary Redcliffe and paying scant attention to politics; but when he got back to London he found the government on the point of collapse. In October Henry Fox resigned and the indefatigable Duke of Devonshire undertook to form an alternative administration in alliance with William Pitt, who had been up to this time a supporter of the widowed Princess of Wales and of her young son, the future George III. Horace Walpole was very dubious about this arrangement: 'The very cement seems disjunctive,' he commented. 'I mean the Duke of Devonshire, who takes the Treasury. If he acts cordially he disobliges his intimate friend Mr Fox; if he does not, he offends Pitt.' Early in December he had to report that Devonshire's precarious balancing act had indeed failed: 'Mr Fox, extremely disgusted with the Duke of Devonshire for preferences shown to Mr Pitt, retired into the country.'[29] William Hogarth's first tentative quest for political patronage had failed also: the thing on which it had depended, the Cumberland-Devonshire-Fox triumvirate, had ceased to exist as a political force.

Two months later he decided to announce his retirement not just from the hazards of political satire but from the whole business of serving 'the public in general'. An advertisement put out in February 1757 said that difficulties with engravers had delayed the remaining *Election* prints yet again – in fact the second print was now ready, but it does not seem to have been delivered until the third and fourth were ready in February 1758 – and that once they were finished they would have no successors. 'That he may neither have any more Apologies to make on such an Account, nor trespass any further on the Indulgence of the Publick, by increasing a Collection already grown sufficiently large, he intends to employ the rest of his Time in PORTRAIT PAINTING chiefly.'[30] This farewell to the public may not have been entirely sincere – he was neither the first nor the last artist to use an

apparent readiness to go as a means of being asked to stay – but it did nevertheless convey a deep bitterness and a dark premonition of approaching death. His brother-in-law John Thornhill had a sharper presentiment and with better reason: he was mortally ill and he decided to resign the place of Sergeant Painter which he had held since his father's death. Hogarth may even have known of this impending vacancy, and of his own chances of filling it, when he made his dramatic announcement in February. Early in June the Duke of Devonshire, now occupying the comparatively humble office of Lord Chamberlain because his coalition with Pitt had collapsed and a new ministry was being put together, was able at last to perform a service for William Hogarth: he got him appointed as Sergeant Painter in succession to Thornhill, who then made his will, paid a last visit to Chiswick and died early in the autumn. Lady Thornhill died some weeks later on 12 November 1757, a couple of days after Hogarth's sixtieth birthday. At last, as he entered his seventh decade, the new Sergeant Painter could feel that he was the successor, and not merely the residuary legatee, of the man whose daughter he had married nearly thirty years before.

It was too late now to go back to the old dreams of sublime history painting. Hogarth himself had admitted as much in February when he had spoken of his future in terms of 'portrait painting chiefly'; and he said later that in 1756 he had had some difficulty in recalling to mind the principles of history painting in order to complete the altarpiece for St Mary Redcliffe*. Even portrait painting had become for him a public and controversial act rather than a simple contract between artist and sitter. In the *Autobiographical Notes* he listed it, along with the *Analysis of Beauty* and his political satires, as one of the 'three things that have brought abuse upon me'.[31] And when he celebrated his new status by painting a self-portrait with the title *Wm Hogarth Sergeant Painter to His Majesty* it was a strangely ambiguous work: he showed himself painting the Comic Muse, looking back to the glories of his comic histories and his dealings with the 'public in general' even as he looked forward to his new dignity as a court official. Not that the

* See above, p. 123.

office was particularly dignified: it was merely a lucrative sinecure, an appropriate reward for his political activities since 1754. Sir James Thornhill had achieved eminence in spite of it rather than because of it and his son-in-law was to find it of little use to him in his efforts to epitomise and exemplify 'the true genius of the nation'. He had turned his back on the Patriot myth, on the idea of the independent country gentlemen as the backbone of society, and his subsequent involvement with career politicans had turned out to be singularly ill-judged. In October 1757 the Cumberland party finally collapsed when the Duke himself resigned his position as Commander-in-Chief after an ignominious surrender in Germany. Pitt took office again, this time in a coalition with George II's favourites which led him to offend the future George III. Pitt too had his own brand of Patriotism, which involved him in the hopeless task of reconciling the belligerence of the commercial classes with the parsimony of the country gentlemen. Since he was leading the country into a colonial war which seemed about to enrich the former and bankrupt the latter, this was not an encouraging sign. William Hogarth, the newly appointed official of a king who was near to death and whose heir disliked most of the existing party leaders, had chosen a bad moment to say farewell to the general public. That amorphous and unpredictable public was in an uncertain state – 'The people are dissatisfied, mutinous and ripe for insurrection,' wrote Horace Walpole shortly after Cumberland's resignation[32] – but it might still prove a more reliable patron than the faithless and frightened politicians with whom Hogarth had now decided to consort. His search for 'the true genius of the nation' was not yet at an end.

CHAPTER XI
The rest of his time

Family business kept Hogarth at Chiswick for some weeks after Lady Thornhill's death. He told his friend John Ellis on 28 November 1757 that he had been forced to spend too much time away from London but that in two or three days 'I shall be in town for good'.[1] He intended to return as a conqueror and reassert once and for all the supremacy which had been challenged on all sides since the publication of the *Analysis of Beauty*. 'I have been assailed by every profligate scribbler in town,' he later wrote, 'and told that though words are man's province they are not my province . . . By those of my own profession I am treated with still more severity. Pestered with caricature drawings and hung up in effigy in prints; accused of vanity, ignorance and envy; called a mean and contemptible dauber.'[2] In the past his mastery over both word and image had been the secret of his greatness: he had been 'the author of these fine prints', a man whose work must be read and not merely looked at. Yet now, ever since the publication of the book which had been intended to set the seal upon this mastery, he had been torn apart by his enemies. While his words were dismissed as being insufficiently literary, his images were derided because they were insufficiently painterly. Men of letters resented him as an upstart painter invading their province, while his fellow artists insisted that his 'literary' qualities, his concern with telling stories and pointing morals, meant that he could never achieve real greatness as a painter. In this context compliments could be as wounding as open attacks: early in November, just before his sixtieth birthday and his mother-in-law's death, he had been hailed at the Foundling artists' tenth anniversary dinner as the 'Cervantes of the art'. It was an apt enough

comparison of its sort – Cervantes, like Hogarth, had raised burlesque to the level of great art and universal satire – but it was not particularly encouraging for a man who had just declared his intention of forsaking his Cervantes-like activities in order to concentrate on portrait painting. Even more galling was the fact that all the other painters mentioned in this celebratory ode were praised for more specific and more painterly achievements – Hayman for history painting, Lambert for his landscapes, Scott for his seascapes and Reynolds for his portraits, which were said to 'breathe at his command'. Only Hogarth was relegated to the realms of story-telling, a communicator rather than a creator.[3]

Samuel Boyce, the man who composed the ode for this festive occasion, probably intended it to be kindly enough. Like most people, he looked with admiration on Hogarth's work but regarded the man himself, with all his touchiness and his strange pretensions, with something rather less than admiration. Tobias Smollett had betrayed the same ambivalence some years before when he had set out to satirise Hogarth in his novel *Peregrine Pickle*: he had created a character called Pallet, in order to mock at the painter's bumptiousness and arrogance, but at the same time he had instinctively used phrases like 'it would be a difficult task for the inimitable Hogarth himself to exhibit . . .' when he had set out to describe scenes which were particularly comic or piquant.[4] However much the inimitable Hogarth himself might yearn for recognition as a sublime painter in the academic sense, his real greatness lay elsewhere. His comic histories, with their subtle intertwining of word and image, represented a tremendous achievement, in fact a triumphant synthesis which towered above the petty preoccupations of the painterly connoisseurs on the one hand and the literary purists on the other. And this achievement had never been greater than it was now, at the very moment when Hogarth himself wanted to turn his back on it. The second of the *Invasion* prints, the last work to appear before the valedictory announcement of February 1757, led the eye with unparalleled ingenuity from word to image and back again. The words under the *Duke of Cumberland* inn sign, 'Roast and boiled every day', brought to mind with intentional ambiguity two

different but linked ideas: the roast beef which was symbolic of English liberty and the meaty figure of the Duke himself, commonly nick-named 'the Butcher', who was attacked almost daily in the press. In case anyone should be offended by this allusion to a member of the royal family, Hogarth also showed soldiers drawing a caricature of the French King, a gentle reminder that English liberty carried with it the right to mock at royalty in a way that was forbidden on the other side of the Channel.

It was a reminder, too, of Hogarth's own preoccupation with the difference between caricature and true comic painting, the difference which he and his friend Fielding had been concerned to explain both in words and in images back in 1743. The words issuing from the mouth of the caricatured Louis xv, like those hanging from the inn sign, led the eye back into the visual imagery: they referred to the sailor on the inn table, who was accused of being a pirate and a thief. The doggerel which linked 'thief' with 'beef' had found its way into the world of nursery rhymes by this time; and Hogarth provided a visual equivalent in the shape of the round of beef by the sailor's feet, a sword lying across it in order to show that freeborn Englishmen carved their meat with the weapon which in France was the symbol of aristocratic arrogance and kingly tyranny. Placed in this context, both the beef and the cold steel gave rise to further associations which operated at the very frontiers of consciousness. The stubborn inde-pendence of John Bull, the virility he acquired from his eating of red beef, his attitudes to militarism and Hanoverian commanders-in-chief, his preference for sailors rather than soldiers – all were included in this masterly cycle of word and image.

And it was this astonishing virtuosity, this transcendent command of two separate and yet associated media, that Hogarth now proposed to leave behind him. His picture of himself painting the Comic Muse, with a reminder in its title of his new dignity as Sergeant Painter, was one part of the valediction: it was published as an engraving in March 1758. The second part, a satirical picture of four judges with an accompanying text, was published six months later. It was called *The Bench* (see plate 18b) and the legal luminaries whom it portrayed were

fairly easily identifiable; but the caption beneath them made it clear that they were not in themselves the real targets for Hogarth's satire. It read: '*The BENCH. Of the different meaning of the Words* Character, Caracatura *and* Outré *in Painting and Drawing. Address'd to the Hon^{ble} Coll. T . . . s . . d'*. George Townshend was a brilliant caricaturist and also a bitter personal enemy of the Duke of Cumberland – indeed, he had only just got his colonelcy a few months before, in May 1758, when he had returned to his army career after the Duke's resignation. Since the Townshends were a leading political family, with a dominant part to play in Parliament and in the affairs of the nation, many people considered that George's fiercely witty caricatures were in doubtful taste. They had made him many enemies, some of them as dangerous as Cumberland himself, and now it seemed that they had brought down upon him the anger of the King's Sergeant Painter. They were among the most wounding of those 'daily roastings and boilings' of Cumberland which had been alluded to in the *Invasion* print; and they summed up for Hogarth the sort of puerile scribblings which he showed soldiers drawing on tavern walls but which he himself scorned to emulate. Having shown in March that he was a painter who had deigned to conquer the field of comic history, rather than a mere storyteller who had learned to paint, he would now show that he was also an aesthetic theorist in his own right, capable of demonstrating that his own comic painting had been a variant of sublimity while that of the caricaturists was merely a form of scurrility.

It was an ill-advised gesture. Townshend had powerful friends, especially now that Cumberland was in disgrace, and he had been made an aide-de-camp to the King himself. His Militia Bill, aimed at creating a local force of freeborn Englishmen to counter the Hanoverian militarism represented by Cumberland, had been passed through Parliament the previous autumn with the support of the King's new chief minister William Pitt: it had gone some way toward reconciling the independent country gentlemen and justifying Pitt's claim to stand for that same spirit of Patriotism which Hogarth's *Election* prints had derided. William Windham, who had worked closely with Townshend to get the Militia Bill through, wrote angrily that Hogarth was 'an

ignorant conceited puppy' who 'has the impudence to attack my friend the Colonel' and must be punished.[5] Windham's threatened attacks never materialised, but there were plenty of others who commented on Hogarth's ignorance and misunderstanding of the very words he used. The text which accompanied *The Bench* read like an appendix to the *Analysis of Beauty* – indeed, it actually contained a note referring to that work – and therefore inevitably brought forth again all the old gibes about words not being Hogarth's province. His untutored insularity also came under attack again: anyone who could mis-spell 'caricatura', it was argued, understood little of the Italianate cultural tradition which he pretended to outshine.

Meanwhile the malign influence of the connoisseurs continued to dominate the world which Hogarth had now determined to re-enter. He was infuriated to learn that a supposed Correggio entitled *Sigismunda weeping over the heart of Guiscardo* had been sold for over £400 at the end of April 1758. He had recently finished a picture of Inigo Jones, which he had done for Sir Edward Littleton in the style of Van Dyck; and others of his portraits at this time were in the style of Rembrandt. But now he decided to show that he could equal not only Dutch masters but also those from Italy for whose works these fantastic prices were paid. His opportunity to do so seems to have come that same autumn, at about the time when *The Bench* was being attacked after its publication early in September. Sir Richard Grosvenor, whom Hogarth described as 'being infinitely rich', asked him to paint a picture on whatever subject he chose and to name his own price. Grosvenor had seen in Hogarth's studio a painting called *The Lady's Last Stake* (see plate 24a), which was being done for Lord Charlemont. It showed a lady who had lost everything at cards to a young officer and who was now deciding whether or not to stake her virtue as a way of winning it all back. It was very different from the portrait in the Dutch style which Hogarth had just completed and from the Italianate exercises in sublimity which he was now contemplating. It was in fact a comic history painting, a final display of Hogarth's old talents before he immersed himself for good in other kinds of painting. Grosvenor clearly expected something of the same

sort; but Hogarth the comic history painter had already said his last word and did not intend to repeat it. Instead he seized on Grosvenor's invitation as a chance to paint a picture which would rival the supposed Correggio and which would command the same high price. The gestures of valediction and retrospection were over: he had painted himself and the Comic Muse in order to indicate what his comic history paintings had been, and he had discoursed on caricature in *The Bench* in order to show what they had not been. For good measure he was painting *The Lady's Last Stake* in order to show that they could be fitted gracefully into the world of private patronage and did not have to risk the humiliations of public auctions and the distortions of incompetent engravers. Now it was time for a gesture that looked forward not indeed to pastures that were entirely new but to those which had been temporarily lost to interlopers and charlatans. The picture for Sir Richard Grosvenor would be a means of winning everything back.

Hogarth's last stake was to prove deeply distressing to him. Unlike the lady in his own picture, he could not simply offer his own spontaneous charms and wait for them to be enjoyed: he had to fashion a specific work of art with them and ensure its acceptability. And he had to do this at a time when he was becoming increasingly conscious of the approach of death and of the futility of human ambition. In November 1758 his friend William Huggins, son of the Warden of the Fleet, wrote to ask him if he would do the illustrations for his translation of Dante's *Divine Comedy*. Hogarth returned a graceful refusal, coupled with some very moving and revealing remarks about his own state of mind:

What you propose would be a noble undertaking which I believe ten or a dozen years ago I should have embraced with joy and would have pleased the public if I could have done the author any degree of justice; but consider now my dear friend, sixty is too late in the day to begin so arduous a task, a work that could not be completed in less than four or five years. The bubble glory you hint I have no antipathy to weighs less and less with me every day, even the profit attending it. I grow indolent & strive to be contented with what are commonly called trifles, for I think otherwise of what best produces the tranquillity of the mind. If I

can but read on to the end of the chapter I desire no more. This is so truly the case with me that I have lately (tho I enjoy and love this world as much as ever) hardly been able to muster up spirits enough to go on with two pictures I have now in hand because they require much exertion if I would succeed in any tolerable degree in them.[6]

The two pictures were those commissioned by Charlemont and by Grosvenor; and the latter was proving by far the more troublesome. Hogarth later said that he spent two hundred days on it, many of them consumed with agonising doubts and re-appraisals as the painting was altered and re-touched. Its subject was the same as that of the fake Correggio: Sigismunda grieving over the heart of her dead lover (see plate 24b). As well as outstripping the Italian masters in its sublimity, the picture was also to outdo them in its realism. 'My whole aim,' wrote Hogarth, reverting to his old analogy with the theatre, 'was to fetch tears from the spectator, my figure was the actor that was to do it.'[7] But in case Sigismunda herself should prove unequal to the task, the heart was also to do its bit: it was apparently a real one, provided by a surgeon friend, and there was blood from it on Sigismunda's fingers. Resplendent with such details the picture was proudly displayed to Sir Richard Grosvenor when he visited Hogarth's studio in June 1759. Beside it, in order to point out the contrast between the trivialities which other men commissioned and the sublimity with which he was to be honoured, was Charlemont's still uncollected *Lady's Last Stake*.

Grosvenor was horrified, so much so that Hogarth took offence and wrote him a rather equivocal letter some days later, reminding him of the terms upon which the painting had been undertaken but begging him to refuse it 'if you think four hundred guineas too much money for it'. He also hinted, perhaps rather foolishly, that there were others who would be glad to pay such a price for it. Grosvenor seized his chance and said that he would have no objection to its being sold to someone else, 'for I really think the performance so striking and inimitable that the constantly having it before one's eyes would be too often occasioning melancholy ideas to arise in one's mind; which a curtain's being drawn before it would not diminish in the least'.[8] So began the last and

most painful of all Hogarth's struggles with the connoisseurs: the struggle to get the *Sigismunda* recognised as a masterpiece. What Grosvenor had rejected the world must be made to accept. For the rest of his life Hogarth was obsessed with this struggle. He boasted about the picture constantly, showing it to all his visitors and rewarding them generously if they could bring themselves to praise it. 'A word in favour of his *Sigismunda* might have commanded a proof print or forced an original sketch out of our artist's hands,' wrote Nichols. 'The furnisher of this remark owes one of his scarcest performances to the success of a compliment which might have stuck even in Sir Godfrey Kneller's throat.'[9] But there was self-doubt as well as self-satisfaction; while compliments resulted in gifts, criticism resulted in re-painting and alterations. Some of these, such as the removal of the blood from Sigismunda's fingers, were concessions to public squeamishness; but most were in deference to what Hogarth's friend Thomas Morell later called 'the criticism of one connoisseur or another'.[10] Never before had these self-appointed arbiters of taste been so eagerly admitted to the studio of their arch enemy. Never before had their comments been so respectfully sought. Hogarth's last throw was no longer against Sir Richard Grosvenor but against the world itself, perhaps against posterity as well; and the connoisseurs, dishonest though they might be, were the only people who could be trusted to hold the stakes.

In December 1759 Hogarth announced the publication of a typically sardonic comment on this last grim contest. It followed closely on the re-issue of his *Invasion* prints – there had been another invasion scare that autumn – and it echoed the circular composition of one of his greatest popular successes, the last of the *Four Stages of Cruelty*; but these links with his comic histories could not disguise the introspective and preoccupied nature of this sombre new print. It was called *The Cockpit* (see plate 25) and its central figure, who represented the notorious blind gambler Lord Albermarle Bertie, brought to mind not only the presiding surgeon in *The Reward of Cruelty* but also the figure of Christ in Leonardo da Vinci's *Last Supper*. The fighting cocks themselves, the objects of the gambling fever portrayed by this

print, seemed to have attracted little of the artist's interest or sympathy: those pious commentators who have seen this print as part of Hogarth's campaign against cruelty to animals have always had some difficulty in making their case. It was a picture of human degradation, concerned above all with the pitiable vulnerability of the gambler. Bertie himself was especially vulnerable because he was blind; but those around him, even those who were busy stealing the money he had staked, were just as enslaved as he was by the passion which bound them all together. Even the advertisement which announced the print underlined Hogarth's own vulnerability: it stated that he was also re-issuing *Paul before Felix* and *Moses brought to Pharaoh's Daughter*, each of them adorned with long quotations from a treatise by Joseph Warton in which they had been unjustly attacked. Warton had already apologised for his mistake and had promised to correct it when his book went into a second edition; but Hogarth, gambling his whole reputation on his latest bid for sublimity, would not wait for this promised restitution. For him, as for the lonely figure he portrayed at the centre of *The Cockpit*, there was no time to be lost if losses were to be recouped and enemies fought off. Those who tried to steal his reputation must be mercilessly exposed.

Darkness was beginning to close in around Hogarth: like Lord Albermarle Bertie, he felt himself surrounded by a howling mob which he could neither understand nor control. According to his own account the rejection of his *Sigismunda* by Grosvenor led to an illness which lasted for a whole year. It has been suggested that he had contracted syphilis and that it was this disease which caused both his childlessness and also the distressing combination of mental and physical disorders which darkened the last few years of his life. On the other hand the trouble may have been, as he himself apparently believed, some kind of breakdown caused by the vicious attacks launched against him. 'I kept my picture, he kept his money . . . Ill nature spread so fast, now was the time for every little dog to bark in their profession and revive the old spleen . . . this affair, coming at a time when perhaps nature rather wants a more quiet life and something to cheer it, as well as exercise after long sedentary proceedings for many years, brought on

an illness which continued a year.'[11] Certainly his illness accentuated and intensified the sense of isolation and impotence which had helped to bring it about. He did very little work and he broke off his old sociable habits. In particular he was unable to attend a series of vital meetings of the Foundling artists during the winter of 1759–60, when they decided to associate themselves with the Society of Arts in order to hold an exhibition. The Society of Arts, founded by William Shipley in 1754, was really concerned with technology rather than the fine arts: its principal concern was to persuade inventors to make their ideas freely available in return for a premium, instead of seeking to patent them. Hogarth had joined it in 1755, but after a few months he had angrily cancelled his membership. To the end of his life he remained critical of the system of premiums; and he seems to have resented, as did many other people at the time, the Society's rather specious claims to be independent and disinterested. Its members liked to pose as public-spirited philanthropists when in fact many of them were busy promoting their business interests and using the Society as a link with the potentates of the political world.[12]

The exhibition which the Foundling artists held at the Society of Arts' premises in April 1760 certainly had political as well as merely artistic importance. Under the influence of Joshua Reynolds, who had by this time completely displaced Hogarth as the dominant figure in the various artists' clubs of London, it was decided to put aside the profits from the exhibition in order to provide a fund for 'the advancement of the arts'.[13] In October 1760, when George II died and was succeeded by his idealistic and well-intentioned grandson, it soon became clear that Reynolds and his supporters saw 'the advancement of the arts' in terms of the establishment of a Royal Academy. It was widely believed that the young George III was in favour of such an institution and it seemed that all the complex manœuvrings of the past few years could now be brought to a head by the triumphant Reynolds. And Hogarth, who had been repeatedly outflanked and isolated by his rivals in the art world, would simply be left as the man who had backed the wrong side at every stage of the game. He had published an anti-academic treatise, he had quarrelled with the Society of Arts, he had

offended many of the Foundling artists, he had stood out against the academy proposals.

Quite apart from these artistic and professional indiscretions, he had also made some political miscalculations. The new reign was startlingly different from the old: Horace Walpole told George Montagu in November 1760 that the equipages that flocked to pay court to the young George III were so numerous and so stylish that 'the Pretender would be proud to reign over the footmen only – and, indeed, unless he acquires some of them he will have no subjects left: all their masters flock to St James's'.[14] There was a grain of truth embedded in his airy exaggerations. George III was so anxious to end party politics that he welcomed, as honest and upright Patriots, those same specious 'independents' whom Hogarth had mocked in his *Election* prints; and the Whig party leaders whose favour Hogarth had so reluctantly and so belatedly sought in the 1750s were now snubbed at royal levees while the king looked favourably on men whom his grandfather would have regarded as Jacobites. The results of his impartiality were to be very different from his idealistic expectations: as Walpole himself remarked, 'the extinction of party is the origin of faction'.[15] But in the meantime men like Hogarth, who had backed the apparently powerful party leaders of the 1750s, were left in bewildered isolation. Even Sir Richard Grosvenor, whose family had long been the mainstay of so-called 'independency' in Cheshire, made his peace with the new monarch and accepted a peerage.[16] And Hogarth's hated rival Joshua Reynolds, now established in a grand house on the other side of Leicester Fields, hastened to make capital out of the new situation by getting up an artists' Address which greeted George III as 'a Monarch no less judicious to distinguish than powerful to reward'.[17] There seemed little fear that such a monarch would be so injudicious as to reward an artist who had not even been represented in the exhibition of 1760.

But in December 1760, before the projected Address had even been published, Hogarth began his counter-attack. He started to appear once again at meetings of the Foundling artists and he made himself the mouthpiece of those among them who were dissatisfied with the

exhibition of the previous spring and with the whole policy of associat-
ing with the Society of Arts. Even Reynolds found it expedient to
change sides: by the spring of 1761 he was busy looking for premises
in which the artists could hold an exhibition of their own. Involvement
with the earlier exhibition at the Society of Arts' premises suddenly
became a liability rather than an advantage; and Hogarth, who was
free of any such involvement, became the acknowledged leader of the
new campaign for complete independence. At a meeting of the
Foundling artists early in April 1761 he pushed through resolutions
which defied both the Society of Arts and the connoisseurs (described
as propagators of 'those errors and prejudices which have hitherto
misguided the judgements of true lovers of arts, as well as discourged
the living artists') and looked forward to the incorporation of the
artists as a society of their own, 'the Free Professors of Painting,
Sculpture and Architecture', with their own free academy and their
own exhibition rooms.[18] They decided to call themselves the Society
of Artists and they soon found suitable rooms in Spring Gardens, near
Charing Cross, where they planned to hold an exhibition early in May.
Hogarth was invited to produce a frontispiece and a tailpiece for the
exhibition catalogue. In the first he showed Britannia cultivating the
visual arts under the benign and watchful eye of George III; in the
second a pitiable ape-like connoisseur vainly tried to bring back to life
the withered masterpieces of the past (see plate 26b). Less than six
months ago it had been Hogarth's own art which had seemed moribund
and backward looking. Now, with startling speed and resilience, he had
turned the tables on his enemies.

Unfortunately the art whose phoenix-like qualities had thus been
demonstrated was not the art which Hogarth himself valued. These
drawings he did for the 1761 exhibition catalogue had all the freshness
and vigour of his early work: they made their point with precision and
without self-pity. They even recalled in some measure Hogarth's old
ability to drive both word and image in double harness. But they did
not satisfy the artist himself: he would only be content when he was
accepted as a creator and not as a mere communicator. The political
and polemical successes which had led up to the exhibition were all

very well, but they did not make up for the continuing public rejection of his *Sigismunda*. It had been put on show in February 1761 with an announcement to the effect that it would be engraved if there was enough public interest in it. A subscription was opened in March but had to be abandoned after a few weeks because there were too few takers. *Time Smoking a Picture* (see plate 26a), the etching Hogarth produced as a ticket for this ill-fated subscription, was a good deal more sombre than the drawings for the exhibition catalogue. The figure of Time, his scythe tearing the picture before him even as the smoke from his pipe gave it the dark patina which connoisseurs misguidedly valued, was far more portentous than the ape-like connoisseur with the watering can. And the allegory of the subscription ticket was more solemn than that of the exhibition catalogue precisely because it was more personal: it attacked not just connoisseurs in general but those particular connoisseurs who had dared to rate old time-smoked masterpieces above Hogarth's *Sigismunda*. When he had decided in 1757 to 'employ the rest of his time in Portrait Painting chiefly' he had brought into being a new and altogether more splenetic Hogarth, a glowering and obsessive creator of unique art objects which stood in his studio like mute substitutes for the children he had never had. The old Hogarth was still to be seen in public, playing the politics of the art world with something like his former zest and humour; but at home the new Hogarth sat and brooded over his grievances, breaking off only to retouch his neglected masterpieces or rewrite his unpublished tirades.

This was the Hogarth that Horace Walpole encountered when he visited the Leicester Fields studio early in May 1761, just before the opening of the Spring Gardens exhibition. The *Sigismunda*, which was to be shown at the exhibition along with *The Lady's Last Stake*, *The Roast Beef of Old England*, some portraits and one of the *Election* pictures, was still standing in the studio while Hogarth considered whether to alter it yet again. It looked, said Walpole, exactly like a picture of a whore tearing off the trinkets her client had given her in order to fling them at his head. He also noted with distaste that there was blood on her fingers 'as if she had just bought a sheep's pluck in

St James's Market'. He listened in silence as Hogarth boasted about his ability to paint as well as Van Dyck or Rubens; and then, as he prepared to go, he was asked to wait because Hogarth had something to say to him. The something turned out to concern Vertue's manuscript journals, which Walpole was known to have bought from Vertue's widow in order to use them as a basis for a book on the history of art in England. Hogarth was very anxious to know what was in the journals and what Walpole intended to publish: his excuse was that it might reflect on the reputation of Sir James Thornhill, but it was clear that he also wanted to know what Vertue had said about him personally. He asked to be allowed to correct Walpole's drafts for the proposed book; and when this somewhat impertinent request was ignored he went on to say that he was planning a similar book himself and wanted to make sure that the two did not clash. When Walpole said that his own book would be 'antiquarian' rather than 'critical', Hogarth seemed to be slightly happier: 'Mine is a critical work,' he replied, 'I don't know whether I shall ever publish it – it is rather an apology for painters – I think it owing to the good sense of the English that they have not painted better.' At this point Walpole decided that he had better leave before Hogarth's ideas became any more demented. 'If I had stayed,' he told George Montagu later, 'there remained nothing but for him to bite me.'[19]

The vision that Horace Walpole carried away with him that day, of a man driven by vanity and rancour to the very frontiers of insanity, was soon to be shared by the public in general as well as by an increasing number of Hogarth's own friends. During the remaining three years of his life the artist who had once held up a looking-glass to all mankind became known for his obsessive introspection. If his work was indeed a looking-glass it now reflected only his own likeness and the distorted images of his enemies. In the end the two became one. In the summer of 1763, goaded beyond endurance by the wounding satires of Charles Churchill,* Hogarth took the plate on which his self-portrait had been engraved and replaced his own likeness with a caricature of Churchill in the shape of a befuddled bear with a heavy club composed

* See below, pp. 191-2.

of lies (see plate 27). It was a strange gesture – Churchill himself commented that it was a form of suicide – and it was made even more strange by the fact that the original image which was thus removed had itself been a picture within a picture, framed in a way which made it seem like a reflection. Another of Hogarth's earlier works underwent a significant change in the summer of 1763: the last scene in *A Rake's Progress* was re-issued with a new scrawl on the walls of the mad-house. It showed the reverse side of a coin, dated 1763, with a crazed and dishevelled image of Britannia as though she too had become one of the pitiable creatures who surrounded Tom Rakewell at the moment of his final degradation. The private nightmares which came to Hogarth as he looked into the mirror were paralleled by the collective horrors which he saw in the world around him. Introspection had reached its last infirmity, the moment at which its subjective fears took on an apparently objective reality.

And yet there was another side to the story. The two years that elapsed between Horace Walpole's visit and the final battle with Charles Churchill were not just years of deepening paranoia. *The Five Orders of Periwigs*, a print which appeared in November 1761, showed little of the new virulence and something of the old urbanity. It pretended to be based on observations and measurements made at George III's coronation, which had taken place on 22 September, and it made the hierarchy of wigs into a parody of the five orders of architecture so beloved of the connoisseurs. *Credulity, Superstition and Fanaticism* (see plate 29), which came out in April 1762, was based on a similar blend of social satire and professional polemic. Its original unpublished version, to which Hogarth had given the provisional title of *Enthusiasm Delineated*, had been full of visual references to an attack which Reynolds had made on him anonymously in *The Idler* in the autumn of 1759 and which had been reprinted, also anonymously, in the summer of 1761. This first version had purported to show 'the idolatrous tendency of pictures in churches' and the enthusiasm which it attacked was the aesthetic enthusiasm which many connoisseurs admired in French and Italian painting and which they associated with sublimity; but in the published print the attack was concentrated almost entirely

on the religious enthusiasm of the Methodists. Horace Walpole, who detested Methodism, was delighted with *Credulity, Superstition and Fanaticism* and said that it was one of the most sublime things Hogarth had ever done.[20] Probably he still did not realise that if he had stopped to listen to Hogarth that day in May 1761, instead of rushing off for fear of being bitten, he might have heard a theory of art which accorded remarkably well with his own dislike of fanaticism and irrationality. Hogarth's remarks about the inferior achievements of English painters being the result of English good sense had not just been wild and whirling words: they had contained the kernel of a view of life and art which was beginning to emerge painfully from among his conflicting preoccupations and might yet make some sort of sense out of them.

One of the things which helped to bring this view into focus was the rather odd episode of the sign painters' exhibition in April 1762. Sign painters were artists of a very humble sort, but sometimes their work reached a very high standard. Hogarth himself probably did some sign painting in his younger days and now his office of Sergeant Painter made him something like a sign painter – or at any rate a supervisor of sign painters – for the King. This fact, which his enemies were always eager to exploit, had already brought him into contact with the frenzy of heraldic and decorative painting necessitated by the recent coronation. Now it made him a natural ally of the sign painters, whose exhibition both mocked and challenged the pretensions of more elevated categories of art. Signs of all sorts, most of them by unknown painters long since dead, were collected together and given fanciful titles which poked fun at connoisseurs and painters alike – even at Hogarth himself, whose line of beauty was an obvious target. Nevertheless it seems that he played an active part in organising the exhibition: and the signs shown included versions of the old 'Nobody and Somebody' figures which Hogarth himself had drawn thirty years before as illustrations to Forrest's account of the jaunt into Kent. More recently he had returned to the same idea in verbal terms: his papers included a projected 'No Dedication' for one or other of his literary works, setting out his reasons for not dedicating it to any particular potentate or friend and concluding by saying that it was 'Therefore Dedicated to nobody; But

if for once we may suppose nobody to be everybody, as Everybody is often said to be nobody, then is this work Dedicated to every Body'. This was an echo of something that Hogarth's friend Fielding had said many years earlier, when he had accused men of fashion in London of using the term 'everybody' to mean just themselves and 'nobody' to mean 'all the people in Great Britain except about twelve hundred'.[21] Behind Hogarth's visual and verbal puns – and also behind the sign painters' exhibition which brought this reminder of them – lay the old question of the few and the many, the question which Hogarth had already raised when he had sought 'the true genius of the nation' and which was also implicit in his remark to Horace Walpole about English painting and English good sense.

Similar questions were raised by *The Times, Plate 1* (see plate 30a), Hogarth's first and only exercise in party political propaganda, which appeared in September 1762. He claimed that it 'tended to Peace and unanimity and so put the opposers of this humane purpose in a light which gave offence to the Fomenters of destruction in the minds of the people'.[22] The chief of these fomenters seemed to be William Pitt, whose opposition to the peace treaty with France was shown in the print as an incendiary activity which was burning up the whole of Europe. Hogarth yielded to nobody in belligerence towards France – as recently as April of that same year he had 'talked much against the French' as he explained the symbolism of the *Election* prints to one of his visitors[23] – but he saw clearly enough that Pitt's commercial friends in the City of London wanted to continue the war for their own gain rather than for the good of the country. Their claim to be 'Patriots', to speak for the whole nation, was as specious as the similar claim put forward by the bigoted squires he had mocked in the 1750s. Indeed by this time Hogarth's political disillusionment was such that he began to think that the only true Patriots were the common people, the helpless puppets who were gulled and manipulated by squire and merchant and politician alike. When he started to put his ideas about the *Election* prints on paper he only got as far as a fragmentary passage about the two men who were fighting in the final print (see plate 31). They were, he wrote, 'two patriots who, let what party will prevail, can be **no**

gainer, yet spend their blood and time, which is their fortune, for what they think is right – a glass of gin perhaps to raise spirits and resolution even to die in the cause, which often happens in these contentions. What did the greatest Roman Patriots more?'[24] Just as the despised Mr Nobody was really everybody, so perhaps the mob itself, that 'headless multitude' so scorned by men of property, represented the true genius of the nation.

This was an astonishing conclusion for Hogarth to draw. All his life he had used the mob as a symbol of anarchy and unreason, a fiercely destructive force which constantly threatened such stability as men had been able to create in the world. Yet the fragment about the *Election* prints was not just an unconsidered trifle: it came at a time when he was known to be re-examining these prints and when his renewed involvement in politics gave them a new and sharper edge. George III's new minister Lord Bute, who had taken over when Pitt resigned in the autumn of 1761, certainly showed little gratitude for Hogarth's defence of his peace policy. *The Times, Plate 2* (see plate 30b), which seems to have been conceived as a companion piece for the first print in order to demonstrate the benefits that would come once the peace was ratified, was decidedly unenthusiastic about Bute. He was shown diverting the flow of royal patronage away from the party leaders in Parliament – George III and Bute, like Pitt before them, claimed to be saving the country from faction and corruption – but his efforts seemed to be directed towards a few fortunate placemen rather than towards the country as a whole, which was shown as being as much cut off from royal favour as the politicians themselves. This print, which in the end Hogarth decided not to publish, included a figure with a wooden leg – an echo of the peg-legged fighter in the election affray. Both were probably intended to represent ex-soldiers or sailors, men who had fought for their country in foreign fields and were now forced to fight again in election mobs for the sake of a few pence and a glass of gin. Like their creator, they would gain little whichever party prevailed. They might even 'die in the cause, which often happens in these contentions', without the politicians caring one way or the other.

By the end of October, only a few weeks after the publication of *The Times, Plate 1*, Bute himself was told that Hogarth was indeed dying and that arrangements had better be made about the succession to his post of Sergeant Painter. The rumour turned out to be exaggerated, but even Hogarth himself said that he was 'in a kind of slow fever' which was made worse by the attacks of his enemies.[25] Paul Sandby had re-emerged to taunt him, producing a print called *The Butifyer* in which the line of beauty became 'the Line of Booty' – Hogarth's alleged readiness to become a political hack for the sake of patronage and financial reward. George Townshend, who also had old scores to settle, published *The Boot and the Blockhead*, in which an enormous jackboot representing Bute was worshipped by a senile Hogarth with ass's ears. Charles Churchill, one of the Pittite journalists who had attacked Hogarth's print, was shown threatening to whip the artist, who cried: 'Damn it Charles, what have you done to me? You'll make me run mad.'[26] Perhaps the cleverest and certainly the cruellest part of the campaign against Hogarth in 1762–3 was this continually reiterated suggestion that the remains of his sanity, already precarious enough, could not survive this latest exposure of his vain and mercenary motives. John Wilkes, whose journal *The North Briton* was Pitt's most powerful mouthpiece, published a savagely wounding piece on Hogarth at the end of September 1762; and this literary onslaught, feeding and in its turn being fed by the spate of satirical prints, continued for the best part of a year and reached its climax in Charles Churchill's *Epistle to William Hogarth* at the end of June 1763. It was this that led Hogarth to blot out his own portrait and turn it into a caricature of Churchill:

However having an old plate by me with some parts ready such as the Back ground and a dog, I thought how I could turn so much work laid aside to account, so patched up a print of Mr Churchill in the character of a Bear. The satisfaction and pecuniary advantage I received from these two prints, together with constant Riding on horseback restored me as much health as can be expected at my time of life. What may follow God knows.[27]

The Bruiser – as Hogarth called this print of Churchill – appeared in August 1763 (see plate 27). The other picture he referred to, the much cleverer and much more successful drawing of John Wilkes (see plate 28), had been published in May of that year. In the meantime he had suffered some kind of stroke – the papers said that 'Mr Hogarth is much indisposed with a paralytic disorder'[28] – and he had once again turned his back on the world. *The Times, Plate 2* remained unpublished, either because it had become politically outdated or because its creator was now totally weary of the unrewarding intricacies of politics, the never-ending hunt to distinguish patriotism from faction. The old obsessions were still strong: his last surviving letter, written in June 1764, was about yet another attempt to interest the public in *Sigismunda*, while his last known drawing was yet another revision of the caricature-character illustrations which he had now added to *The Bench*. Most of his attention was concentrated on his writings – on the *Autobiographical Notes*, originally conceived as introductory material for a collected edition of his prints, and on the *Apology for Painters*, the work which as Horace Walpole had already heard was to justify the good sense of the English as well as the prejudices and grievances of William Hogarth. What he was doing was undeniably apocalyptic and perhaps even morbid, but it was not as disconnected and divergent as it later appeared to be. He felt that his life was drawing to a close, that 'the rest of his time' which he had looked forward to in February 1757 was almost over; and he wanted to bring together before it was too late the things that had really mattered to him. On the one hand he would prepare a full edition of his popular prints with proper explanations; on the other he would explain once and for all the true relationship between the narrowly defined sublimity of the connoisseurs and his own wider understanding of that concept, an understanding in accord with 'the true genius of the nation'. Unfortunately it was already too late: his attempts at convergence, interrupted by death, would serve only to give an even greater impression of divergence and even of derangement.

The final and most disturbing presentiment of death came early in 1764. He needed to do one more engraving, to serve as the tailpiece

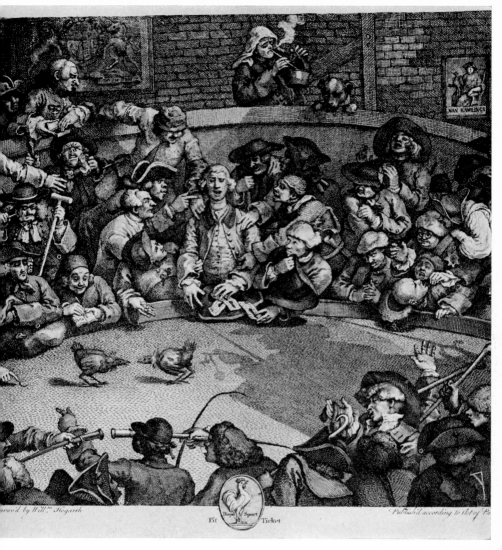

25 *The Cockpit* (detail), engraving published November 1959, by Hogarth

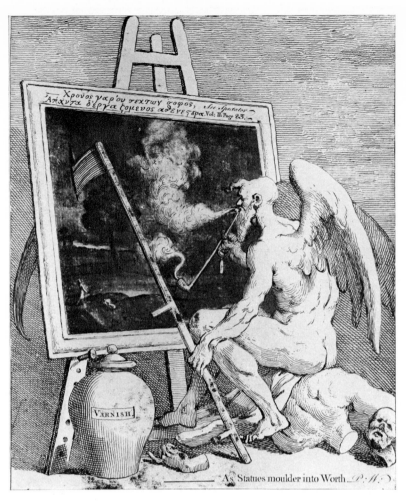

26a *Time smoking a Picture,* etching and mezzotint published March 1761, by Hogarth

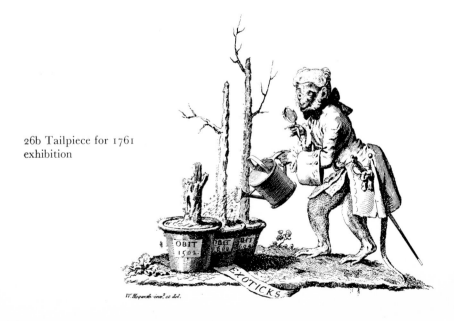

26b Tailpiece for 1761 exhibition

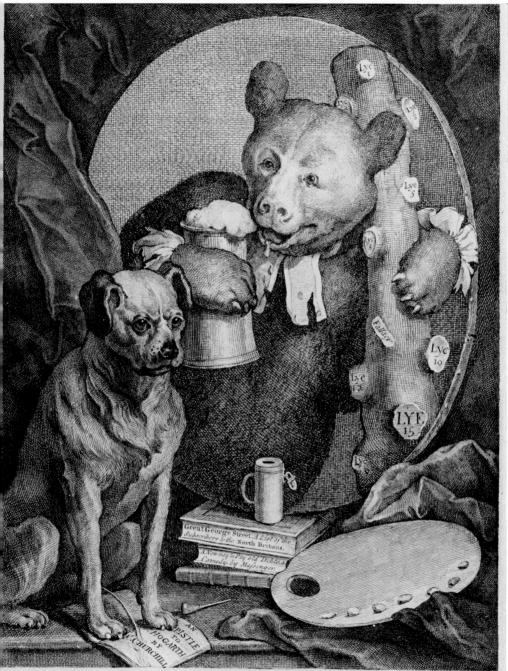

THE BRUISER, C. CHURCHILL *(once the Rev.^d) in the Character of a Modern* Hercules, *Regaling himself after having Kill'd the Monster* Caricatura *that so Sorely Gall'd his* Virtuous *friend the* Heaven born WILKES.

— But he had a *Club* this Dragon to Drub, Or he had ne'er don't I warrant ye. ——

Design'd and Engraved by W.^m Hogarth Price 1^s *Publish'd according to Act of Parliament August 1. 1763.*

27 *The Bruiser,* second state, engraving published August 1763, by Hogarth

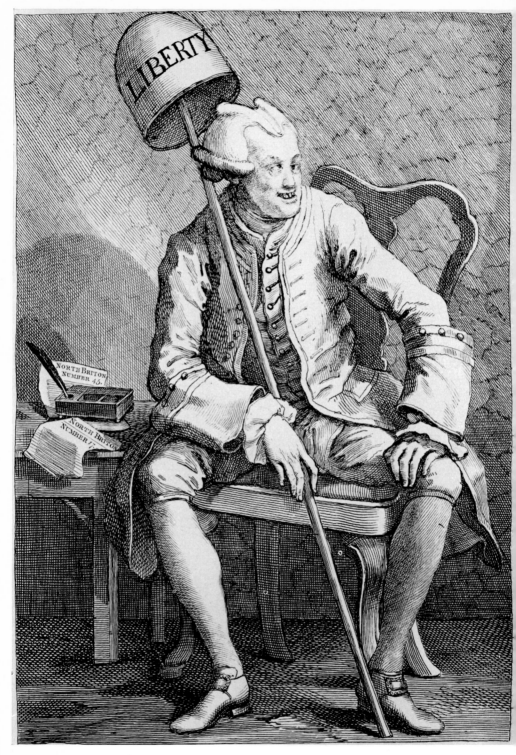

28 *John Wilkes Esq.*, etching and engraving, 1763, by Hogarth

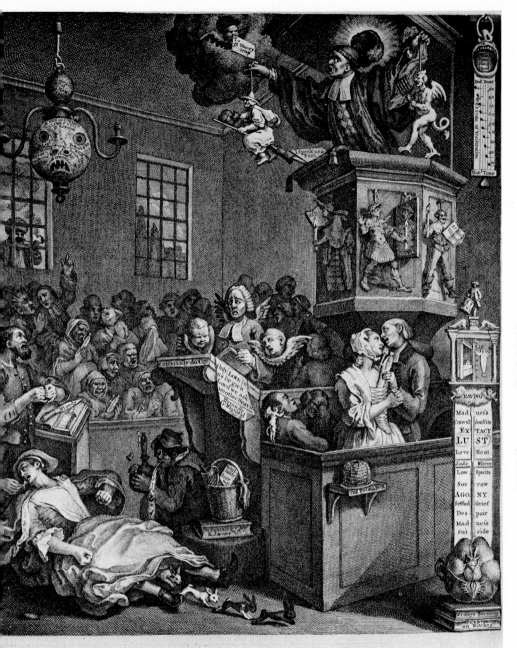

CREDULITY, SUPERSTITION, and FANATICISM.
A MEDLEY.

'eve not every Spirit, but try the Spirits whether they are of God: because many false Prophets are gone out into the World.

1.John.Ch.4.V.1.

igrid and Engravd by Wᵐ. Hogarth.

Publish'd as the Act directs March yᵉ 15ᵗʰ 1762.

Credulity, Superstition and Fanaticism: A Medley, engraving published April 1726, by Hogarth

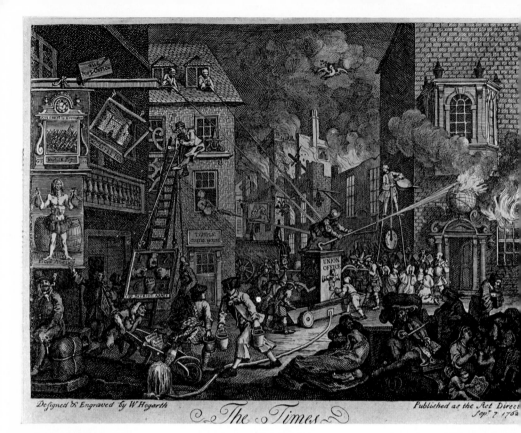

Designed & Engraved by W. Hogarth

The Times

Published as the Act Directs
Sep. 7 1762

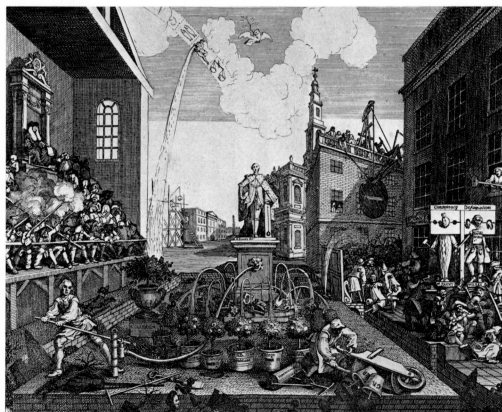

31a (Above) *An Election Entertainment* (detail), second state, engraving
published February 1755, by Hogarth

31b (Below) Chairing the Members (detail), engraving published
January 1758

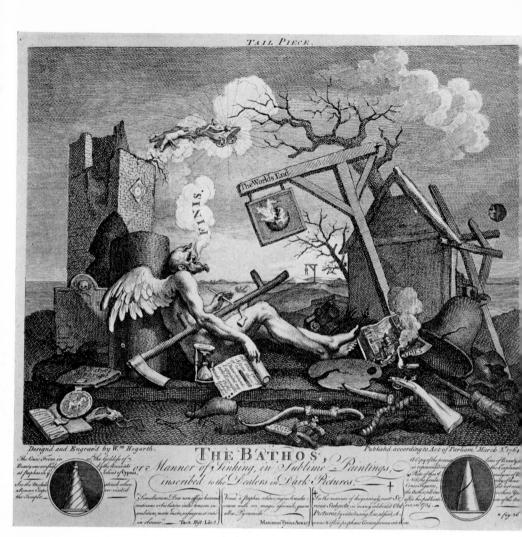

32 *The Bathos,* etching and engraving published March 1764, by Hogarth

for the collected edition of his prints. The original frontispiece for this work, the engraved version of the self-portrait of 1745, had already been changed into the caricature of Churchill; and the tailpiece was to go further still, associating the destruction of his own image with the destruction of the universe itself. He told his friends that this print would represent 'the End of all Things'; and when they replied jokingly that this would presumably include his own end, he answered in all seriousness that this was true and that he must therefore get on with it as quickly as possible.[29] It was published in April 1764, with the title *Tailpiece* above it and a caption below which read: 'The Bathos, or Manner of Sinking in Sublime Paintings, inscribed to the Dealers in Dark Pictures' (see plate 32). A further explanatory note said: 'See the manner of disgracing the most Serious Subjects, in many celebrated Old Pictures, by introducing Low, absurd, obscene & often profane Circumstances into them'. And in the picture Time himself mocked at the pretensions of the connoisseurs, at the vanities of life, perhaps even at William Hogarth. Time was dying and such sublimity as the world had ever possessed was dying with him. Low and absurd circumstances, emblems of futility and transience, lay all around him. Creation itself, in its ultimate decrepitude, commented on the absurdity of all theories of art. And the artist himself, the man whose whole career had been crippled by the opposing concepts of the grotesque and the sublime, was nowhere to be seen. His apocalyptic vision had at last reconciled the non-existent opposites that had tormented him for so long, but it had no place for his own image. The landscape he depicted was dead and empty. Even the hanged man who seemed to dangle from a distant gibbet turned out on closer examination to have disappeared long ago. All that was left was the empty iron cage that had once held his rotting carcass.

On 25 October 1764, six months after the publication of the *Tailpiece*, Hogarth was taken suddenly ill shortly after supper. He died a few hours later, a fortnight before his sixty-seventh birthday.

CHAPTER XII
What may follow God knows

Jane Hogarth was not present at her husband's deathbed: he had come up from Chiswick to the Leicester Fields house that same morning and he had not seemed ill enough to warrant her coming with him. He had eaten a hearty meal – a pound of beefsteak according to one account – and had done some writing before going to bed. Then he had been seized with fierce chest pains and uncontrollable vomiting and by the time Jane arrived he was dead, apparently from a ruptured artery. For consolation she had a handful of obituaries, most of them polite rather than enthusiastic, and a will leaving her his etched and engraved copper plates. She could not sell them without the permission of her sister-in-law Anne, but after Anne's death in 1771 they passed completely into her control. Meanwhile an Act passed in 1767 extended her copyright in the prints for a further twenty years. She also had a legacy of responsibilities: she knew well enough the convergence her husband had been seeking, the reconciliation between the two sides of his career, and she did her best to bring it about posthumously. Visitors were always shown an unsold painting of a shrimp-seller, usually described as *The Market Wench* (see plate 1b), which illustrated better than any words could have done his ability to straddle the gap between his popular prints and his portrait painting. As for the words themselves, they were quietly put aside. Jane presumably read the disjointed and unfinished manuscripts which later came to be known as the *Apology for Painters* and the *Autobiographical Notes*, but she did not think it advisable to publish them. Rightly or wrongly, she thought that her husband's pictures spoke more clearly – or perhaps more discreetly – than his words. However disparate they

might seem, the images would in the end knit together to give him the kind of reputation he had always wanted. The words, which he had intended to help the process, had been left in a state where they were more likely to hinder it. They would do so in spite of – or perhaps because of – the light they threw on the nature of the man himself. His posthumous fame, like his last engraving, was all the better for the absence of the artist's own image.

When Jane died in November 1789 they opened up the Hogarth family vault in Chiswick churchyard to receive her coffin; and they found to their horror that there was no sign of Hogarth's corpse. It was a macabre moment. The empty vault was a reminder of the empty iron cage in the *Tailpiece*: perhaps Time himself had removed all traces of the artist who had once prophesied his final demise. Then they remembered that the vault had only been constructed after Hogarth's burial. His body was safely ensconced beneath its floor, weighed down by a grandeur to which his family had only aspired after his death. It was not an uncommon fate, but it did not often overtake the childless. In Hogarth's case it resulted from the growing fame of the images he had created rather than the increasing wealth of his descendants. And unfortunately some of his most cherished images still failed to get what he would have considered their proper share of the fame. *Sigismunda*, which Jane had kept to her dying day because nobody would pay the price her husband had put on it, was sold after her death for a mere fraction of that price. Even when it was bequeathed to the nation in 1859 its troubles were not over: in due course the Trustees of the Tate Gallery decided that it could no longer be kept in the Gallery and must be banished to a storeroom in Acton, where it can now be seen by special request on one day of the week only. Even the fastidious Horace Walpole could hardly have conceived an unkinder fate for the picture that had shocked him so much.

The *Apology for Painters*, the other thing that had shocked Horace Walpole on that memorable day in 1761, passed to John Ireland after Jane's death, along with the *Autobiographical Notes* and other miscellaneous manuscripts. In his *Hogarth Illustrated* he made considerable use of the autobiographical writings but did comparatively little with

the *Apology*, which was not published in its original form until 1968. Ireland was by no means an unsympathetic or an unscrupulous editor and he was remarkably successful in turning Hogarth's staccato utterances into readable English prose. But his concern, naturally enough, was with biography rather than with theory, with anecdote rather than with conjecture. He wanted to know what Hogarth had remembered as he looked inward and backward, not what he had dreamed as he looked outward and forward. Ireland's version of the papers revealed a vain and irritable man, constantly belittling his rivals and boasting of his own achievements. The Hogarth who wrote the *Autobiographical Notes* was lonely and desperately insecure, living out the last years of his life in a heavily fortified entrenchment on the disputed frontiers of the art world. By the time Ireland published these notes the frontiers had shifted and the disputes had come to seem sterile and pointless. All that was left was the rancour itself, casting its dark shadow backwards over the whole of the artist's life. The public had already been taught, by the pious works Jane encouraged and even to some extent by Hogarth himself, to see the prints as the work of a detached and somewhat distant moralist; and in any case it was not the business of a mid-eighteenth-century artist to be subjective and introspective. Ireland's book came out in 1798, the year in which Wordsworth and Coleridge turned their backs on the dying century in their *Lyrical Ballads*. It was their generation, not Hogarth's, that was entitled to talk about the artist's 'inward eye' and to view artistic creativity in terms of 'emotion recollected in tranquillity'. Hogarth's recollections were anything but tranquil and they therefore produced more embarrassment than interest. People preferred to think of him as a typically detached rationalist of the eighteenth century, holding up his looking-glass to the follies of mankind and having no need of such esoteric devices as the inward eye.

This view of Hogarth, this separation between the man and his work, gained more and more strength as the nineteenth century became increasingly prudish and moralistic. The Victorians picked out from his work the things of which they most approved, the didactic prints with obvious moral lessons to impart, and they put the

rest on one side. They admired and commended him for delineating so sternly the downward path of rakes and harlots and other ungodly and indelicate persons, but they seldom delved into the details of his imagery or into its links with his own life and personality. It was the simplicity of his message they wanted, not the complexity of his world. In any case that world was a corrupt and coarse one which they were glad to have left behind them. They were edified by the sermons he preached but they did not wish to follow him when he climbed down from the pulpit and picked his way through eighteenth-century London. Still less did they want to trace connections between his pictures and his personal life, between his anger and his art. If Hogarth the man could only be given flesh and blood by recourse to these embarrassing and distasteful documents of his later years then he was better forgotten. The clean and neat lines of the empty cage were preferable to the distressing spectacle of the personality which had once inhabited it. By a strange irony, an irony only possible in the context of the Englishman's peculiar horror of self-revelation, the searing honesty of this man's last writings had led to a growing reluctance to see his work and his life as an integrated whole.

And yet the last writings were not entirely made up of self-pity and self-justification. While the *Autobiographical Notes* were permeated with resentment and discontent, the *Apology for Painters* was the work of a man who was genuinely trying to come to terms with life. It was – or would have been, had it reached completion – a book about the patronage of the arts in England. Hogarth disliked private patrons but at least he could understand their motives: 'No wonder,' he remarked, 'that they should dislike those who deprive them of so much honour by daring to make themselves without their assistance'.[1] There was great bitterness here but there was also a degree of acceptance. 'Therefore let us sit down contented,' he said at another stage of his argument, 'and not attempt to force what in the nature of things can never be accomplished.'[2] It is true that he dwelt longer and more bitterly on the things that could not be accomplished than on those that could, but at least he showed restraint and charity when it came to dealing with individuals. Michael Kitson, in pointing this out, remarks that

the *Apology* shows Hogarth as being 'not wholly a rebel and a maverick. In some ways he was a joiner, not an outsider, by nature, although he would "belong" only on his own terms and provided he did not have to sacrifice his integrity or his views'.[3] Unfortunately the *Apology* broke off before it made these views clear: readers were advised to sit down contented but they were not told the basis for their contentment. There were, however, some hints. Towards the end of his drafts Hogarth turned from creation to communication, from the unique art objects which would inevitably be imported by rich patrons to the kind of artistic language which native English artists might profitably employ. It was at this point that he made his famous remark that 'Drawing and painting are only a much more complicated kind of writing.'[4] With this sentence he spanned the whole of his life and work: the intellectual inheritance he had received from his father, the progress from erudite emblem to popular print, the turbulent last years and their culmination in the sardonic imagery of the *Tailpiece*. Here at least was an utterance which – like the *Tailpiece* itself – brought the man and his work into harmony instead of perpetuating the discord which had been set up by the *Autobiographical Notes*. Most of what Ireland had published showed a man torn apart, a man who had to write in order to justify his painting and who perhaps even painted in order to justify his writing; but this sentence was a reminder that there was nevertheless an underlying unity in what he did.

The real nature of that unity became clearer during the course of the nineteenth century. In England painters continued to strive after the 'grand manner', patrons continued to collect unique art objects and critics continued to see the reproducible world of line drawing as the province of mere printmakers and comic artists. In other countries, however, there were men who saw that sublimity might begin on the far side of caricature. Goya, perhaps the greatest of them, did not draw back from the discovery, as Hogarth had done after *Gin Lane* and *The Four Stages of Cruelty*, but went on to produce etchings which said as much about the ultimate mysteries of the human condition as any painting could have done. Hogarth had thought that technical advances, especially the development of the mezzotint, might supersede mere

linear engraving techniques; but in fact the invention of photography and the reproductive techniques which followed upon it destroyed for ever the hierarchies of image-making. Paint – or at any rate flat paint – became as reproducible as the humble line of the engraver. Only the collage or the construction, the canvas covered with heavy impasto or super-imposed textures, could defy for a little longer the advancing technology of reproduction. Social changes, too, threatened the cult of the unique art object. On the one hand the idea of art as private property was challenged and on the other the modes of communication, artistic as well as literary, were greatly extended and altered. The result was the emergence of the public museum or gallery as the focus of interest in the visual arts. The dutiful crowds, standing respectfully before the unique object and then buying their mass-produced reproductions on the way out, were closer to the public Hogarth had dealt with than they were to the esoteric visions of the connoisseurs.

And yet Hogarth's importance was still not fully recognised. For a time it was obscured by mankind's dying belief in the need for literacy. As long as men regarded an ability to read as the first requisite of all understanding they tended to see the popular print as nothing more than a peepshow for the ignorant. Having faced in his lifetime the contempt of those who saw communication as an inferior form of art, Hogarth now had to face the arrogance of those who saw art as an inferior form of communication. Even today, when we are at last beginning to understand that the ability to think in images may be as important as the ability to think in words, there are still those who hate to be reminded that Hogarth's work had more influence on more people than any literary composition of the time with the possible exception of Thomson's *Rule Britannia*. Just as the art historians have never quite forgiven him for reaching a wider public than any artist had ever done before, so the literary historians have never quite forgiven him for outstripping the influence of the writers whose world he entered. Most surprising of all, he has been largely ignored by the new breed of pundits who claim to view with Olympian gaze the whole field of human art and communication. In 1964, the bi-centenary of Hogarth's death, a book appeared which sought to trace the whole

progress both of the word and of the image, from their beginnings to their final loss of their unique qualities, the first with the inventions of Gutenberg and the second with the advent of television.[5] Hogarth got no mention in it. But the death of literacy, the enormous consequences of the new power of the visual image, have other and deeper implications. They are linked with the investigation of the unconscious, with a loss of faith in the self-sufficiency of conscious thought and in the linguistic and semantic garments in which it is clothed. In the melting pot of the unconscious mind the distinction between a thing and its attribute is dissolved along with that between word and image, concept and symbol, intellect and imagination. The fear of idolatry becomes no more than an unjustified pause at a non-existent threshold. Even the apparently out-dated emblems that Hogarth knew so well reappear, not as gods and demi-gods but as archetypal images. And the use he made of them, the language he forged from them, can at last be seen as expressing the unity and not the divisions of human thought.

NOTES

Full details are given of works cited for the first time; subsequent references are given in a shortened form. Place of publication is London unless otherwise stated. The following abbreviations are used:

Add MSS Additional Manuscripts, British Museum

Analysis William Hogarth, *The Analysis of Beauty*, ed. Joseph Burke, Oxford 1955

Anecdotes John Nichols *et al.*, *Biographical Anecdotes of William Hogarth*, 1781, 1782, 1785

Apology William Hogarth, *Apology for Painters*, ed. Michael Kitson, Oxford 1968 (Walpole Society, vol. xli, pp. 46–111)

DNB *Dictionary of National Biography*, new edition, 22 vols, Oxford 1970

GM *Gentleman's Magazine*

Notes William Hogarth, *Autobiographical Notes*, printed in Joseph Burke's edition of *The Analysis of Beauty* (see above), pp. 201–31

Paulson Ronald Paulson, *Hogarth, His Life, Art and Times*, 2 vols, New Haven 1971

Vertue George Vertue, *Notebooks, Volume III*, Oxford 1933–4 (Walpole Society, vol. xxii). The Walpole Society has published Vertue's notebooks in seven volumes including an index (Walpole Society, vols xviii, xx, xxii, xxiv, xxvi, xxviii, xxix), but this is the only volume cited here

Walpole *Letters of Horace Walpole*, ed. Mrs Paget Toynbee, 16 vols, Oxford 1903–5. I have cited this edition because the fuller and more recent edition by W. S. Lewis is still in process of publication

Works John Nichols and George Steevens, *The Genuine Works of William Hogarth*, 3 vols, 1808–17.

INTRODUCTION
1. *Apology*, p. 46
2. *Ibid.*, p. 106

CHAPTER I
1. *Notes*, p. 201
2. Paulson, i, 27. I have indicated below, in the section on 'Further Reading', the tremendous contribution which Ronald Paulson has made to Hogarth studies; but I should also like to acknowledge here, on first reference to his book, the great debt which I owe to it.
3. See Paulson i, 18–21; Peter Quennell, *Hogarth's Progress*, 1955, pp. 14–17. The former draws on Ned Ward's account of 1699, the latter on Sorbière's of the previous year. Both these sources are described in Henry Morley, *Memoirs of Bartholomew Fair*, new edition, 1880, pp. 262–72.
4. *Notes*, p. 204
5. Morley, *Bartholomew Fair*, p. 288
6. These accounts are printed in G. W. Thornbury and E. Walford, *Old and New London*, 4 vols, 1873–8, i, 322. For fuller details, linking verbal accounts with pictorial representations such as Hogarth himself produced in Plate 12 of *Industry and Idleness*, see J. Asthon, *The Lord Mayor's Show*, 1883. Material on the masks, costumes and effigies used by the City companies in these shows can be found in R. Withington, *English Pageantry*, 2 vols, Cambridge (Mass.) 1918 and D. M. Bergeron, *English Civic Pageantry, 1558–1642*, 1971. I am grateful to Dr Elspeth Veale for drawing my attention to these works.
7. *Notes*, p. 204
8. This 'judgment of Mr Hezekiah Woodward, sometimes an eminent Schoolmaster in London' was prefaced to Charles Hoole's translation of Comenius's book in 1658 and reprinted in subsequent editions.
9. *Notes*, p. 201
10. (Richard Hogarth), *Thesaurarium Trilingue Publicum*, 1689, pp. 31–41
11. John Wilkins, *Essay towards a real Character*, 1668, pp. 385–6

12. *Notes*, p. 204
13. Paulson, i, 13
14. *Notes*, p. 204
15. *Catalogue of Prints and Drawings in the British Museum: Political and Personal Satires*, 11 vols, 1870–1954, nos 1072, 1084, 1607. As well as providing him with specific images – e.g., the leering monk in *The Invasion*, *Plate 2* – these pictures of processions may also have served as models for Hogarth's own work. See Ross Watson, *A selection of paintings from the collection of Mr and Mrs Paul Mellon*, Washington 1971, no. 3.
16. Paulson, i, 30
17. Printed, in English and in the original Latin, in Paulson, i, 35 and ii, 485–6
18. *Notes*, p. 205
19. Paulson, i, 43
20. *Notes*, p. 204

CHAPTER II
1. (Richard Hogarth), *Thesaurarium*, pp. 31–41
2. The emblem tradition in England is exhaustively treated in Rosemary Freeman, *English Emblem Books*, 1948. On the European background see Mario Praz, *Studies in seventeenth century imagery*, (*Studies of the Warburg Institute*, 3), 2 vols, 1939, revised edition, 1964. Some of the wider implications are dealt with in Mario Praz, *Mnemosyne, the Parallel between literature and the visual arts*, 1970. See also Victor Anthony Rudowski, 'The theory of signs in the eighteenth century', *Journal of the History of Ideas*, Oct–Dec 1974, vol. xxxv, no. 4, pp. 683–90.
3. Nathaniel Crouch's most successful publications ranged from *The Apprentice's Companion*, 1681, through *Delights for the Ingenious*, 1684 and its re-issue, *Choice Emblems*, 1721 to *Winter Evening's Entertainments*, which by 1737 had reached its sixth edition. It is worth noting that John Bunyan's *Book for Boys and Girls*, 1686, which Paulson suggests may have influenced Hogarth's childhood, had its title changed to *Divine Emblems* when it was re-issued in the early eighteenth century. On this and other children's books of the period see Percy Muir, *English Children's Books 1600–1900*, 1954, and Judith St John, *A Catalogue of the Osborne Collection of Early Children's Books 1556–1910*, Toronto 1958. Bunyan in his turn was influenced by the *Tabula Cebetis*, a popular emblematic portrayal of the world's temptations which has been described as 'a classical Rake's Progress'. See E. H. Gombrich, 'A Classical Rake's Progress', *Journal of the Warburg and Courtauld Institutes*, vol. xv, 1952, pp. 255–6.

4. *Notes*, p. 201
5. *Works*, i, 13–14
6. *Notes*, p. 210
7. *Apology*, pp. 89, 91
8. *Notes*, p. 201
9. Freeman, *Emblem Books*, p. 95
10. John Ireland, *Hogarth Illustrated from his own Manuscripts, Volume III and last*, 1798, p. 377. Quite apart from the enormously powerful imagery of the Tarot cards, which included such Hogarthian favourites as Hercules and the Wheel of Fortune, there was a great vogue at this time for playing cards with topical, geographical and political designs. The British Museum Print Room has an extensive collection, sections of which have been catalogued by W. H. Willshire, 1876–7, A. W. Franks, 1892 and F. M. O'Donoghue, 1901. See also C. P. Hargrave, *History of Playing Cards*, new edition, 1966.
11. Paulson, i, 9–12
12. (Richard Hogarth), *Thesaurarium*, preface (un-numbered pages)
13. *Notes*, p. 204
14. *Ibid.*, p. 201
15. *Ibid.*, p. 205
16. Anthony Ashley Cooper, third earl of Shaftesbury, *Characteristics*, 6th edition, 3 vols, 1737–8, iii, 387
17. A. A. Cooper, earl of Shaftesbury, *Second Characters or the Language of Forms*, ed. Benjamin Rand, Cambridge (Mass.) 1914, p. 142
18. *Ibid.*, p. 58
19. Aglionby's *Painting Illustrated*, first published in 1685, was re-issued in 1719. For this and other textbooks of painting in this period see H.V.S. and M. S. Ogden, 'Bibliography of seventeenth century writings on the pictorial arts in England', *Art Bulletin*, vol. xxix, Sept 1947, pp. 196–201.
20. Paulson, i, 271–5

CHAPTER III
1. *Notes*, p. 202
2. *Ibid.*, pp. 206, 215
3. *Ibid.*, p. 209
4. *Ibid.*, p. 210
5. *Ibid.*, p. 210
6. John Carswell, *The South Sea Bubble*, 1961, p. 114. The follower in question was Erasmus Lewis, who had close links with Swift, Pope, Gay and other literary opponents of the administration. See *DNB*, xi, 1054–5.

7. Carswell, *South Sea Bubble*, p. 222
8. These alterations, along with all those made to Hogarth's other prints, are meticulously described in Ronald Paulson's invaluable edition of *Hogarth's Graphic Works*, 2 vols, New Haven 1965, revised edition 1970.
9. *Boswell's Life of Johnson*, ed. G. B. Hill, revised L. F. Powell, 6 vols, Oxford 1934, ii, 452
10. *Complete Letters of Lady Mary Wortley Montagu*, ed. R. Halsband, 3 vols, 1965–7, ii, 38–40
11. D. Knoop and G. P. Jones, *The Genesis of Freemasonry*, Manchester 1949, pp. 152, 170; Lewis Melville, *The Life and Writings of Philip Duke of Wharton*, 1913, p. 110; Paulson, i, 130
12. The first academy of painting in England was established in 1711 with Kneller at its head. Thornhill formed a breakaway group and ousted Kneller in 1715, only to be opposed in his turn by a young painter called John Vanderbank and a French Huguenot refugee called Louis Cheron, a man in his sixties with a great reputation as a draughtsman. Together they founded their own academy in October 1720, giving instruction both in painting and in drawing, and Hogarth was among the initial subscribers. In the *Apology for Painters* he gave a brief history of these successive academies and seemed to think that because he had inherited Thornhill's 'neglected apparatus' he had himself become the guardian of the academic tradition. See *Apology*, p. 93.

CHAPTER IV
1. Paulson, i, 124
2. *Diary of Mary, Countess Cowper, 1714–1720*, 1864, pp. 137, 142, 144
3. On the Jacobite leanings of the supposedly 'independent' gentlemen and on their contacts with French secret agents, see R. Sedgwick, *The House of Commons, 1715–1754*, 2 vols, 1970.
4. F.-C. Legrand and F. Sluys, *Arcimboldo et les arcimboldesques*, Brussels, 1955; Benno Geiger, *I Dipinti Ghiribizzosi di Giuseppe Arcimboldi, 1527–1593*, Florence, 1954
5. *Correspondence of Jonathan Swift*, ed. Harold Williams, 5 vols, Oxford 1963–5, iii, 182
6. Arthur Grimwade, *Rococo Silver*, 1974, p. 14
7. *Notes*, p. 206
8. For a full discussion of these doubts see Paulson, *Hogarth's Graphic Works*, i, 135–6

CHAPTER V

1. *Notes*, pp. 215–16
2. Morris' brief, from which this quotation is taken, is printed in *Works*, i, 39–42 and reprinted in Paulson, ii, 487–8.
3. *Notes*, p. 212
4. *Ibid.*, p. 218
5. *Apology*, pp. 100–1
6. W. T. Whitley, *Artists and their friends in England, 1700–1799*, 2 vols, 1928, i, 53; *Apology*, pp. 83, 101
7. *Notes*, p. 202
8. The list is in the British Museum (Add MSS 27995, fo. 1) but part of it has been cut off. This fragment is now in the Huntington Library. The whole list is printed in J. Ireland, *Hogarth Illustrated III*, 1798, p. 21.
9. *The Parliamentary Diary of Sir Edward Knatchbull, 1722–1730*, ed. A. N. Newman, *Camden Third Series*, vol. xciv, 1963, p. 88
10. *Ibid.*, p. 89
11. Paulson, i, 71
12. *Diary of Sir E. Knatchbull*, p. 92
13. John Nichols, *Literary Anecdotes of the Eighteenth Century*, 9 vols, 1812–15, i, 405
14. Vertue, p. 38
15. Paulson, i, 204
16. *Anecdotes*, p. 27
17. Horace Walpole, *Anecdotes of Painting in England*, ed. James Dallaway, 4 vols, 1828, iv, 131
18. Paulson, i, 204
19. I am grateful to Mr John Brooke, who kindly examined these inscriptions and confirmed that they are not in the handwriting either of Walpole himself or of any amanuensis known to have been employed by him.
20. Add MSS 27995, fo. 1. Paulson's assertion (i, 213) that these pictures were ordered in March rather than November presumably results from an error in transcription.
21. *GM* 1732, pp. 771–2
22. Paulson, i, 556n63
23. Vertue, p. 41
24. *Ibid.*, pp. 41, 46
25. *Ibid.*, p. 68; Whitley, *Artists and their friends*, i, 35; Paulson, i, 316–7
26. Vertue, p. 68
27. Paulson, i, 423–4

28. *Notes*, p. 216
29. *Ibid.*, p. 216

CHAPTER VI

1. Vertue, p. 156
2. *Works*, i, 15
3. Vertue, p. 61
4. Paulson, i, 206
5. Vertue, p. 30
6. *Ibid.*, p. 120
7. *Ibid.*, p. 68
8. James Puckle, *The Club*, 1711. E. Ward, *Secret History of Clubs*, 1709, provides a satirical contemporary view of the rage for clubs. See also H. W. Troyer, *Ned Ward of Grub Street*, Cambridge (Mass), 1946; R. J. Allen, *The Clubs of Augustan London* (*Harvard Studies in English* vol. 7), Cambridge (Mass.), 1933.
9. J. Ireland, *Hogarth Illustrated III*, p. 21
10. *Notes*, p. 202
11. Within a very short time the pretence of anonymity had worn even thinner: 'I am also assured that while Hogarth was painting the *Rake's Progress* he had a summer residence at Isleworth; and never failed to question the company who came to see these pictures, if they knew for whom one or another figure was designed. When they guessed wrong, he set them right'. (*Anecdotes*, pp. 17–18)
12. Paulson, i, 311. Thirteen years later Hogarth made an even more profitable journey to St Albans in order to draw the captured Jacobite rebel Lord Lovat. The resulting print, sold at a shilling a copy, was said to have been Hogarth's greatest financial success.
13. Vertue, p. 41
14. For a fuller account of Hogarth's use of caricature as a weapon see Paulson, i, 228–9.
15. *Notes*, p. 216
16. Vertue, p. 58
17. *Notes*, p. 216
18. *Universal Spectator*, no. 119, 16 Jan 1731, reprinted *GM* 1731, p. 15
19. Vertue, p. 58
20. Paulson, i, 305–6
21. *Ibid.*, i, 312
22. *Ibid.*, i, 323
23. *Ibid.*, i, 119

24. *Ibid.*, i, 363
25. *Ibid.*, i, 353

CHAPTER VII

1. *GM* 1732, p. 566
2. *GM* 1731, pp. 307, 340. The sad story of the apprentice George Barn-well, 'who was undone by a Strumpet that caused him to rob his master and murder his uncle' featured in eighteenth-century chap books along with such tales as 'A Terrible and Seasonable Warning to Young Men' and 'A Timely Warning to Rash and Disobedient Children'. These stories, each more gory and sensational than the last, had an obvious influence on Hogarth and helped to provide material for his series *Industry and Idleness*. See J. Ashton, *Chap Books of the eighteenth century*, 1882.
3. *Notes*, p. 206
4. *Ibid.*, p. 205
5. *DNB*, iv, 135–6; xiv, 155–6
6. *Notes*, pp. 209, 215
7. See Derek Jarrett, *England in the Age of Hogarth*, 1974, pp. 192–3
8. R. E. Moore, *Hogarth's Literary Relationships*, Minneapolis 1948, pp. 29–52
9. *Notes*, p. 227
10. *Ibid.*, p. 206
11. *Ibid.*, pp. 209, 212
12. J. B. Leblanc, *Letters on the English and French Nations*, 2 vols, Dublin, 1747, i, 161. For a fuller account of Leblanc's views on England see Derek Jarrett, *The Begetters of Revolution: England's involvement with France, 1759–1789*, 1973, p. 20.
13. This need for re-arrangement emphasised the interpretative and sub-ordinate rôle of engraving as an art. Vertue said it was 'unregarded' and the critic Jonathan Richardson insisted that engravers could not excel. A modern writer has pointed out that their prints were 'not only copies of copies but translations of translations'; and Anthony Gross, one of the most distinguished of modern engravers, warns his students never to sacrifice painting or sculpture to printmaking since the former can make discoveries while the latter can only utilise them. See Paulson, i, 56–8; William M. Ivins, *Prints and Visual Communication*, 1953, p. 66; Anthony Gross, *Etching, Engraving and Intaglio Printing*, Oxford 1970, p. 1.
14. *Hogarth's Peregrination*, ed. Charles Mitchell, Oxford 1952, p. 3
15. *Ibid.*, pp. 4–5

16. *Ibid.*, p. 5
17. *Ibid.*, p. 7
18. *Ibid.*, p. 15
19. *Ibid.*, pp. xxiv–xxxi
20. See Walter Arnold, *The Sublime Society of Beefsteaks*, 1871.
21. Shaftesbury, *Second Characters*, pp. 93–4
22. For the full text of this article see Paulson, ii, 491–3.
23. *Notes*, p. 217

CHAPTER VIII

1. *Apology*, pp. 88–9. As Howard D. Weinbrot has pointed out ('History, Horace and Augustus Caesar: some implications for eighteenth century satire', *Eighteenth Century Studies* vol. vii, no. 4, Summer 1974, pp. 391–414) the attitude of the Greeks and Romans to the arts was still 'politically considered' at this time. Horace, the servant of a despotic ruler, was by no means as universally respected as believers in the 'Augustan age of the eighteenth century' would have us think.

2. *Apology*, p. 89. Hogarth's friend James Ralph had the courage to point out that 'holy and devout Pictures are no Fault in themselves and 'tis certain they have a very fine Effect in making the Face of Religion gay and beautiful' (Paulson, i, 376); but most Englishmen feared that Popish pictures would lead to Popery itself. Horace Walpole played at Catholic aestheticism in private – 'At the Vyne', he told Horace Mann, 'there is the most heavenly Chapel in the world; it only wants a few pictures to give it a truly Catholic air ... If you can pick us up a tolerable "Last Supper", or can have one copied tolerably and very cheap, we will say many a mass for the repose of your headaches' – but even he would hardly have said such things in public. (Walpole, iii, 319–20)

3. *Notes*, p. 219
4. Vertue, p. 58
5. *Notes*, p. 218
6. Vertue, p. 111
7. *Notes*, p. 225
8. Paulson, i, 465
9. *Ibid.*, i, 477
10. *Ibid.*, i, 478
11. Leblanc, *Letters on English and French*, ii, 42–3
12. *Apology*, p. 89
13. Vertue, p. 124
14. *Ibid.*, p. 124

15. See Lawrence Gowing, 'Hogarth, Hayman and the Vauxhall Decorations', *Burlington Magazine*, xcv, January 1953, pp. 4–19.
16. *Analysis*, p. 10
17. Vertue, p. 126
18. Add MSS 27995, fo. 2
19. See, for instance, his letter to 'J.H.' of Norwich, 21 Oct 1746, in A. P. Oppé, *The Drawings of William Hogarth*, 1948, no. 39.
20. *Works*, i, 215–16

CHAPTER IX
1. Moore, *Literary Relationships*, pp. 12–14
2. *Notes*, p. 225
3. *Works*, i, 143–4; *Notes*, p. 227
4. *Notes*, p. 228
5. *Ibid.*, p. 228
6. Paulson, ii, 432n26
7. *North Briton*, no. 17, 25 Sept 1762, reprinted in *Anecdotes*, pp. 81–7
8. Samuel Ireland, *Graphic Illustrations of Hogarth*, 2 vols, 1794–9, ii, 8–10
9. Paulson, ii, 85
10. It was William Cole who noted, as early as 1736, that Hogarth forbade vails. (*Works*, i, 23; for Cole's further memories of Hogarth see Add MSS 5826, fo. 5.) Nichols noted that 'some of his domestics had lived many years in his service, a circumstance that always reflects credit on a master'. (*Anecdotes*, p. 98)
11. Paulson, ii, 127
12. Austin Dobson, *William Hogarth*, new edition, 1907, p. 147
13. *The Autobiography of Mary Granville, Mrs Delany*, ed. Lady Llanover, 2 vols, 1861, i, 283; cited Oppé, *Drawings of Hogarth*, p. 13 and Paulson, i, 226
14. Henri Testelin, *Sentimens des plus habiles Peintres sur la Pratique de la Peinture et Sculpture, mis en tables de preceptes avec plusieurs discours academiques*, Paris 1696, table iii (Conference de 6 juin 1675)
15. Edmund Burke, *A Philosophical Enquiry into the Origin of our Ideas of the Sublime and Beautiful*, 1757, pt. i, section xiv. For a full discussion of this work see the critical edition by J. T. Boulton, 1958.
16. *Notes*, p. 226
17. *Ibid.*, p. 209
18. *Ibid.*, p. 226
19. *Ibid.*, pp. 226–7
20. Vertue, p. 156
21. *Ibid.*, p. 144

22. *Daily Advertiser*, 28 May 1751, reprinted Paulson, ii, 122–3
23. *Ibid*
24. *Works*, i, 186

CHAPTER X
1. Add MSS 27995, fos 12–13
2. *Ibid.*, fo. 7
3. Franciscus Junius, *The Painting of the Ancients*, 1638, p. 10
4. *Ibid.*, pp. 52, 66–7
5. *Analysis*, p. 99
6. *Ibid.*, p. 56
7. *Ibid.*, p. 71
8. *Ibid.*, p. 149
9. *Apology*, p. 106
10. *Analysis*, p. 161
11. Jarrett, *Begetters of Revolution*, p. 34
12. *True Patriot*, no. 4, 26 Nov 1745, cited in R. C. Jarvis, *Collected Papers on the Jacobite Risings*, 2 vols, Manchester 1971–2, ii, 199
13. *The Protester*, 11 and 25 Aug and 15 Sept 1753, pp. 63, 77, 96
14. Paulson, ii, 204. It seems to me that when describing the crucial events of the early 1750s Paulson is too ready to assume that Hogarth and Ralph saw politics in terms of aesthetics. He underrates the importance of *The Protester*, as compared with Ralph's other ventures, and when he does mention it he calls it *The Protector*.
15. *Notes*, p. 231
16. *Ibid.*, p. 230
17. These details, together with further documentation on the political commitments of supposedly 'independent' members, are given in my paper 'The Myth of Patriotism in Eighteenth Century British Politics' in *Britain and the Netherlands*, vol. V, eds J. S. Bromley and E. H. Kossmann, The Hague, 1976, pp. 120–40.
18. *British Museum Satires*, no. 2863
19. For details of these pamphlets see Derek Jarrett, 'The Regency Crisis of 1765', *English Historical Review*, vol. lxxv, April 1970, pp. 282–315.
20. *The Protester*, 8 Sept 1753, p. 88
21. *Correspondence of John, Fourth Duke of Bedford*, ed. Lord John Russell, 3 vols, 1842–6, ii, 135–6; *Political Journal of George Bubb Dodington*, eds. J. Carswell and L. A. Dralle, Oxford 1965, pp. 218–19, 221, 238.
22. *Apology*, pp. 94, 95
23. Walpole, iii, 221
24. See R. J. Robson, *The Oxfordshire Election of 1754*, Oxford 1949.

25. Paulson, ii, 203
26. It is difficult to gauge the reactions of the politicians themselves to the *Election* prints. Among the five hundred people who subscribed for them (see Hogarth's subscription book, Add MSS 22394) I have only been able to identify eight with any certainty as being 'independent' members, while at least five times that number were career politicians or party leaders. However, the potentates are more easily identifiable because they are given their titles or christian names, whereas nonentities from the country, unknown to the compilers of the list, often appear as unadorned surnames and thus defy identification. It is also worth remembering that 'independents' would be less likely than the professionals to be in London so soon after an election.
27. Both quotations come from the paragraph cited in Paulson, ii, 203.
28. Walpole, iii, 377
29. *Ibid.*, iv, 12, 20
30. Paulson, ii, 220
31. *Notes*, p. 213
32. Walpole, iv, 109

CHAPTER XI

1. S. Savage, 'A Recently discovered Letter of William Hogarth', *Connoisseur* lxx, Nov 1924, pp. 167–8
2. J. Ireland, *Hogarth Illustrated III*, pp. 111–12
3. *Works*, iii, 292–4
4. For a masterly analysis of Smollett's satire see Paulson, ii, 130–5.
5. Paulson, ii, 453–4n8
6. *Ibid.*, ii, 264–5
7. *Notes*, p. 220
8. Add MSS 22394, fos 32, 37
9. *Anecdotes*, p. 56
10. *Works*, i, 317
11. *Notes*, pp. 220–1
12. On the Society's political ambitions see D. G. C. Allan, 'The Society of Arts and Government, 1754–1800', *Eighteenth Century Studies*, vol. vii, no. 4, Summer 1974, pp. 434–52. Its efforts to get technology on the cheap may be studied in William Bailey, *The Advancement of Arts, Manufactures and Commerce, or, Descriptions of the useful machines and models contained in the Repository of the Society for the Encouragement of Arts, Manufactures and Commerce*, 1772. James Ferguson, for instance, put his newly invented 'crane with three powers' at the disposal of the Society in 1762 for a premium of £50.

13. Paulson, ii, 310
14. Walpole, v, 3–4
15. *Ibid.*, v, 11
16. For the subsequent fortunes of the Grosvenor family see Sir Lewis Namier and John Brooke, *The House of Commons, 1754–1790*, 3 vols, 1964, ii, 557–9. The pretence of independence was kept up into the 1780s, even though by that time Sir Richard had been promoted from baron to earl and his son had been brought into Parliament for a government-controlled borough and had been given a government sinecure.
17. *London Gazette*, 6–10 Jan 1761
18. Paulson, ii, 320
19. Walpole, v, 55–7
20. *Anecdotes*, p. 103
21. Jarrett, *England in the Age of Hogarth*, p. 192. The 'No Dedication' is Add MSS 39672, fos 87–8.
22. *Notes*, p. 221
23. Paulson, ii, 342
24. *Notes*, p. 231. Paulson's view (ii, 380) that Hogarth was writing about *The Times Plate 2* is hard to accept. There is nothing in that print to which these words could conceivably refer and in any case it had remained unpublished, so that it would hardly be among the works for which the *Autobiographical Notes* were intended as a commentary.
25. *Notes*, p. 221; Paulson, ii, 379
26. *British Museum Satires*, no. 3977
27. *Notes*, pp. 221–2
28. Paulson, ii, 392
29. *GM* 1785, p. 344

CHAPTER XII
1. *Apology*, p. 105
2. *Ibid.*, p. 91
3. *Ibid.*, pp. 54–5
4. *Ibid.*, p. 106
5. Marshall J. McLuhan, *Understanding Media*, 1964

FURTHER READING

The first biography of Hogarth was John Nichols's *Biographical Anecdotes of William Hogarth*, first published in 1781 and re-issued several times during the next forty years. Nichols assembled a formidable team of collaborators and contributors, so that his compilation seemed to represent all that could be found out about the artist. Nevertheless it was criticised by Hogarth's widow and in the 1790s, after her death, Nichols's monopoly was challenged by John Ireland and Samuel Ireland, two men who were apparently unrelated except in their shared enthusiasm for Hogarth. John Ireland's *Hogarth Illustrated*, 3 vols, 1791–8, culminated in that triumphant publication of original material which I have already described in the Introduction to this book. Samuel Ireland, in *Graphic Illustrations of Hogarth*, 2 volumes, 1794–9, replied by attacking the quality of the prints used in his namesake's book and by belittling the importance of the manuscripts. Then both men found their work swept up into *The Genuine Works of William Hogarth*, brought out in three volumes by John Nichols and his collaborators between 1808 and 1817.

The condescending tone already apparent in the *Biographical Anecdotes* was even loftier in this new compilation: whereas in the first book Hogarth's alleged illiteracy was compared to that of Jack Cade (who was supposed to have put a man to death because he resented the fact that he could read), in the second there was a section which claimed to illustrate Hogarth's work 'from passages in authors he never read and could not understand'. The compilers also took it on themselves to omit those prints which they considered indelicate, 'in order to make this edition in every respect an instructive and moral work, worthy of the great master whose name it bears'. Finally, in 1833, Nichols's son J. B. Nichols published *Anecdotes of William Hogarth*, incorporating much of the material turned up by his father and by John Ireland and adding some later essays on Hogarth for good measure. And there, for the time being, the matter rested. After half a century of profitable enterprise the Nichols family and its rivals had finished their sport with William Hogarth. The results of their efforts have now been made more widely available: facsimile reprints of the *Anecdotes* and the *Biographical Anecdotes* were published in 1970 and 1971 respectively.

Hogarth's next biographer was Austin Dobson, who published his *William Hogarth* in 1879 and re-issued it several times up to 1907, the date of the most complete and most useful edition. It was Dobson who found the *Thesaurarium* in the London Library and realised that it was by Hogarth's father. Apart from this there was not a great deal of new material in the book, but it was enthusiastic and sympathetic and it helped to re-awaken interest in the subject. In 1890 F. Weitenkampf published an exhaustive bibliography of works on Hogarth, most of them very short. W. T. Whitley, in *Artists and their Friends in England, 1700–1799*, 2 volumes, 1928, drew on George Vertue's manuscript notebooks, which the Walpole Society started to publish from 1930 onwards (see above, p. 201). This gave a new impetus to the study of eighteenth-century English art, but Hogarth himself was not an immediate beneficiary. The somewhat limited approach of M. Bowen's *Hogarth the Cockney's Mirror*, 1936, was made clear in its title.

Serious modern work on Hogarth began in 1948 with the publication of A. P. Oppé's *The Drawings of William Hogarth*. Another edition, by Michael Ayrton, appeared in the same year. R. B. Beckett's *Hogarth*, a catalogue of the paintings, followed in 1949. Meanwhile R. E. Moore, *Hogarth's Literary Relationships*, Minneapolis 1948, opened up the important subject of the links between literary and visual satire in the artist's work. In 1951 a Hogarth exhibition was mounted to mark the Festival of Britain and a catalogue, prepared by R. B. Beckett, was published. Charles Mitchell's edition of *Hogarth's Peregrination*, Oxford 1952, made available once more this rare work describing the journey into Kent in 1732 (see above, p. 114). In 1955 Peter Quennell published a stimulating biography, *Hogarth's Progress*, and in the same year Joseph Burke's scholarly edition of *The Analysis of Beauty* appeared, incorporating both the *Autobiographical Notes* and the unpublished parts of the *Analysis* itself (see above, p. 201). Frederick Antal, *Hogarth and his place in European Art*, 1962, was somewhat dogmatic in its approach to the political and social context of Hogarth's work, but its authoritative and wide-ranging scholarship did much to convince even the English that Hogarth was a serious artist and not a mere comic illustrator.

The latest and perhaps the greatest chapter in Hogarth studies began in 1965 with the appearance of Ronald Paulson's *Hogarth's Graphic Works: First Complete Edition*, 2 vols, New Haven. Placed alongside the work of Oppé and Beckett, this magnificent and scholarly edition enabled the student to view Hogarth's whole achievement for the first time in a connected fashion. Three years later Michael Kitson's edition of the *Apology for Painters* (see above, p. 201) completed the process, already begun by Joseph Burke, of making Hogarth's written work as readily available as his prints and paintings and drawings. In 1970 Ronald Paulson published a revised edition of *Hogarth's Graphic Works* and in the following year he produced his master-

piece, *Hogarth: His Life, Art and Times*, 2 volumes, New Haven 1971. This great work surveys the whole field of Hogarth studies without seeking to possess it: 'it belongs, in fact,' said the *Times Literary Supplement* when reviewing it, 'to the select class of book that offers one the equipment to disagree with it'. Its appearance was an appropriate curtain-raiser to the comprehensive exhibition of Hogarth's work which was mounted at the Tate Gallery from December 1971 to February 1972. The catalogue for that exhibition, incorporating a biographical essay by Ronald Paulson, was compiled by Lawrence Gowing, who had recently thrown some new light on the artist in his lecture 'Hogarth Revisited' (*University of Leeds Review*, vol. xiii, no. 2, Oct 1970, pp. 186–98).

Any attempt to list 'background reading' on Hogarth makes one realise immediately just how vast his background was. I have already written on some aspects of it and my earlier books (*Britain 1688–1815*, 1965; *The Begetters of Revolution*, 1973 and *England in the Age of Hogarth*, 1974) contain bibliographies which it would be pointless to repeat here. They list works on political and social history in the eighteenth century and *The Begetters* may be of particular interest because it concerns England's involvement with France, a topic of special importance for Hogarth's work. The specifically artistic aspects of that involvement can be followed up from the references contained in Elizabeth Einberg, *The French Taste in English Painting during the first half of the eighteenth century*, a catalogue prepared for the Kenwood Summer Exhibition of 1968. Other aspects of eighteenth-century art and patronage which particularly concerned Hogarth are covered in: John Charlton, *A History and Description of Chiswick House and Gardens*, 1958; Edward Croft-Murray, *Decorative Painting in England, 1537–1837*, 2 volumes, 1962, 1970; Michael Foss, *The Age of Patronage*, 1971; Christopher Hussey, *English Country Houses, Early Georgian, 1715–1760*, 1955 and *English Country Houses, Mid-Georgian 1760–1800*, 1956; James Lees-Milne, *The Age of Adam*, 1947 and *Earls of Creation*, 1962; Ellis Waterhouse, *Painting in Britain 1530–1790*, 1953.

The background to Hogarth's graphic satire – and indeed, to eighteenth-century London life as a whole – is wonderfully revealed in the *Catalogue of Prints and Drawings in the British Museum, Division I: Political and Personal Satires*, begun in the 1870s under the editorship of F. G. Stephens and continued, from 1935 onwards, under that of the late M. Dorothy George. In addition to the catalogue itself Mrs George produced some important and extremely readable books both on the caricatures themselves and on the life they reflected: *England in Transition*, 1953; *English Political Caricature*, 2 volumes, Oxford 1959; *London Life in the Eighteenth Century*, revised edition, 1965, and *Hogarth to Cruikshank: Social Change in Graphic Satire*, 1967. More recently Herbert M. Atherton, *Political Prints in the Age of Hogarth*,

Oxford 1974, has provided a scholarly survey of political caricatures between 1727 and 1763, other than those by Hogarth himself.

Ronald Paulson, *Emblem and Expression: Meaning in English Art of the Eighteenth Century*, 1975, which appeared after the present book had gone to press, includes a section on Hogarth.

Index